VENICE

The Artist's Vision

A guide to
British and American painters

JULIAN HALSBY

Unicorn Press · London

ISBN 0 906290 35 X

Printed in China by
Midas Printing
for the Publisher
Unicorn Press
21 Afghan Road
London SW11 2QD

*To the memory of my father James A. Halsby
(born New York 1908 – died Menton 1981)
who first introduced me to Venice in 1967
and shared with me his love of the city.*

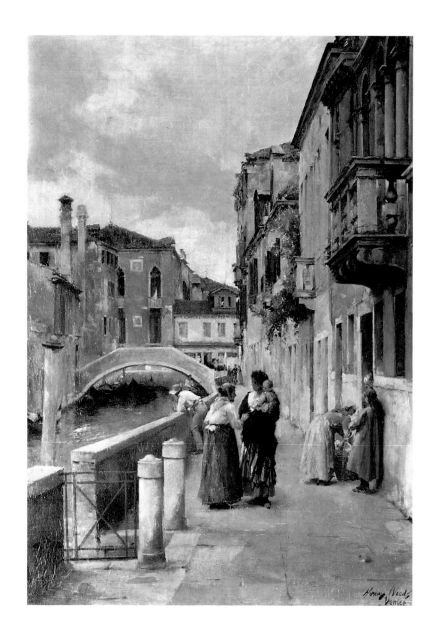

HENRY WOODS
Fondamente San Sebastiano
Oil on canvas, 16 × 11 in
(40.6 × 27.9cm)
Photograph courtesy of
Sotheby's

Contents

Preface and acknowledgements

Over many years I noticed paintings of Venice in public and commercial galleries, as well as in the salerooms, and I wanted to find out more about the development of Anglo-American paintings of my favourite city. Dealers told me that Venetian subjects usually sell at a premium, and it seemed that the popularity of Venice amongst both collectors and artists remained as great in the late twentieth as in the early nineteenth century. As I researched I discovered more about the social life of the artists in Venice, about Anglo-American society, and about interesting ex-patriots such as Rawdon Brown, William Dean Howells and Horatio Brown. I discovered that Venice attracted artists from many countries, not solely for its wealth of painterly subjects, but also for its way of life, the comradeship amongst artists and its tolerance of eccentric and unusual behaviour. Glimpses into Eng-lish-speaking society in Venice were revealed by diaries or letters, and although I always wished for more information, I was able to piece together a coherent picture. This is, therefore, a book not only about art history, but also about social history.

I have written about British and American artists because their development, as regarded Venice, was closely linked. The major American painters in Venice, John Singer Sargent and James McNeill Whistler, both lived and worked for long periods in London, and probably had more British friends and associates than American. Moreover, many Americans studied in the Paris ateliers meeting English and Scottish students. Influences passed easily between the countries: Turner,

for example, influenced the earlier American visitors to Venice – in particular Thomas Moran – while Whistler and Sargent influenced many British painters and etchers towards the end of the century. Socially the two groups met regularly in Venice at the palaces of the Curtises, the Bronsons, the Brownings, the Montalbas and the Layards. Thus there is much logic in dealing with British and American artists separately from the French, Germans and Italians.

I have not attempted to give an overall view of modern artists working in Venice, as this would result in a long and tedious list. Instead I have focused on a few artists and discussed their attitude to working in Venice. I apologize to artists thus excluded, but omission is in no way intended as judgement. In my previous book *Scottish Watercolours 1740–1940* (Bats-ford), I included a dictionary section which allowed me to continue a discursive text without overburdening it with lists of names. This system worked well, and I have therefore included some 400 artists, not in the main text but who also worked in Venice, in a dictionary section. Again, I could not hope to include all contemporary painters and the bulk of the entries were active before 1950.

I also thought that a chronology, however incom-plete, would be useful as it helps to throw into historical perspective the overlapping styles in which Venice was rendered. Thus it came as a surprise to me that William Callow's final visit came just two years before Arthur Melville's only visit, and just three years before Sickert's first visit. Similarly, Ruskin's last visit took

place eight years after Whistler's departure. The chronology stops in 1914 as the arrivals and departures of artists between the wars are so frequent that a chronology becomes meaningless.

While working on this book I discovered that the Royal Watercolour Society was, quite independently, planning an exhibition of British watercolours of Venice for November 1990. The exhibition organizer, Tim Wilcox, has allowed me to study his research notes and has put aside time for discussion of the subject. I owe him a great debt of gratitude for selflessly sharing his research. Peter Rose and Albert Gallichan both read the first draft, making many useful criticisms and suggestions. These led to substantial revision and, I think, improvement of the text. They have also put me in contact with private collectors and have taken a continued interest in the project.

Many commercial galleries have helped in providing information and illustrations, and in particular I thank Christopher Kingzett of Agnews, Andrew Patrick of The Fine Art Society and the Photographic Departments of Sotheby's and Christie's. Chris Beetles not only helped to provide photographs, but also allowed me access to Walter Tyndale's fascinating diaries and notebooks. Patrick Bourne and Juliet and Chris Moller kindly helped with the dictionary section, often asking 'Did you know that . . . worked in Venice?' Often I did not. I have been helped by museum staff both in Britain and in the United States, and I must in particular thank Stephen Wildman of Birmingham Museum and Art Gallery for his interest in the book.

It has been most interesting talking to artists about their reaction to Venice and I am grateful to Bernard Dunstan, Diana Armfield, Patrick Procktor and Ken Howard for the time they spent with me. I will long remember discussing art, late into the night, with Ken Howard and Christa Gaa while sitting in little restaurants in the *campi* around San Barnaba. I feel that talking about the delights and pitfalls of painting Venice with contemporary artists has given me an insight into the attitude of nineteenth-century painters.

Finally I would like to thank my wife, Miranda, for sharing my love of Venice, for helping me locate artists' studios in the remoter parts of Venice, for being an excellent sounding board for my ideas and for providing the map (see page 6). Some authors have to apologize to their families for long absences while researching books. To apologize for being in Venice would, I fear, be hypocrisy.

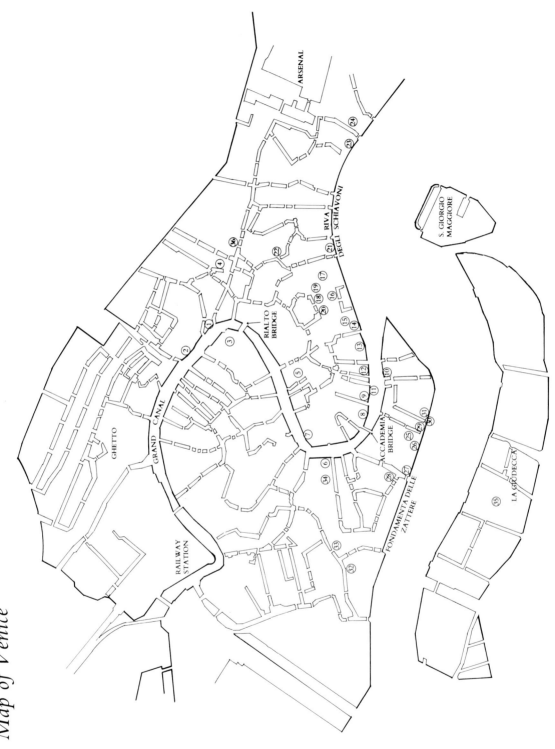

Map of Venice

ARSENAL

RIVA DEGLI SCHIAVONI

S. GIORGIO MAGGIORE

GHETTO

GRAND CANAL

RIALTO BRIDGE

ACCADEMIA BRIDGE

FONDAMENTA DELLE ZATTERE

LA GIUDECCA

RAILWAY STATION

1 The discovery of Venice

Byron, Turner and Bonington

In an age when almost every *campo* in Venice contains an artist at his easel, it is difficult to imagine a time when British artists passed the city by. Yet, in the eighteenth century Venice was not commonly visited by British artists, who flocked instead to Florence, Rome, Sicily and the Campagna to study classical ruins and draw Arcadian landscapes, leaving Venice to Canaletto and his Italian followers. That there was a huge demand for views of Venice cannot be doubted, but the dominance of Canaletto and the *vedutisti* frightened off foreign competition.

Venice was a popular goal for English nobility on the Grand Tour as Lady Mary Wortley Montague complained in 1740:

. . . this town is at present infested with English who torment me as much as the frogs and lice did [at] the palace of Pharoah.

It was especially popular during the great festivals of the Ascension and the Carnival. During Ascension a fair was held in the Piazza San Marco, when the Doge symbolically wedded Venice to the Adriatic. The Piazza had for long fascinated the British tourist as noted by a writer in 1792:

When the piazza is illuminated, and the shops in the adjacent streets are lighted up, the whole has a brilliant effect, and it is the custom for the ladies as well as the gentlemen to frequent the casinos and coffee-houses around, the Place of St Marks answers all the purposes of either Vauxhall or Ranelagh.

Architects went to Venice not for the splendours of St Mark's or the Gothic palaces, but to study the Palladian buildings in

RICHARD PARKES BONINGTON

The Rio dei Greci and the Greek Church 1826
Pencil, $15 \times 10\frac{3}{4}$in
(38.1×27.3cm)
Bowood House, Wiltshire.
Photograph courtesy of
Thomas Agnew and Sons

Vicenza, along the Brenta Canal, as well as in Venice itself. To a century nurtured on classicism St Mark's did not appeal, as Joseph Woods the architect recorded:

The church of S. Marco surprises you more by its extreme ugliness than by anything else . . . The Ducal Palace is even more ugly than anything I have previously mentioned.

While John Evelyn in the previous century found it 'much too dark and dismal, and of heavy work', other visitors like Edward Gibbon in 1765 complained about the dirt and decay:

Of all towns in Italy I am the least satisfied with Venice . . . Old, and in general ill-built, houses, ruined pictures and stinking ditches dignified with the pompous denominations of canals, a fine bridge spoilt by two rows of houses upon it, and a large square decorated with the worst architecture I ever saw.

For other travellers, gnats provided a further source of irritation, apparently as difficult to avoid as the prostitutes:

The courtesans here are the most insinuating and have the most alluring arts of any in Italy.

Despite such complaints, some British artists did visit the city, usually with the intention of studying the Venetian Masters. Richard Wilson spent a year in Venice from 1750 to 1751 studying Titian's portraits and he found time to produce a number of drawings of San Giorgio, Chioggia and landscapes based on the Venetian rococo style of Marco Ricci and Francesco Zuccarelli. In December 1751 he left for Rome where he found his true inspiration in the classical landscapes of Poussin and Claude Lorrain. Sir Joshua Reynolds had also studied Venetian portraits but no drawings of Venice by him are known. Another early visitor was Thomas Patch who had settled in Italy around 1747. He was in Venice in 1760 and saw the work of Canaletto and Bellotto, which had already influenced his own views of Florence; but possibly intimidated by the success of Canaletto, he produced nothing of Venice that we can trace today. John Cozens was in Venice in 1782 for a few days and one sketch from that visit is known. We also know from a sketchbook in the Victoria and Albert Museum that Thomas Rowlandson was in Venice in the 1780s. On the other

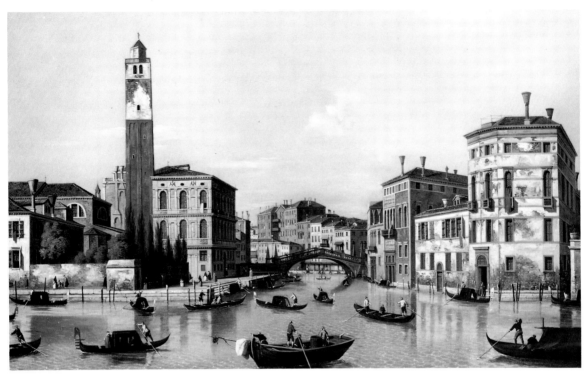

WILLIAM JAMES

The Grand Canal with St Geremia and the Entrance to the Cannaregio
Oil on canvas, 24 × 38in
(61 × 96.5cm)
Photograph courtesy of
MacConnal-Mason Galleries,
London

hand, many paintings in the style of Canaletto are attributed to the English artist William James who worked from 1754 to 1771. While some are genuine, many must be indifferent copies of Canaletto by minor Italian artists brought back by English tourists after 1815.

The fall of the Republic in 1797 went unnoticed amongst artists in Britain and yet within a mere thirty years Venice had become one of the most popular locations for artists and their buying public. This transformation was brought about by a poet and a painter – Lord Byron (1788–1824) and J.M.W. Turner (1775–1851). Byron arrived in Venice in November 1816, having travelled down the Brenta to Mestre where he left his carriages and took a gondola across the lagoon. He was immediately impressed by the melancholy of a decaying city:

It has not disappointed me; though its evident decay would perhaps have that effect upon others. But I have been familiar with ruins too long to dislike desolation.

That very desolation and decay which appalled the eighteenth-century mind appealed to a new generation of Romantics:

It is one of those places which I know before I see them, and has haunted me the most after the East. I like the gloomy gaiety of their gondolas, and the silence of their canals. I do not even dislike the evident decay of the city . . .

In April 1817 Byron left for Rome but he was back in Venice in May, renting the Villa Foscarini at La Mira on the Brenta to escape the summer heat. He returned to the city in November and threw himself into the social life, attending operas by Rossini, plays by Goldoni and the *conversazioni* of Venetian society. He had hoped to buy a palace, but in the event rented the third Palazzo Mocenigo, one of three Gothic masterpieces on the bend in the Grand Canal between the Accademia and the Rialto. The palace saw a succession of Byron's mistresses and scandalous stories reverberated around Venice for decades after his death. For relaxation Byron liked to ride his horse along the open sands of the Lido, and he was also a prodigious swimmer, on one occasion crossing from the Lido to his palace on the Grand Canal. His last love in Venice was the nineteen-year-old Teresa Guiccioli, who was bored with her marriage to a Count in his late fifties. They met clandestinely in gondolas and were rowed to the Lido to savour the sunsets over Venice; so enamoured was Byron that in July 1819 he left Venice to follow her to Ravenna. His adventures continued, but Venice was no longer to be his stage.

During his Venetian interlude Byron wrote much, including *Beppo*, *The Two Foscari*, *Ode on Venice* and the important *Childe Harold's Pilgrimage* which was to influence Turner:

> I stood in Venice, on the Bridge of Sighs;
> A palace and a prison on each hand:
> I saw from out the wave her structures rise
> As from the stroke of the enchanter's wand:
> A thousand years their cloudy wings expand
> Around me, and a dying glory smiles
> O'er the far times, when many a subject land
> Look'd to the wing'd Lion's marble piles,
> Where Venice sate in state, throned on her hundred isles.

To Byron, Venice was an omen, a decaying city whose crumbling buildings and fallen Republic pointed a warning

finger towards Britain's proud democracy and obvious pros-
perity. If the mighty Venice, Serenissima, Mistress of the Sea,
could be brought so low, Britain beware.

Turner's vision of Venice has influenced generations of artists
and it is difficult for any traveller not to see the city at times
through his eyes; and yet his stays in Venice were remarkably
brief. In all, Turner spent no more than four to five weeks there,
split between three trips over a period of 21 years. His
extraordinary visual memory enabled him to recapture the
sunlight, mists and storms of the Lagoon as well as the character,
if not details, of its buildings in his paintings which were
executed from sketches years later. Turner's paintings
influenced Ruskin to go there and many minor artists, both
British and American, caught their first glimpse of Venice
through his canvases, watercolours and even reproductions.

With the arrival of peace in 1815 many British artists set off to
the Continent, but Turner's plans to visit Italy were delayed by
pressure of work until 1819, when his goal was Rome. He was
now aged 44, a stocky figure with broad shoulders and not
given to effusive conversation. It is possible that his reason for a
diversion to Venice was to produce etchings for *Picturesque Tour
of Italy*, a book planned by his friend James Hakewill. Hakewill
had been to Venice and recommended that Turner stay at the
famous Osteria del Leon Blanco in what is known as the Ca' da
Mosto, an important example of Veneto-Byzantine architec-
ture which still stands on the Grand Canal opposite the Rialto
Market.

He arrived on the 8th or 9th September and remained for
only five days; yet during that time he worked incessantly,
making sketches in his notebooks and some watercolours on the
spot. From these sketchbooks it is possible to trace Turner's
itinerary through Venice during these vital five days. He
sketched economically, succinctly recording the topography in
a few lines. The Grand Canal attracted his attention, especially
views with the bustle of people and boats. His hotel was near the
Rialto Bridge and many sketches relate to the busy Riva del Vin
and Riva del Carbon on either side of the bridge. He was
impressed by the views from the Piazzetta, and painted a
watercolour of San Giorgio in the morning light, a view of the
Punta della Salute with the Giudecca behind, and a view of St

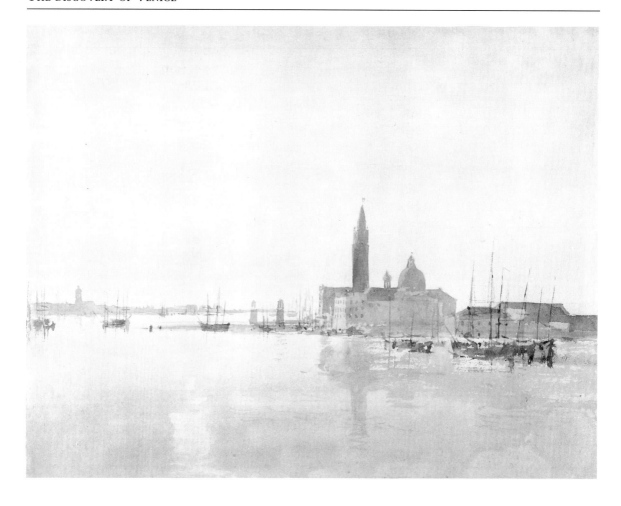

JOSEPH MALLORD WILLIAM
TURNER

*San Giorgio from the Dogana,
Sunrise* 1819
Watercolour, $8\frac{3}{4} \times 11\frac{1}{4}$
(22.2 × 28.6cm)
Tate Gallery, London

Mark's with the Ducal Palace. He crossed over to the Giudecca where he painted a watercolour looking east. These four watercolours were probably the only ones actually painted on the spot, but his sketchbooks contain colour notes and the names of buildings (often, in fact, wrong) and he certainly hired a gondola and worked from the water. There was no time to explore the remoter corners or visit the islands, but the atmospheric effects of Venice, especially the sunsets, caught his eye and he annotated one sketch 'All the Steeples blood red'.

Turner returned to London early in 1820 and executed a few Venetian watercolours from his sketches in a somewhat desultory manner; we must conclude that while he was certainly interested in Venice he was by no means bowled over by it. It was only in the early 1830s when, spurred on by Bonington's

posthumous success and Clarkson Stanfield's growing reputation, Turner returned to his Venetian sketchbooks to work up two canvases for the 1833 Royal Academy Summer Exhibition. One was a view of the Ducal Palace, the other a topographically inaccurate view entitled *Bridge of Sighs, Ducal Palace and Custom-House, Venice: Canaletti Painting*. The *Morning Chronicle* of 6 June 1833 records, probably apocryphally, that Turner painted this picture

it is said, in two or three days, on hearing that Mr Stanfield was employed on a similar subject – not in the way of rivalry of course, for he is the last to admit anything of the kind, but generously, we will suppose, to give him a lesson in atmosphere and poetry.

Whether in rivalry or not, Turner had noted the growing interest in Venice and his response lay in these two paintings, which effectively counterbalanced Stanfield's *Venice from the Dogana*. The critics were, for once, right; Stanfield's oil, while being more topographically accurate, lacked Turner's light and atmosphere. Turner took great liberties with the topography of

JOSEPH MALLORD WILLIAM
TURNER

*Bridge of Sighs, Ducal Palace
and Customs House, Canaletti
Painting* (RA 1833)
Oil on canvas, $20\frac{1}{4} \times 32\frac{1}{2}$in
(51.4×82.6cm)
Tate Gallery, London

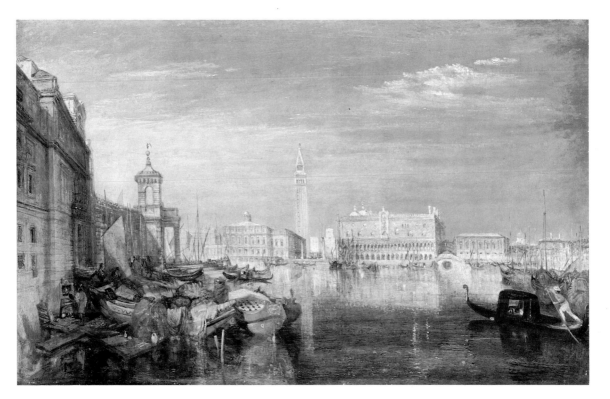

Venice, often moving whole buildings in order to create the composition he required; he also distorted the architecture. He may have done this because of lack of visual information, but more likely it was to emphasize his break with the topographical school of Canaletto and his followers. Moreover, when painting his impression of a storm or a sunset, the architectural details became incidental to the overall effect. The critics were certainly impressed by the overall effects of these two oils: 'Viewed from whatever distance, Turner's work displayed a brilliancy, breadth and power, killing every other work in the exhibition' and this critical and commercial success encouraged Turner to return to Venice in September 1833 when the Royal Academy Exhibition had closed.

Whilst there is no documentary evidence of Turner's second visit to Venice we can again reconstruct some details from his sketchbooks and watercolours. He stayed this time at the Hotel Europa on the Grand Canal opposite the Dogana and made a number of watercolours of his hotel bedroom and some nocturnal views from the roof of the building. These served as the background for *Juliet and her Nurse*, a major oil which was exhibited at the Royal Academy in 1836. Turner's imaginative recreation of Shakespeare's scene upset the critics:

A strange jumble – 'confusion worse confounded'. It is neither sunlight, moonlight, nor starlight, nor firelight . . . Amidst so many absurdities, we scarcely stop to ask why Juliet and her nurse should be at Venice. For the scene is a composition as from models of different parts of Venice.

Another critic attacked the picture's 'deformities in drawing', but a young man aged 17 sprang to Turner's defence:

Turner is an exception to all rules, and can be judged by no standard of art . . . he has filled his mind with materials drawn from the close study of nature (no artist has studied nature more intently) – and then changes and combines, giving effect without absolute cause . . . seizing the soul and essence of beauty, without regarding the means by which it is effected.

The young man sent his manuscript to Turner, but it was not published until sixty years later. However, John Ruskin had entered the world of art criticism.

Turner's stay in Venice in 1833 was again short, and it is difficult to know which watercolours were done on the spot and which were painted later in London, either from sketches or over pencil drawings done in Venice. He found that his Venetian oils were selling well and decided to return in 1840. This visit is documented: we know that he arrived in mid-August to stay for two to three weeks, and we have an eyewitness account written by William Callow in his autobiography:

The next time I met Turner was at Venice at the Hotel Europa where we sat opposite at meals and entered into conversation. One evening whilst I was enjoying a cigar in a gondola I saw in another one Turner sketching San Giorgio, brilliantly lit up by the setting sun. I felt quite ashamed of myself idling away the time whilst he was hard at work so late.

Not only was Turner working on evening scenes, he was also

JOSEPH MALLORD WILLIAM TURNER

The Campo Santo 1842
Oil on canvas, $24\frac{1}{2} \times 36\frac{1}{2}$in
(62.2 × 92.7cm)
The Toledo Museum of Art

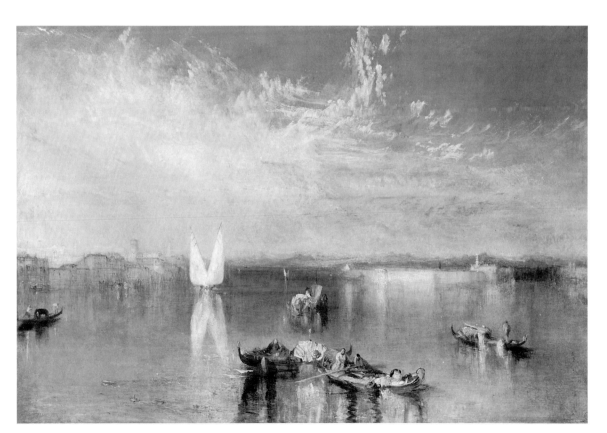

recording the violent summer storms on the Grand Canal. His vision had broadened and moved yet further towards a Romanticism in which the decline of Venice was symbolically represented. *The Dogana, San Giorgio, Citella from the Steps of the Europa* shows Venice in its prime, with the Customs House at the centre of world trade and a symbol of mercantile power, while *The Campo Santo* represents the moral and spiritual death of Venice rather than simply a cemetery. Fallen empires fascinated Turner, and Carthage and Rome, extinguished by luxury, superstition and moral weakness, also featured in his work. *The Sun of Venice Going to Sea* was exhibited at the Royal Academy in 1843 along with slightly altered lines from Thomas Gray's *The Bard*:

> Fair shines the morn, and soft the zephyrs blow,
> Venezia's fisher spreads his painted sail so gay,
> Nor heads the demon that in grim response,
> Expects his evening prey.

The freshness of the morning light and the picturesque beauty of the boat are in stark contrast to the impending storm, just as, unknown to the people of Venice, the golden days of the Republic had been numbered. The critics attacked Turner's use of quotations to add depth to the pessimistic meaning of the picture:

His style of dealing with quotations is as unscrupulous as his style of treating nature and her attributes of form and colour.

However, the marriage of literary and visual concepts are fundamental to Romantic art. *The Sun of Venice* was one of Ruskin's favourite pictures and in a letter to his father from Venice, dated 14 September 1845, he wrote that he had seen:

. . . a fishing boat with its *painted* sail full to the wind, the most gorgeous orange and red, in everything, form, colour, and feeling, the very counterpart of the Sol di Venezia.

As a result of his 1840 visit Turner painted 19 finished oils of Venice, mostly 24 × 36in (61 × 91cm), a size he found suitable, in addition to several experimental oils and a large number of watercolours. By 1845 he was 70 and his health was beginning to fail, but he had shown that Venice, far from being a

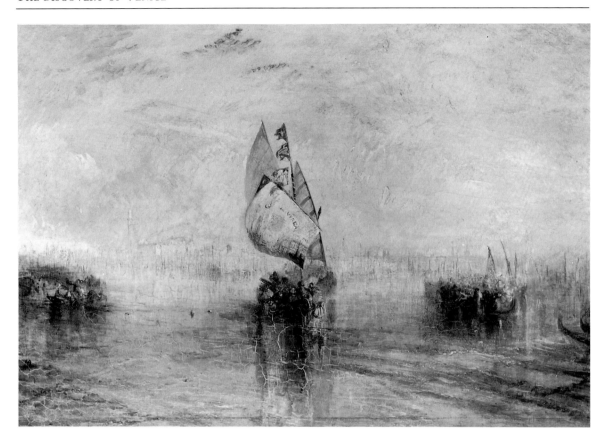

JOSEPH MALLORD WILLIAM TURNER

The Sun of Venice Going to Sea
(RA 1843)
Oil on canvas, 24½ × 36¼in
(62.2 × 92.1cm)
Tate Gallery, London

backwater for British artists, a picturesque city to be painted in the style of Canaletto or, at best, a museum for the study of Titian or Tintoretto, was instead a subject worthy of truly heroic and Romantic interpretation; a city whose atmospheric effects were equal to those of the Alps, and whose history was as tragic as Rome or Carthage.

On 20 April 1826 a young English artist, Richard Parkes Bonington (1802–1828) arrived in Venice and took rooms in the Albergo Danieli. He was to remain for only one month, but during that time he painted oils and watercolours which were to surprise and delight the public, and to force fellow artists to turn to Venice as a subject suitable for painting. Two years later, Bonington was dead, aged only 26, but his influence far outlived his short life.

Bonington was born in Nottinghamshire, but when he was 15 his family moved to Calais where his father was involved in the design and manufacture of lace. He trained in Calais under

RICHARD PARKES BONINGTON

The Doge's Palace from the
Ponte della Paglia
Watercolour, bodycolour and
gum varnish, 8 × 10¾in
(20.3 × 27.3cm)
Wallace Collection, London

Francia and in Paris where he briefly attended Baron Gros'
atelier at the Ecole des Beaux-Arts. In 1825 Bonington visited
England and met Samuel Prout who had been in Venice the
previous year. This aroused Bonington's interest in Venice and
when in 1826 Baron Charles Rivet, a patron of the Romantic
School, proposed a trip to Italy, Bonington readily agreed.
According to Rivet, writing from Milan:

Bonington thinks only of Venice; he makes sketches and works a
little everywhere, but without satisfaction and without interest in the
country. He makes no effort to learn Italian, keeps to his tea, and
requires the help of an interpreter in everything.

They arrived in Venice to find the weather overcast which put
Bonington into 'a dismal mood'. Together they visited the
Accademia and many churches, and, as the weather improved,
Bonington began to paint out of doors. Rivet noted:

Our life is always the same. After the walks and the work of the day we return at half-past five, when dinner is served in our room. The menu does not vary. Then we go and take coffee in the Piazza San Marco . . .

Rivet also noticed that as Bonington began to gain experience of Venice his work improved:

He works hard and adopts so readily the suitable style and method that he is more and more successful and more and more easily so.

Bonington, like Turner, was imbued with the Romantic creed, but expressed it very differently. He was less interested in the symbolic and visionary aspects of art, concentrating instead on the theatrical and exotic possibilities of Venice. His figures are

RICHARD PARKES BONINGTON
The Piazetta
Watercolour, $6\frac{3}{4} \times 8\frac{3}{4}$in
(17.2×22.2cm)
Wallace Collection, London

often dressed in Eastern costume or in styles taken from the Venetian Masters. Moreover his colour reflects the Venetian School with its rich reds and deep blues. He managed to alter famous views, so that they appear more dramatic and theatrical, but the viewer is often unaware that any changes have been made. For example, he achieves a dramatic effect by incorporating wide angles of vision as in *The Doges' Palace*; yet this is achieved with apparently effortless skill and technique. Both Bonington's oils and watercolours have a lightness of touch and a transparencey of colour which conceal careful planning and execution. Delacroix wrote many years after Bonington's death:

I could never weary of admiring his marvellous understanding of effects, and the facility of his execution; not that he was easily satisfied. On the contrary, he frequently repainted things that were completely finished and seemed wonderful to us; but his skill was such that his brush immediately produced fresh effects as delightful as the first.

As their planned stay drew to a close, Bonington thought of extending it into July; but Rivet wanted to see Bologna and Florence so they decided to stay only ten days more, finally leaving on 19 May 1826. Sadly, Bonington was never to return, although he continued to produce oils based on his sketches. In 1827 he returned to London and exhibited at the Royal Academy and the British Institution, where he showed two Venetian subjects, both now in the Tate Gallery, and in the following year he showed a picture of Venice at the Royal Academy. He was by now ill with consumption and he died in London on 23 September 1828. His memorial exhibition – held the following year – included a number of Venetian works and we know that Turner, amongst other artists, was impressed by their quality and by the pictorial possibilities of Venice that they revealed.

Both Turner and Bonington escaped from the influence of Canaletto and the *vedutisti* who concentrated on the architectural rather than the atmospheric aspects of Venice, usually painting the city in a strong midday sun, avoiding overpowering shadows and working within a close tonal range. To Turner, architectural accuracy was an irrelevance compared to atmospheric effects such as dawns, sunsets and violent summer

RICHARD PARKES BONINGTON

La Siesta 1828
Pencil and watercolour,
$7\frac{3}{4} \times 5\frac{1}{4}$in (19.7 × 13.3cm)
Wallace Collection, London

storms. He also exploited the Romantic possibilities of Venice, and the flat tones of the *vedutisti* became a style of the past. Bonington, while more concerned with architectural accuracy, created a new freedom, especially in his handling of water-colour, at the same time introducing an exotic note. His depiction of flamboyant, Eastern costumes was to have a lasting influence on many British artists in the following decades.

It can be argued that Turner and Bonington represent the two pillars on which the popularity of Venice rested, at least until the late nineteenth century. They demonstrated, on the one hand, the picturesque decay, the nostalgia, even pessimism, represented by a fallen power, with its crumbling palaces and its unintentional rejection of the Industrial Revolution; and on the other hand the hint of the exotic, the meeting of East and West, the Gothic intertwined with Byzantine and Moorish influences, combined with all the colour of an Eastern market. These two currents run deep throughout the British and American response to Venice.

2 'Venezia, cara Venezia'

1822–1840

The Napoleonic Wars had put Europe out of reach of the British traveller, and the coming of peace in 1815 rekindled the desires of many British to visit Europe. Whereas in the previous century travel was confined to the wealthy, the advent of cheaper, more convenient travel in the early nineteenth century enabled the middle classes to venture abroad. As this demand grew, so too did the call for illustrated travel books to remind some of their past voyages and to prepare others for trips to come.

Commissions for illustrations played an important part in getting artists to foreign locations; Turner might not have visited Venice in 1819 had it not been for Hakewill's commission. During the 1820s a number of illustrated travel albums or 'Annuals' appeared, usually published shortly before Christmas each year. *Jennings' Landscape Annual* started in 1830 and was published regularly until 1839; *Heath's Picturesque Annual* ran from 1832 until 1843 and other publishers, including John Murray and William Brockedon, commissioned artists to work abroad. Great improvements to the art of engraving on steel had been made in the previous decade, and thousands of high-quality impressions could be taken from a plate with no obvious deterioration. For the artist, these publications were a boon, as payments were substantial; Prout received £360 for the 1830 *Landscape Annual* and David Roberts raised this to £500 for the 1837 volume. At a time when a large watercolour by Prout would fetch 50 guineas, these were handsome rewards for trips abroad. In addition to the annual volumes many

illustrated books appeared and sets of lithographic prints, expertly and faithfully taken from the originals, were popular. The growing number of dioramas also provided work for artists, especially as the subjects most in demand were those depicting foreign travel.

Samuel Prout (1783–1852) was born in Plymouth and took some lessons from Benjamin West in London, but like many artists of the period, his art education derived chiefly from

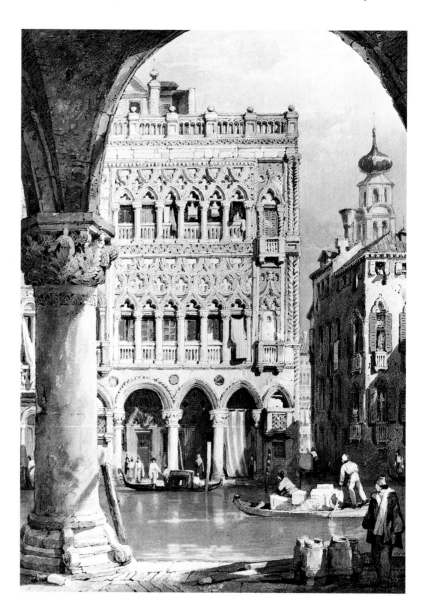

SAMUEL PROUT

The Ca d'Oro on the Grand Canal
Watercolour and bodycolour, 17 × 11¾in (43.2 × 29.9cm)
Victoria and Albert Museum, London

SAMUEL PROUT
The Rialto
Engraved by R. Wallis. From
Roscoe, *Landscape Annual* 1830
Victoria and Albert Museum,
London

practical work – in Prout's case producing illustrations of the British landscape for the publisher John Britton. In 1818 he made his first trip abroad, to northern France, and in 1823 his *Illustrations of the Rhine*, a series of lithographs, appeared. Thus, by the time he first visited Venice in 1824, he was experienced at recording foreign places. We know little about this first visit except that he was in Venice by 25 September and probably remained there for a few weeks. In the following year he exhibited three Venetian pictures at the Old Water-Colour Society and two more in 1826. These, along with a view of the Ducal Palace shown at the Royal Academy in 1826, represent the first important Venetian pictures to be shown in London exhibitions. Prout probably returned to Venice in 1827 to work on a major publication, *Sketches from Venetian History*, which appeared in two volumes between 1831 and 1832. He continued to exhibit Venetian subjects in London, and his reputation was considerable, not only amongst the buying public, but also

amongst fellow artists. Thomas Uwins, who had set off for Venice in 1824, recalled:

When I left England, one of my waking dreams was to do a series of views of Venice for publication. I had hardly descended the southern side of the Alps when I heard of Prout being there for the same object, and I knew he would do the thing much better than myself. I instantly abandoned it.

When Robert Jennings planned his first volume of the *Landscape Annual* he called upon Prout to illustrate it, likewise for the second volume in 1831. Written by Thomas Roscoe, these guided tours took the traveller to Italy via Switzerland, illustrating in particular the beauties of Rome and Venice. The third volume for 1833 was illustrated by J.D. Harding and gave rise to a dispute between the two artists. Sadly, although many of Prout's watercolours of Venice were engraved or lithographed, a volume devoted solely to Venice was never published.

Prout's views of Venice are based on accurate observation rather than on atmospheric effects or flickering light. This accuracy appealed to Ruskin, who became Prout's greatest advocate:

Turner saw things as Shelley or Keats did; and with perfectly comprehensive power gave all that such eyes can summon to gild, or veil, the fatalities of material truth. But Prout saw only what all the world sees, what is substantially and demonstrably there; and drew that reality, in his much arrested and humble manner indeed, but with perfect apostolic faithfulness.

Ruskin admired Prout's honesty and what he called his unpretentious 'humble manner' whilst recognizing the quality of his pencil sketches. Prout often chose Gothic buildings and it is extraordinary that some 30 years before the publication of Ruskin's *The Stones of Venice* he was responsive to those very qualities of Venetian Gothic that Ruskin was to advocate. Yet, although his watercolours are painstaking, they are neither laboured nor mechanical, but often highly evocative. Ruskin wrote to Prout in 1849:

I had not the least idea of the beauty and accuracy of those sketches of Venice, – so touchingly accurate are they, that my wife, who looks

back to Venice with great regret, actually and fairly burst into tears over them, and I was obliged to take them away from her . . .

Throughout the 1830s Prout remained a popular watercolourist, becoming Painter in Water-Colours Ordinary to Queen Victoria and Prince Albert. He probably visited Venice again in the 1830s but the exact date is not known. In the 1840s he moved to south London, where he became a neighbour of the Ruskin family who had bought a number of his watercolours. There can be little doubt that Prout's love of old buildings and his style of drawing influenced the young John Ruskin. He continued to produce work of quality, although he travelled less, and even based some of his later watercolours on drawings made by Ruskin in Venice. He died in 1852 after returning from a birthday party at the Ruskins:

Prout I never saw in such spirits, and he went away much satisfied. Yesterday at church we were told that he came home very happy, ascended to his painting-room, and a quarter of an hour from his leaving our cheerful house was a corpse . . .

Two other early visitors to Venice were the artists Sir David Wilkie (1785–1841), who was there in 1826 and William Etty (1787–1849), who spent several months there in 1822. Wilkie had established a huge reputation as a genre painter, but his health had suffered as a result of overwork. He set off on a recuperative trip to Italy in 1824 and was in Venice in the spring of 1826, studying the work of Titian and Veronese. Although he painted nothing of Venice, he appreciated the beauty of its architecture and its lack of traffic:

Street there is none, nor horses, nor carriage, nor any animal larger than a dog . . . foot passengers have it all to themselves – all is pavement, and, though in crowds, you walk alone, without either mud or dust. The Piazza of St Mark's is the largest open space to be found; this, with the Byzantine Church of that saint, and the palace of the Doge, is splendid and finished beyond any place or building I have seen – a perfect picture . . .

William Etty was known for his classical and historical canvases, in which sensuous nudes played an important part. Venetian artists appealed to his sense of colour and composition and he

learnt much during his stay, making copies of Titian, Veronese and Carpaccio. Charles Eastlake, a painter of Italian genre and later President of the Royal Academy and Director of the National Gallery, gave Etty an introduction to the British

WILLIAM ETTY

The Bridge of Sighs
Oil on canvas, $31\frac{1}{2} \times 20$in
(80 × 51cm)
York City Art Gallery

Consul in Venice, Richard Belgrave Hoppner, who had been a close friend of Byron. Etty fell in love with Venice:

Dear Venice, Venezia, Cara Venezia, thy pictured glories haunt my fancy now! Venice, the birthplace and cradle of colour, the hope and idol of my professional life . . . I felt most at home in Venice though I knew not a soul.

Etty arrived in Venice on 17 November 1822 and remained for several months. He made a reputation for himself at the Venice Academy, where his speed and facility of execution gained him the nickname 'Il Diavolo'. His fame spread so wide that Rossini paid him a visit. He was, however, surprised by the lack of British art students.

. . . it seems to me not a little strange that a place abounding with such specimens of Venetian art . . . should be so neglected by our general travelling students . . .

Although he made a number of sketches of Venetian views, Etty was not really interested in painting the city itself, and the only known view by him is *The Bridge of Sighs*, an oil, now in York City Art Gallery, painted between 1833 and 1835 from drawings made in Venice.

In September 1834 two young British artists arrived in Venice and took rooms in the Hotel Europa: George Arthur Fripp (1813–1896) and his close friend William Müller (1812–1845). Their route had taken them through Belgium, down the Rhine and across the Alps, where they stayed for ten days on Lake Maggiore before visiting Milan and Verona. The pair remained in Venice for nearly two months, leaving on 22 November for Florence and then Rome for Christmas, before returning to England in February 1835. Müller was an exceptionally gifted artist with a facility for painting rapidly in watercolour on the spot, often from the gondola they had hired, complete with a gondolier named Jacobo. Fripp recalled that Müller would paint two or three watercolours a day, and a half-imperial, i.e. 14×20in (36×51cm) drawing would take no more than three hours to complete. Despite this speed Müller painted with precision and fluency, avoiding any clumsy or inelegant passages. At their best his watercolours recall those of Bonington. Müller must have produced a substantial number of

WILLIAM JAMES MÜLLER
The Grand Canal
Oil on canvas, 29 × 50in
(73.7 × 127cm)
Photograph courtesy of
Thomas Agnew and Sons

drawings and watercolours during those seven weeks which served as the basis for larger oil paintings, some on a huge scale, that he worked up when back in England. Like Turner, he occasionally used historical events around which to compose these large canvases, although the majority were straight views, such as *The Rialto*, sold at Christie's in 1910 and measuring five feet (one and a half metres) in length. Despite their size they were painted rapidly, as his biographer tells us:

From the sketches made by Müller during his tour on the Continent, a great number of oil pictures were rapidly produced. He made up his mind what he would do, commenced at the top of the canvas, and painted all in quickly and without hesitation.

Whilst Müller's Venetian oils were popular, his watercolours painted *en plein air* best represent his Venetian work. He planned to return in 1843, but went instead to Greece and Asia Minor, and died in 1845, aged only 32, without seeing Venice again.

Another early visitor to Venice was William Wyld (1806–1889) who arrived in 1833 with a young English companion. Wyld spent most of his life abroad, principally in Paris, and he has often been ignored by writers on the English School.

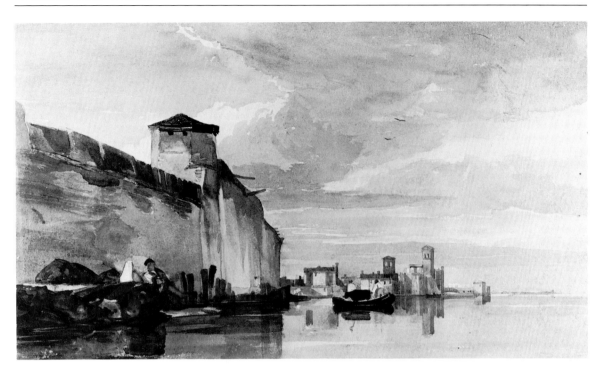

William James Müller

The Arsenale and the
Fondamente Nuova
Watercolour, $9\frac{1}{4} \times 16$in
(23.5×40.6cm)
Victoria and Albert Museum,
London

Nevertheless his work was favoured by Queen Victoria and he produced a number of pictures of Royal events during the 1850s in London and Scotland. His Venetian pictures, dating to the 1830s and executed both in oil and watercolour, owe much to Bonington's elegant draughtsmanship, and he was particularly good at handling complex architecture. He built up a reputation and clientele for his views of cities, including Venice, as P.G. Hamerton, the critic, wrote, 'It will be remembered that Mr Wyld is not a rustic landscape painter, but chiefly a painter of continental cities'.

A better-known artist was James Duffield Harding (1798–1863) whose reputation rested not only on his watercolours but also his illustrations for travel books, annuals and practical manuals on how to draw. Ruskin took lessons from him, and some of Harding's theories, especially about the deptiction of trees and skies, appear in Ruskin's *Modern Painters*. They went together to Venice in 1845, but Harding had been there before, possibly in the 1820s, certainly in 1831, when he spent four months in Italy woking on illustrations for *Jennings' Landscape Annual*, and again in 1834. A most accomplished draughtsman, he found the comparatively new art of lithography to his taste,

and produced a substantial number of lithographic volumes. His best Venetian works are his preliminary sketches painted on the spot, as Martin Hardie noted:

His little *Salue Venice*, a study for a larger version, records the unity of a single happy impression. It is dashed in broadly with brilliant blots of colour and conveys the very spirit of sunshine, largely gained by untouched patches of white paper. Like so many other outdoor sketches, made with an immediate attempt to summarize an effect of light and colour, it is far more honest and forthright than the deliberate product of the studio.

The Drury Lane Theatre Christmas pantomime for 1831 featured an exciting new diorama entitled *Venice and its Adjacent Islands*. Although not the first diorama of Venice, it was certainly the most ambitious, taking nearly 20 minutes to show with scenes painted 20ft (6m) high and in total some 300ft (91m) long. The audience sat in darkness while the images, painted on translucent calico cloth, were illuminated by daylight or gaslight, whereby many different effects could be achieved. Nine views of Venice were depicted: The Grand Canal; The Church of Santa Maria della Salute; The Dogana; San Giorgio Maggiore; The Lido; The Lagoon at Night; The Bridge of Sighs by Moonlight; The Piazza San Marco and the Ducal Palace. As was often the case, this diorama was incorporated into a pantomime – *Harlequin and Little Thumb* – but its brilliant effects of light and day, its moving gondolas and its realistic drawing made it popular in its own right. The artist was Clarkson Stanfield (1793–1867), an experienced theatre scene-painter, and this was not his first diorama. *The Times* commended Stanfield for rendering the scene

. . . with a truth and finish which were never bestowed upon scene painting in our times at least, until he applied his talents to the work.

although the newspaper did highlight some of the practical difficulties in staging such a spectacle:

For example, it does not sound well to hear an invisible scene-shifter call out to a pasteboard gondolier, who seemed to be rowing as well as he could 'D – n ye, keep close to the lights'.

Clarkson Stanfield had trained as a scene painter, but by the

1820s was also known as a painter of seascapes, becoming a founder member of the Society of British Artists in 1823 and its President in 1829. He travelled widely, visiting Holland, Belgium, Germany and the Alps, and in October 1830 he arrived in Venice to stay in the Osteria del Leone Bianco where Turner had stayed 11 years earlier. A letter to his wife of 5 October 1830 strikes a familiar note today:

I am hard at it from morning till night (Venice is truly magnificent!!! its palaces, churches, boats and costumes . . . make a whole to be equalled in any other place in the world) . . . I will leave Venice on Monday first, for I am afraid I am at an expensive hotel. I can see the Rialto from my window . . . one of my eyes is completely closed up with a mosquito bite in the night.

Despite these problems Stanfield's stay was successful. He produced a number of watercolours and on his return to London was able to work his drawings into oils. There were

CLARKSON STANFIELD

The Dogana and Church of the Salute
Watercolour, $8\frac{3}{4} \times 12\frac{1}{4}$in
(22.2 × 31.1cm)
British Museum, London

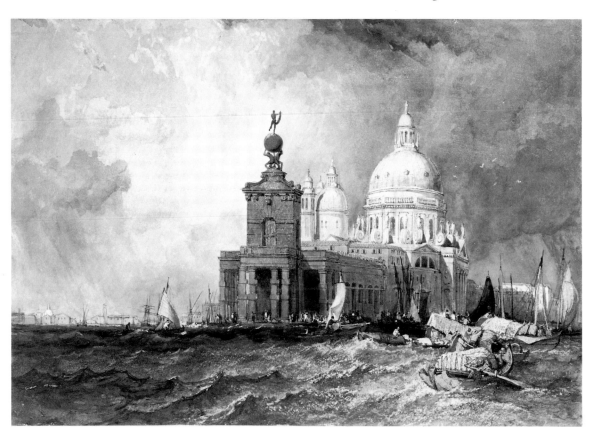

autumn storms in Venice that year which Stanfield recorded in *The Dogana and Church of the Salute*. His watercolour style owed much to Bonington, but his oils are somewhat harsher, with clear detail and a polished brilliance, and less interest in atmospheric effects. Ruskin summed up this aspect when he found Stanfield's Venetian pictures to leave 'nothing to hope for or to find out, nothing to dream or discuss'. Nevertheless, they were successful; *Venice from the Dogana* (Earl of Sherburne) was shown in the Royal Academy in 1833 and reputedly prompted Turner into action, and between 1834 and 1838 Stanfield painted a series of five large Venetian oils for the Duke of Sutherland. These paintings were sold at Chritie's in 1908 and have since disappeared. His work was also in demand for illustrations in travel books and in 1838 he returned to Italy, remaining from August until March of the following year. He worked extremely hard and productively and appears to have been in Venice around October 1838. He was never to return,

CLARKSON STANFIELD

The Canal of the Giudecca and the Church of the Gesuati
Oil on canvas, 24 × 35½in
(61 × 90.2cm)
Tate Gallery, London

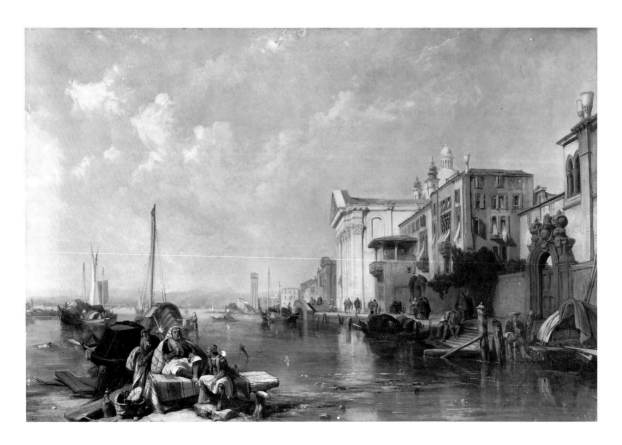

but continued to paint fine Venetian views throughout the 1840s, including the more unusual views of Torcello, Mazorbo and Murano, which had largely been ignored by other artists.

In addition to the popular dioramas, the stage settings of Shakespeare's and Byron's dramas helped to bring Venice to the public's attention. Byron's dramatic poems, *Marino Faliero* and *The Two Foscari* when first performed during the 1820s were not successful in their own right, but they contributed to a growing British interest in Venetian culture and politics. France was out of fashion as a result of the Napoleonic Wars, while Germany was yet to become a tourist attraction. Thus, during the intervening years, between 1815 and 1840, British eyes turned sympathetically towards Italy. This interest was reflected in the number of guides, histories, novels, poems and plays published about Italy, and while many writers extolled the Italian landscape and climate, others sympathized with the growing nationalist movement. Venice, which had largely been ignored by the eighteenth-century British traveller, featured in this literature, and in addition, revivals of *The Merchant of Venice* and *Othello* were staged, often with elaborately detailed sets. Edmund Kean acted a romatic Shylock at Drury Lane in 1814 while his son Charles Kean staged a monumental *Merchant of Venice* in 1858, which included realistic scenery painted by William Telbin (1815–1873), who also painted watercolours of Venice which he visited in the 1850s. Like Clarkson Stanfield, Telbin was both an easel and scene painter and his work for the theatre illustrated the contemporary pictorial, historically accurate approach to stage design. Costumes were also designed to be historically accurate, as can be seen in the drawings of J.R. Planché (1796–1880), a versatile writer for the stage, and an expert on the history of costume. In later years, designers moved away from this pedantic approach, attempting to create the spirit of a place and time rather than copy precise historical details, but nevertheless, views of the Rialto or the Piazza must have stimulated the interest of many Victorian theatre audiences.

During the 1830s a vogue developed for pictures of pretty young girls, sitting by a window, on a balcony or placed in a landscape. They were often given Shakespearean titles such as 'Desdemona' or 'Miranda', but they were usually simply

excuses to paint a pretty young girl. Venice was often used as a romantic backdrop, as can be seen in the small oils of James Holland or Augustus Egg (1816–1863) both of whom revelled in the rich colours of the earlier Venetian painters.

During these years a new interest in Venetian history developed, often seen in lurid and over-dramatized terms. The many years of uneventful prosperity were passed over in favour of episodes like the elopement of Bianco Capello, the execution of Doge Faliero, grim accounts of the Republic's prisons and bloody stories of the Inquisition. The idea of a wicked Venice was deeply imbued in most English and American painters, and it can be argued that even Sargent, in his earlier dark, brooding Venetian interiors and street scenes captured this atmosphere. Several histories of Venice, such as Thomas Roscoe's *Legends of Venice* (1838) with illustrations by John Rogers Herbert (1810–1890) and Smedley's *Sketches from Venetian History* (18131–2), promoted the vision of an evil Venice.

Many artists who were not actually involved in the theatre still took an interest in Shakespearean or historical subjects. Turner had used Venice as a backdrop for a scene from *Romeo and Juliet* and Bonington also painted Shakespearean subjects, although not set in Venice. Just as scene painters used prints for their Venetian backdrops, so no doubt many early-nineteenth-century artists painted scenes from *The Merchant of Venice* or *Othello* without having visited the city. However, as travel improved, more and more artists visited Venice in order to satisfy the new taste for accurate theatrical scenery. Many of the resulting pictures were theatrical, with figures dressed in sixteenth-century Venetian costume set before a backdrop of Venice, and few rose above the pedantic. There were exceptions, such as James Stephanoff (1788–1874) who visited Venice from the 1830s to the 1850s. His paintings of Shakespearean subjects set against a dramatic Venetian backdrop have charm, vitality and movement, as do the best works of George Cattermole (1800–1868). Both artists had absorbed the lessons of Titian in their handling of colour, while Titian himself was the subject of many history paintings of this period. George Arthur Fripp, who had accompanied Müller to Venice in 1834, produced a number of detailed watercolours, often with much body-colour and dense colours, illustrating scenes from Vene-

tian history, such as Titian teaching in his studio, complete with a topographically impossible view over St Mark's. Several of the leading Royal Academicians like Frederick Richard Pickersgill (1820–1900), Frederick Goodall (1822–1904) and Charles West Cope (1811–1890) painted large canvases depicting Venetian stories such as *The Death of the Foscari* or *Felice Ballarin reciting Tasso*. The demand for such works peaked between the 1830s and the early 1860s, although some artists such as Sir John Gilbert (1817–1897) continued the tradition into the later part of the century.

To what extent the public were influenced by stage sets and historical or Shakespearean paintings is difficult to assess. In some instances, such as Sir Squire Bancroft's 1875 production of *The Merchant of Venice*, large paintings of Venice were displayed between acts, and this, coupled with the popular dioramas, must have aroused considerable interest; on the other hand many of the academic canvases shown at the Academy did scant justice to the beauty of Venice. More important than both of these was the completion of the railway link to Venice in 1846 and the writings of John Ruskin.

3 'The Stones of Venice'

John Ruskin and his influence

Thank God I am here! It is the Paradise of Cities . . . and I am happier than I have been these five years – so happy – happier than in all probability I shall ever be again in my life! I feel fresh and young when my foot is on these pavements . . . Thank God I am here! [May 1841]

John Ruskin's love-affair with Venice spanned more than half a century, from his first visit in 1835 to the eleventh and last in 1888. More than any other writer or painter, Ruskin popularized Venice, making it a 'must' for British and American tourists who, armed with *The Stones of Venice* and his later *St Mark's Rest*, or *Guide to the Academy at Venice* began arriving in great numbers to throng through the Piazza and across the Rialto.

Ruskin's first visit was in 1835, but he had already seen Venice through the eyes of Turner, Prout and Stanfield. His second trip in 1841 followed a breakdown in his health while studying at Oxford, coupled with disappointment over his dreams of marrying Adèle Domecq, the daughter of the Spanish sherry shipper who was a business colleague of his father. Ruskin's depression and ill-health lifted while in Venice and it became, along with the Alps, one of the spiritual foundations of his life 'This and Chamouni are my two bournes of Earth'.

On the early trips to Venice, Ruskin had been escorted by his parents, but in 1845 he returned accompanied only by John Hobbs, always known to Ruskin as George, who acted as valet and photographer, and by Couttet, a Swiss courier who helped with the travelling details and the languages. Couttet also appears to have held an umbrella over Ruskin while he was

sketching in the sun. They were met in Florence by James Duffield Harding who accompanied them to Venice to act as drawing instructor. They arrived on 9 September and stayed at the Hotel Europa. Ruskin remained for five weeks until 14 October, but Harding left on 24 September. Ruskin was concerned about the changes evident in Venice, in particular the new railway bridge which was being built to link Venice with the mainland. Until 1846 all visitors had to be rowed across the water from Mestre, having come down the road alongside the Brenta Canal from Padua. Ruskin describes this in *The Stones of Venice*:

The Brenta flows slowly but strongly; a muddy volume of yellowish-grey water . . . Dusty and shadeless, the road fares along the dyke on its northern side; and the tall white tower of Dola is seen trembling in the heat mist far away . . .

Once at Mestre the visitor took a gondola across the Lagoon:

Stroke by stroke, we count the plunges of the oar, each heaving up the side of the boat slightly as her silver beak shoots forward . . . the sea air blows keenly by as we stand leaning on the roof of the floating cell . . . to the West, the tower of Mestre is lowering fast, and behind it there have risen purple shapes of the colour of dead rose-leaves, all round the horizon, feebly defined against the afternoon sky – the Alps of Bassano.

The railway bridge changed not only the idyllic view but the whole romance of arriving in Venice by water. Ruskin wrote to his father that on arriving at the end of the Brenta Canal he saw

. . . the Greenwich railway, only with less arches and more dead wall, entirely cutting off the whole open sea and half the city, which looks as nearly as possible like Liverpool at the end of the dockyard wall.

He also disliked the introduction of gas lamps in Venice itself:

. . . as we turned under the arch, behold, all up to the Foscari palace – *gas lamps!* on each side, in grand new iron posts of the last Birmingham fashion . . . Imagine the new style of serenades – by gas light.

But most worrying to Ruskin was the destruction of important buildings:

JOHN RUSKIN
The Ca d'Oro 1843
Watercolour, 13 × 18¾in
(33 × 47.6cm)
Ruskin Galleries, Bembridge
School, Isle of Wight

You cannot imagine what an unhappy day I spent yesterday before the Casa d'Oro, vainly attempting to draw it, while the workmen were hammering it down before my face.

Ruskin was planning a second volume to *Modern Painters* and he needed to study the Venetian Masters. On this trip he 'discovered' Tintoretto, Titian and Veronese, while taking a strong dislike to Canaletto:

Venice has never yet been painted as she should, never . . . That foul son of a deal board, Canaletti – to have lived in the middle of it all and left us *nothing*.

He also began taking an interest in Venetian architecture, often sketching on the spot or arranging for daguerreotypes to be taken by Hobbs. The process had been announced in 1839 and by 1845 much technical progress had been made, with exposure

time in good light down to a couple of seconds. Ruskin was the first artist or critic to value the results:

Daguerreotypes taken by this vivid sunlight are glorious things . . . it is a noble invention, say what they will of it, and any one who has worked and blundered and stammered as I have for four days, and then sees the thing he has been trying to do so long in vain, *done* perfectly and faultlessly in half a minute, won't abuse it afterwards.

During the day Ruskin would sketch with Harding or supervise photography, while in the evening he would write up his notes and make drawings from the daguerreotypes, although at this stage he had no specific plan for a book on Venetian architecture.

1848 was a fateful year; while revolutions swept many of the fragile European monarchies, Ruskin married Euphemia Gray in April. Effie, as she was known, had been born in Perth in the house that John Ruskin's grandfather had owned; in fact she was born in the very room in which Ruskin's grandfather had committed suicide. Ruskin poured out his affection to this young and beautiful girl.

You are like a sweet forest of pleasant glades and whispering branches – where people wander in and on in its playing shadows they know not how far – and when they come near the centre of it, it is all cold and impenetrable . . . You are like a wrecker on a rocky coast luring vessels to their fate . . . You are like a fair mirage in the desert – which people follow with weary feet and longing eyes – until they faint on the burning sands – or come to some dark salt lake of tears.

The marriage was indeed to end in a dark lake of tears, but in 1849 Ruskin took his wife to Venice for an extended stay in order to start work on *The Stones of Venice*. In March 1848 Daniele Manin had proclaimed the re-establishment of a Venetian Republic and had forced the occupying Austrians to evacuate. After a siege, in which the Austrians shelled the city from the safety of the islands and used bombs launched from balloons, the short-lived Republic fell. Feelings against the Austrians ran high, as William Dean Howells, the American Consul, wrote in 1862:

The Venetians are now. . . . a nation in mourning and have . . . disused all their former pleasures and merry-makings. . . . To be seen

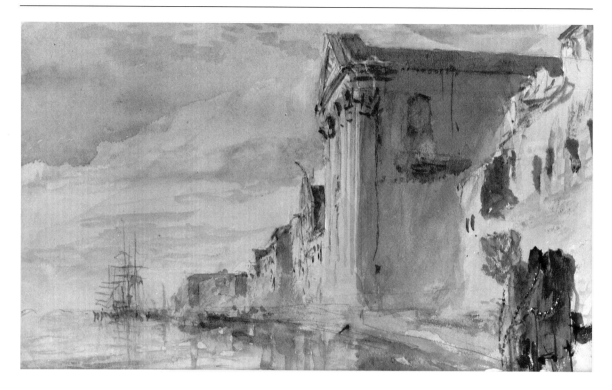

JOHN RUSKIN
The Zattere with the Church of the Gesuati
Watercolour, $5\frac{3}{4} \times 9\frac{1}{4}$in
(14.6 × 23.5cm)
Ruskin Galleries, Bembridge School, Isle of Wight

in the company of officers is enmity to Venetian freedom, and in the case of Italians it is treason to country and race. . . . By no sort of chance are Austrians, or Austriacanti ever invited to participate in the pleasures of Venetian society.

Ruskin and his wife, accompanied by Effie's friend, Charlotte Ker and Hobbs, arrived to a tense Venice in November 1849 and took rooms in the Albergo Danieli where their sitting room overlooked the Riva. Ruskin appreciated the architecture of the Danieli:

A glorious example of the central Gothic nearly contemporary with the finest parts of the Ducal Palace.

He threw himself into work, drawing and measuring architectural details, as Effie recorded:

John excites the liveliest astonishment to all and sundry in Venice. . . . Nothing interrupts him and whether the square is crowded or empty he is either seen with a black cloth over his head taking Daguerreotypes or climbing about the capitals covered with dust, or else with cobwebs.

Effie was shown round by Rawdon Brown, who had come to Venice in 1834 to find the tombs of Shakespeare's 'Banished Norfolk' in *Richard II*, only to remain there for the rest of his life, becoming an expert on Venetian history. The Austrian officers soon noticed Effie, who took great pride in her clothes:

. . . they pass me and say 'dear creature' and lots of things like that and throw bouquets at me

and soon she was being invited to military balls:

The other night John left the Ball at eleven and Charlotte and I enjoyed ourselves till between one and two . . . I danced so much, indeed I could not help myself . . . here they dance so fast, Prince Troubetzkoi danced the galope with me twice as fast as Lord Charles [Lord Charles Ker, a friend from Perth].

The thought of leaving in March 1850 filled Effie with sadness:

I cannot tell you how sorry I shall be to leave Venice. London will look such a black uninteresting whirrling sort of place after this where one enjoys the greatest freedom of action of any place I ever saw. . . .

In March 1851 the first volume of *The Stones of Venice* was published and was well received by the critics. As a result, Ruskin began to plan further volumes. In September he and Effie returned to Venice, finding accommodation at the Casa Wetzlar, now the Gritti Palace Hotel, where their drawing-room and study overlooked the Grand Canal. Ruskin had found living in the Danieli expensive and hoped to save some money. In this he was disappointed:

I thought 'living in lodgings' in Venice would be so delightfully cheap that I need not mind paying a good rent for the rooms. . . . I am especially puzzled because it seems to cost nearly as much as when we had Miss Ker with us and two carriages and lived at an hotel.

It must be said, however, that the Ruskins did not stint themselves. They employed, in addition to Hobbs and their maid Mary, an Italian cook (whose meals appear to have been copious), two gondoliers, a modelling master and a further maid three times a week. Their domestic life was tranquil, although Effie was infuriated by the continuing influence of Ruskin's mother.

Then follows rules à la Mrs Ruskin for all the things he is to eat from breakfast till tea, and when his stomach is out of order another diet and so on.

More serious was Effie's growing feeling that John's parents disapproved of her and she talks in her letters to her parents of, 'Mr R's continued and never-ceasing disappointment of John's marriage with me instead of . . . some person of higher position and more fortune'. There is also a hint of the coming tragedy in Effie's letter of early 1852:

He is, like all men of genius, very peculiar, but he is very good and considerate in little things . . . and I try to be as happy as I can. If I don't always succeed and have sometimes forebodings rather gloomy, I perhaps forget often the many blessings I have . . .

Nevertheless these were happy months for Effie as she was, as she herself admitted, 'the Belle at all the Balls' and was even invited to Marshall Radetsky's Ball in Verona. On 15 May 1852 they moved into temporary lodgings in 110 Piazza San Marco, on the same side as Quadri, prior to returning to London in July. John Ruskin was not to return to Venice for 17 years.

The second and third volumes of *The Stones of Venice* were published in 1853 and represent some of Ruskin's most coherent and beautiful writing. He inspires his readers with his enthusiasm for Venice and with his growing concern for the social background to the Gothic architecture which he admires so much. He argues that the Gothic style allowed individual craftsmen to express their personalities, whereas the classical orders so loved by the Renaissance reduced the craftsman to the role of a slave. Chapter Six of the second volume, *The Nature of Gothic*, had a wide influence in later years and is one of the theoretical cornerstones of the Arts and Crafts Movement. Ruskin argues against the division between designer and manufacturer:

All ideas of this kind are founded upon two mistaken suppositions: the first, that one man's thoughts can be, or ought to be, executed by another man's hands; the second, that manual labour is a degradation when it is governed by intellect.

Ruskin claimed that the Gothic is superior to the Renaissance

because it allows variety, imperfection and the expression of individual character. Ruskin also rediscovered Byzantine architecture in Venice, but he attacked the Renaissance whenever possible, using the strongest language. Of the façade of San Giorgio Maggiore he wrote:

It is impossible to conceive a design more gross, more barbarous, more childish in conception, more servile in plagiarism, more insipid in result, more contemptible under very point of rational view.

The elgant, hexagonal Cappella Emiliana of 1530 attached to Codussi's San Michele in Isola he described as 'a German summer-house' while many interesting baroque churches, such as the Gesuati, are dismissed as 'of no importance', but he grudgingly admitted that Santa Maria della Salue was 'effective when seen from a distance'. Modern architectural historians dispute the accuracy of Ruskin's theories about the development of Gothic architecture, and today few people would agree with his condemnation of the Renaissance, and of Palladio in particular. *The Stones of Venice* was, nevertheless, a seminal work: it introduced innumberable tourists to Venice, and then opened their eyes to the beauty of its architecture: it influenced a generation of architects, who began to use Venetian forms and polychrome in their buildings. Above all, *The Stones of Venice* is a work of art in itself, in which Ruskin achieved some of his finest prose, as when he ponders the decline of Venice since the great days of the Republic:

. . . a ghost upon the sands of the sea, so weak – so quiet – so bereft of all but her loveliness, that we might well doubt, as we watched her faint reflections in the mirage of the lagoon, which was the City, and which the shadow.

Ruskin returned to Venice in 1869, a changed man. His marriage had ended in annulment. Although he had never publicly commented upon his failure to consummate the marriage, he was deeply upset, feeling increasingly isolated from society, especially from the lower classes for whom he believed he was writing and working. He had also begun to lose his faith in both art and religion, the two corner-stones of his earlier life. He wrote to Elizabeth Barrett Browning:

. . . great Art is of no real use to anybody but the next great Artist . . . it is wholly invisible to people in general.

He returned to Venice with some forebodings but found it had changed less than he had expected. He met the Pre-Raphaelite Holman Hunt in the Piazza, and over dinner at the Danieli confided in him his loss of faith:

The convictions I have arrived at lead me to the conviction that there is no Eternal Father . . . that man has no helper but himself.

He returned in 1870 for a longer trip and again in 1872 with Albert Goodwin, and Arthur Severn and his wife. His depressions were increasing and he was easily irritated:

I can't write this morning, because of the accursed whistling of the dirty steam-engine of the omnibus for the Lido, waiting at the quay of the Ducal Palace for the dirty population of Venice.

At other times he looked nostalgically back to happier years in Venice, 'Day by day passes and finds me more helpless; coming back here makes me unspeakably sad'.

In 1876 Ruskin took leave of absence from his post as Slade Professor at Oxford to spend the winter in Venice rewriting *The Stones of Venice* and recovering from the death of Rose La Touche, the girl he hoped, against hope, to marry. He was aware that his deepening depressions were turning into insanity and he confided black thoughts to his diary:

Oh me, if I could conquer the shadow of death which harries me at work and saddens me at rest!

The stay was nevertheless successful; he was pleased with his rooms above a restaurant on the Zattere overlooking the Giudecca, 'commanding sunrise and sunset both'. The *pensione* was called the 'Calcina' and exists today, but totally rebuilt. Ruskin's biographer described the 'Calcina' some years later:

The restaurant on the ground floor had a side entrance, opening onto a little courtyard, and there under a pergola of vines one ate ones humble meals . . . The landlord had a pleasant word for every guest . . . This was the kind of lodging that Ruskin loved. He was free from the intrusion of hotel guests.

Ruskin worked on his *Guide to the Academy at Venice* and on *St Mark's Rest* while continuing his association with Count Alvise Zorzi, who, like Ruskin, was trying to save historic buildings from damaging over-restoration. He told Count Zorzi that he was 'a foster child of Venice. She has taught me all that I have rightly learned of the arts which are my joy.' Ruskin's final trip to Venice came in 1888, a short visit which was followed by a mental breakdown in Paris on the way back to London.

In addition to writing about Venice, Ruskin produced many watercolours and drawings of buildings and architectural details. Some were intended as illustrations for his books, others simply as records. He himself believed that his watercolours were purely factual, unlike J.D. Harding, about whom he wrote to his father in 1845:

> His sketches are always pretty because he balances their parts together and considers them as pictures – mine are always ugly, for I consider my sketches as only a written note of certain *facts* . . . Harding's are all for impression – mine all for information.

Ruskin underestimated his own abilities as a watercolourist and draughtsman, and this lack of confidence gives his work a fragility and sincerity which goes far beyond the many superficially pretty views of Venice which were to be produced in the following decades. Many of his watercolours are detailed studies of St Mark's, the Doge's Palace and the Ca' d'Oro, but despite the architectural accuracy of these drawings, they are never laboured or mechanical. In comparison to Samuel Prout's well-worked and confident watercolours, they have an appealing sensitivity. Ruskin's watercolours are often left unfinished, hence his belief that they were merely working sketches, as opposed to Harding's 'pictures', but this very unfinished quality gives them a freshness and directness often lacking in more complete works. It is as if we can follow Ruskin's thought processes as he visually explores those areas of a building which fascinate him, before moving on, often leaving areas blank or adding a few notes about colour, shadows or architectural details.

Coupled with sensitive draughtsmanship and accurate observation is a delicate sense of colour. Ruskin used a pure, prismatic palette applied in delicate, broken brushstrokes to recreate the

luminosity of the flickering Venetian light reflecting from the water across the marble and mosaic façades. Not all of Ruskin's watercolours were architectural studies, he painted a number of looser, atmospheric studies of Venice at dawn, at sunset and by moonlight, as well as views down the Grand Canal or along the Zattere. The purpose of Ruskin's drawings was different from that of Harding or Prout; he drew in order to record buildings or architectural details, either for his own reference or for later use in *The Stones of Venice*. Although he did exhibit some Venetian views at the Royal Watercolour Society, and was indeed elected an Honorary Member, Ruskin never considered himself a professional painter.

Ruskin encouraged many younger artists to paint in Venice; some employed directly by him to record façades and architectural detail, others simply fired by Ruskin's enthusiasm for Venice. John Inchbold (1830–1888) had met the Pre-Raphaelites during the 1850s, but his shy and awkward manner kept him from being close to the group. Swinburne wrote of him:

He had not many friends, being very shy and rather brusque in manner, so that people were apt to think him odd.

Contemporaries also recorded his kindness and sincerity. By the late 1850s he had become the leading Pre-Raphaelite painter of pure landscape and in 1858 accompanied Ruskin to the Alps. He first visited Venice in 1862, probably inspired by Ruskin, returning in the two subsequent years, and the resulting pictures show a luminosity of colour which was achieved by painting thinly in oil over a white ground. The elegance of his style and the handling of his paint look forward to Whistler, although there is no evidence that they knew each other. He tended to choose unusual subjects, such as broad panoramas of Venice from across the lagoon, or a sunset seen from the public gardens.

John Wharlton Bunney (1828–1882) met Ruskin when he was working as a clerk at Ruskin's publishers, Smith, Elder and Co., and subsequently became his pupil at the Working Men's College. In 1863 he settled in Florence, moving to Venice in 1870 where he remained until his death. His meticulous attention to detail and painstaking technique appealed to Ruskin, who first engaged him in Verona in 1869 whilst

working on a planned, but never realized book, *The Stones of Verona*. Ruskin wrote of Bunney:

You may like to know that he is doing lovely work for me – coloured drawings of the buildings, large – while I myself draw the detail, requiring (though I say it) my advanced judgement to render accurately.

Thus Ruskin felt free to add details to Bunney's watercolours and several examples of their combined work exist. His principal work is *The West Front of St Mark's* which he started in 1877 and worked on until his death. Ruskin was concerned about the destruction caused by over-restoration of the West Front and he commissioned Bunney to record it as it stood. Accordingly Bunney spent 600 days of constant labour on the 57 × 89in (144 × 226cm) picture.

In 1882 a memorial exhibition of Bunney's work was held at the Fine Art Society in London and Ruskin, with characteristic generosity, organized an appeal for the benefit of his widow:

JOHN WHARLTON BUNNEY

The West Front of St Mark's
1877–1882
Oil on canvas, 57 × 89in
(144.8 × 226.1cm)
The Ruskin Gallery,
Collection of the Guild of St
George

JOHN WHARLTON BUNNEY and
JOHN RUSKIN

Palazzo Manzoni, Grand Canal
1871
Watercolour and bodycolour,
$27\frac{1}{2} \times 33$in (69.6 × 83.8cm)
The Ruskin Gallery,
Collection of the Guild of St
George

. . . Mr Bunney's name will remain ineffaceably connected with the history of all efforts recently made in Italy for preservation of true record of her national monuments; nor less with the general movement in which he so ardently and faithfully shared for the closer accuracy and nobler probity of pictorial . . . art.

George Price Boyce (1826–1897) met Ruskin in 1854 as a result of his friendship with Dante Gabriel Rossetti, and was impressed by his knowledge. Boyce wrote in his diary for 21 April 1854:

Ruskin and his father called . . . On expressing my liking for after sunset and twilight effects, he said I must not be led away by them, as

on account of the little light requisite for them, they were easier of realization than sunlight effects. He was very friendly and pleasant and encouraging in manner and showed no conceit, grandeur, or patronising mien.

Later that year Boyce set off for a trip through Europe to see those places Ruskin admired, arriving in Venice on 16 June. Ruskin wrote to him in Venice urging him to paint the exterior

GEORGE PRICE BOYCE

Church of the Frari from the Campiello San Rocco 1854
Watercolour, $10\frac{1}{2} \times 7\frac{1}{4}$in
(26.7 × 18.4cm)
Birmingham City Art Gallery

of St Mark's and the south-west portico, 'I congratulate myself, in the hope of at last seeing a piece of St Mark's done as it ought to be'. Boyce spent four months in Venice but in addition to painting architectural subjects, he also produced atmospheric watercolours of sunsets and moonlight effects, despite Ruskin's earlier warning. That Boyce never returned to Venice, finding instead inspiration in the villages of the Thames Valley around Pangbourne, is to be regretted.

Thomas Matthews Rooke (1842–1942) was introduced to Ruskin by Edward Burne-Jones who had used him as an assistant for his design work with William Morris's firm. Ruskin and Count Zorzi were concerned about the destruction of the old mosiac floor in St Mark's and Rooke was employed to make accurate drawings from May until December 1879. He was not highly paid, as Ruskin wrote:

I have got an absolutely faithful and able artist, trained by Mr Burne-Jones, to undertake the copying of the whole series of mosaics yet uninjured. He is doing this for love and mere journeyman's wages . . .

Unfortunately most of the drawings were destroyed in a fire in the Mont Cénis railway tunnel, but Rooke recreated many from his original tracings. He was again copying mosaics for Ruskin in Venice and Ravenna in 1884, and several of his watercolours were bought by Ruskin's Guild of St George and are now in the Ruskin Museum, Sheffield.

Two Americans also accompanied Ruskin to Venice. Charles Herbert Moore (1840–1930) visited Ruskin at Brantwood and joined him on his 1876/7 trip to Venice, helping him to make copies of Carpaccio's St Ursula series. Moore was influenced by Ruskin's looser watercolour style and his wide art-historical background made him an ideal companion for Ruskin who wrote from Venice:

I am very much delighted at having Mr Moore for a companion – we have perfect sympathy in all art matters and are not in dissonance in any others.

Moore later became Professor at Harvard and the first Curator of the Fogg Art Museum. It was Moore who introduced Ruskin to Henry R. Newman (c.1843–1918), the son of a New York

THOMAS MATTHEWS ROOKE

North Atrium of St Mark's 1907
Watercolour, $24\frac{3}{4} \times 22\frac{3}{4}$in
(63 × 57.8cm)
Birmingham City Art Gallery

CHARLES HERBERT MOORE

San Giorgio Maggiore 1876
Watercolour, 11 × 15½in
(27.9 × 39.4cm)
Ruskin Galleries, Bembridge
School, Isle of Wight

doctor who had settled in Europe in 1869. His advice to Newman in 1880 sums up Ruskin's ideals in watercolour:

Go on quietly – trying always for more light, precision in drawing, and of expression of what is old and broken, or weather-stained.

Ruskin also employed an Italian artist, Angelo Alessandri, to work in Venice while the young Englishman, Frank Randal, was sent to France and Italy by Ruskin and probably visited Venice on at least one occasion. Ruskin was considerate towards these young artists, enquiring after their health and diet, and he engendered considerable affection. His house at Brantwood on Lake Coniston where he lived for the last 22 years of his life was run by his niece, Joan Agnew, who married the artist Arthur Severn (1842–1931) in 1871. In the following year they accompanied Ruskin to Venice, but although Severn was influenced by Ruskin's theories, his watercolour style was looser and less centred upon architecture.

The most imaginative artist in Ruskin's circle was Albert Goodwin (1845–1932) whose long artistic career spanned eight decades. In later life he was, as his biographer described him, 'A Victorian who wandered into the twentieth century'. As a young man he had been encouraged by Arthur Hughes and in 1872 he accompanied Ruskin and the Severns to Venice. They travelled via the Alps to Rome and Florence, but Ruskin kept the delights of Venice to the end, as Arthur Severn recalled:

None of us has been there and the Professor kept it a sort of 'bonne-bouche' for us at the last. We arrived there at night . . . and no words of mine can describe the interest and delight we all felt on getting out of the railway station into the darkness – and hearing the splashing of water and gondolas.

They met John Bunney who admired Goodwin's work:

In the evening I went to see Mr Goodwin's sketches; he has a good many. I was greatly pleased with them. Some of them are very lovely, very tender and beautiful . . .

Bunney described Goodwin as 'quiet, practical, full of feeling. No gush but very earnest, without pretension of any kind'. Goodwin was nevertheless a complex and deeply religious character, very concerned about the direction of his work. His earlier Venetian watercolours are highly coloured, reflecting the influence of Arthur Hughes and Turner, whom he greatly admired, but during the 1880s he turned away from colour towards an emphasis on line and form, partially as a result of Ruskin's admonitions:

Colour has been to me the joy of my life. And I owe much thanks to Ruskin, who ballyragged me into love of form when I was getting too content with colour alone . . .

Goodwin appears not to have returned to Venice until 1902, when colour was again a major element in his work. As a result of this trip and a further one in 1905 or 1906, he produced some of the most exquisite images of Venice. His ability to capture the delicacy and fire of a sunset, to create real depth and vibrancy of colour, to make buildings shimmer with light while not losing their solidity, makes Goodwin one of the greatest painters of Venice.

WILLIAM BELL SCOTT
The Basin of St Mark's from the Campanile
Watercolour and bodycolour,
10 × 14in (25.4 × 35.6cm)
Photograph courtesy of the
Fine Art Society, London

Goodwin worked both in oils and watercolour into which he worked body-colour and ink outlines when appropriate. He did not work entirely on the spot:

One should, I think, get time about equally divided between direct study from nature then carry this out to finish and completion away from the place (while the impression is still fresh) in the studio . . .

Another entry in his diary further reveals his ability to create effects away from the image:

Today started on a canvas which last year I cleaned my palette on, and painted a sunset from Lido, Venice – partly from a sky I saw in my late travel, and think it as good as done.

Goodwin's ability to create shimmering colour rested upon his understanding of tonal values, and his thoughts on this as entered into his diary on 2 October 1900 are surprisingly modern:

... tones of grey are things that invariably surround and frame beautiful colour, and without these your colour will never tell as *colour*, but is merely crude paint. But when you begin to introduce the greys, then the colour begins to tell out . . . In fact *tone* has much to do with colour as the grey days of life are to us the emphasis and foils for the blue ones.

William Bell Scott (1811–1890), the son of a well-known Edinburgh engraver, first met Ruskin in London in 1853, when he took a dislike to the man and his theories of art and art education. Some of this hostility was due to the fact that Scott was himself an art educationalist, being Head of Newcastle School of Art, and found Ruskin's views rather eccentric. He visited Venice twice, in 1862 and 1873, painting detailed watercolours which reflect, if not Ruskin's theories, then the influence of Pre-Raphaelitism. *The Basin of St Mark's from the Campanile*, probably painted in 1862, is a fascinating view, with what appears to be an Austrian soldier in the foreground.

To many Englishmen, John Ruskin was the embodiment of Venice. *The Stones of Venice* continued to be a popular guidebook right up to the 1920s, sometimes reprinted in a single-volume abridged edition specifically for the tourist; Ruskin's views about the Venetian Gothic were held as sacrosanct by generations of travellers, writers and architects, artists, whether or not in sympathy with the Pre-Raphaelite movement, continued to be influenced by Ruskin's vision of Venice, and in 1912 we find the artist Walter Tyndale apologizing for admiring the Salute and the Dogana against the judgement of Ruskin. But apart from popularizing Venice, Ruskin also helped to preserve it, being one of the first true conservationists to work in the city. When he died in 1900 his friend and fellow-conservationist, Count Zorzi wrote a fitting epitaph:

English by birth, Venetian by heart, Ruskin has true right to Venetian citizenship, for but few of my compatriots have loved this our fatherland as he has loved it, and after having visited and loved it as a youth, studied, wrote of it and illustrated it over a course of thirty years.

4 'City of palaces, pigeons, poodles and pumpkins'

The Victorians in Venice 1840–80

By the mid-century Venice had become a mecca for tourists from Britain, France, Germany and America and that perceptive observer, the American Consul, W.D. Howells wrote of the English tourist:

. . . the party which fills a gondola with well-cushioned English middle age, ruddy English youth, and the substantial English baggage . . . the father and the mother sit upon the back seats, and their comely girls at the sides and in front. These girls all have the honest cabbage-roses of English health upon their cheeks . . . They are coming from Switzerland and Germany, and they are going south to Rome and Naples, and they always pause at Venice for a few days. Tomorrow we shall see them in the Piazza, and at Florian's, and St Mark's and the Ducal Palace.

The German tourists on the other hand

. . . always seek the Sehenswürdigkeiten in companies of ten or twenty – the men wearing their beards, and the women their hoops and hats, to look as much like the English as possible . . .

While the French tourist is distinguished, 'by his evident skepticism concerning his own wisdom in quitting Paris for the present purpose'. The demand for pictures of Venice grew apace and there is no doubt that many Victorian artists produced indifferent pot-boilers to cater for the often undiscerning public. William Makepeace Thackeray lamented the seemingly endless succession of Venetian views:

How long are we to go on with Venice, Verona, Lago di So-and-So, and Ponte di What d'ye call-em? I am weary of gondolas, striped awnings, sailors with red night (or rather day) caps, cobalt distances and posts in water. I have seen too many white palaces standing before dark purple skies, black towers with gamboge amosphere behind them.

William Callow (1812–1908) was a regular visitor to Venice and his watercolours, especially his exquisitely detailed yet unlaboured façades, are amongst the finest Venetian views of the period. He spent the 1830s in Paris where he came under the influence of Thomas Shotter Boys and indirectly that of Bonington, but his first visit to Venice was not until 1840, when he stayed at the same hotel as Turner:

Being anxious to arrive at Venice, we took the *malle poste* to Mestre, where we embarked in a gondola, traversing for several miles over the lagoons, and arriving in the evening at the steps of Hotel Europa, delighted with our first view of the Queen of the Adriatic. We stayed for ten days, seeing all the wonderful sights and making many sketches. We left Venice with great regret . . .

In 1841 Callow finally left Paris and settled in London but he continued to travel widely in France, Germany and Holland and in 1846, following his marriage in the previous year, he spent his honeymoon in Venice.

From Verona we went to Vicenza, where we took the train to Venice and rowed up the Grand Canal to Hotel Europa late in the evening. The calm and quietude were heavenly after several weeks' of travelling by diligence and rail.

Callow's Italian watercolours, especially those of Venice, were admired by the public and in 1848 he was elected a full member of the Old Water-Colour Society (which became the Royal Society of Painters in Water-Colours in 1881). The Society encouraged large-scale watercolours, heavily framed in gilt, to rival the oils in the Royal Academy, and Callow worked successfully on the required substantial scale. He was on good terms with Prince Albert, with whom he discussed watercolour techniques and styles of framing. He continued to paint views of Venice throughout the 1850s, before returning there in 1865

with Sidney Percy (1821–1886), whom he described as 'a clever landscape painter in oils'. This trip was hampered by an outbreak of cholera and the artists had to be regularly fumigated. He returned again in 1877 and was once more rowed around Venice by Jacomo, the gondolier who had served Callow on each trip since 1840. On his return in 1880, however, the peace and calm of Venice had been shattered:

It was during this visit I first saw steamboats plying on the Grand Canal, much to the disgust of the gondoliers, who refused to take their gondolas out of the way of them, and ran a great risk of being run down.

Callow's last trip was in 1892:

In the year 1892 having now reached eighty years of age, I had a strong desire to once more visit Italy, feeling that if I were to put it off any longer, I might never see that wonderful country again . . . Finally we arrived at Venice and put up at our old quarters, Hotel Europa, facing the Grand Canal, where I had first stayed in 1840 and on each subsequent visit . . . After a fortnight of perfect enjoyment, intermingled with the pleasures of sketching, spending our days chiefly in a gondola, and visiting the Lido and the glorious shores of the Adriatic, we reluctantly left Venice, for myself at least for the last time . . .

Over the course of a long career Callow produced many watercolours and oils of Venice, although his earlier watercolours are probably the finest, having real delicacy and atmosphere. Some of the later watercolours tend to be static and even too large, and his oils sometimes lack the exquisite colouring of the watercolours, especially in the shadows. Nevertheless, Callow must be considered one of the most dedicated and successful Victorian painters of Venice.

The influence of Bonington can also be felt in the watercolours, and to a lesser extent in the oils, of James Holland (1799–1870). He had been trained as a flower painter by his mother, but in 1831 made the first of many trips to France, and found himself moving towards landscape painting. He first visited Venice in 1835 and was there again in November 1845. The quality of the watercolours resulting from these earlier trips is outstanding, certainly on the same level as Prout or Harding.

He was particularly good at leading the viewer's eye down narrow, shaded canals towards sunlit buildings in the distance, but even in his early work he was not concerned with accurate topography. His pictures show well-known buildings, often arranged in a whimsical manner. Turner had done this, and Holland's earlier Venetian fantasies have sparkle and charm, but as the demand for his Venetian work increased, so the quality

JAMES HOLLAND
Canal in Venice with a Group of Ladies Playing and Singing: Santa Maria della Salute in the Background
Watercolour, $19\frac{1}{2} \times 13\frac{1}{2}$in
(49.5×34.3cm)
Victoria and Albert Museum, London

declined; the watercolours lost their transparency and the topographical inaccuracies can irritate. Holland was back in Venice in 1857 and almost certainly in the 1860s, but his method of painting and dating Venetian works executed in his London studio makes it difficult to determine exactly when he was in Venice. Martin Hardie well summed up Holland's later Venetian works:

Few artists can face the full hazard of Venice. Many of Holland's Venetian subjects . . . are the output of a London studio, worked up fancifully and theatrically as to colour. His luscious reds and yellows and purples are too intense; his clear waters and deep skies are bluer than any blue which even Italy can produce.

One of the most intrepid travellers of this period was David Roberts (1796–1864), whose watercolours of the Middle East and Spain were well known to the Victorian public in lithographic reproduction. He visited Venice only once – in 1851 for three weeks – and although he was impressed by the city he found the lay-out confusing:

DAVID ROBERTS

The Piazzetta and Doge's Palace
1851
Oil on canvas, 13 × 21 in
(33 × 53.5 cm)
Photograph courtesy of the
Fine Art Society, London

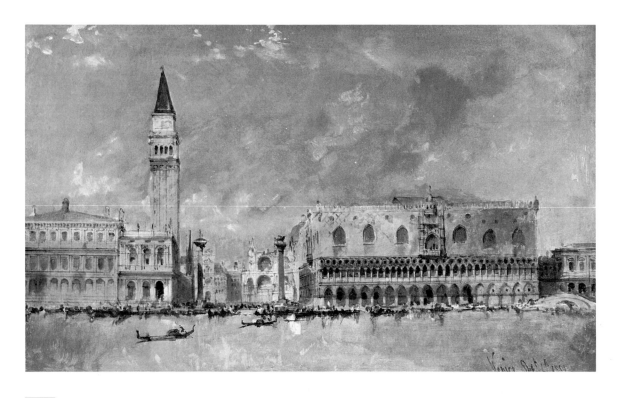

DAVID ROBERTS
The Interior of SS Giovanni e Paolo 1851
Watercolour, $12\frac{1}{2} \times 20\frac{3}{4}$in
(31.8×52.7cm)
Photograph courtesy of the Fine Art Society, London

. . . the streets . . . are so crooked that the most cunning could never find his way in them, or, if in, out again. Secondly, from their narrowness and the great height of the houses, the stench arising from the canal and the innate dirtiness of the Venetians, you can scarce breath.

Roberts's visit coincided with Ruskin's, who was not a wholehearted admirer of his work. Ruskin wrote to his father on 25 September:

I saw David Roberts today : what you say of him is very true. But Venice has been used to all kinds of libels and must put up with it.. . .

Ruskin also recorded his departure in a letter of 23 October:

Mr Roberts left us last night at half past nine . . . He is hurried away from Venice to go to paint the Great Exhibition for the Queen. However, Venice does not lose much. He has been what he calls sketching . . . He sketches the Ducal Palace this way (very rough sketch) and says it is quite enough. How he is ever to work up his sketches I cannot imagine . . .

However, Roberts did work up his sketches and painted a number of Venetian views over the next decade. They may not represent his most exciting work, but the church interiors, although not always strictly accurate, are fascinating. Ruskin in fact disliked Roberts's ability to simplify and edit architectural views, preferring the picturesque details of Samuel Prout.

It seems likely that Venice was not one of Roberts's favourite locations, a sentiment shared by another Victorian artist-traveller Edward Lear (1812–1888) known today as much for his limericks as for his paintings. Lear's ungainly figure and poor health made him an outsider in Victorian art circles, but he retained a humorous approach to his work. He lived mainly in Italy between 1837 and 1848 but it was not until November 1857 that he first visited Venice, and his first impressions were not favourable:

Now, as you ask me my impressions of Venice, I may as well shock you a good thumping shock at once by saying I don't care a bit for it, and I never wish to see it again . . . those very buildings have been so stuffed and crammed in to my sense since I was a child, that I knew the size, place, colour and effect of all and every one beforehand – and derived not one whit more pleasure from seeing them there, than in any of the many theatre scenes, Dioramas, Panoramas, and all other ramas whatever.

EDWARD LEAR

Venice from the Lagoon
Watercolour, $6\frac{3}{4} \times 14\frac{3}{4}$in
(17.2×37.5cm)
Photograph courtesy of
Sotheby's

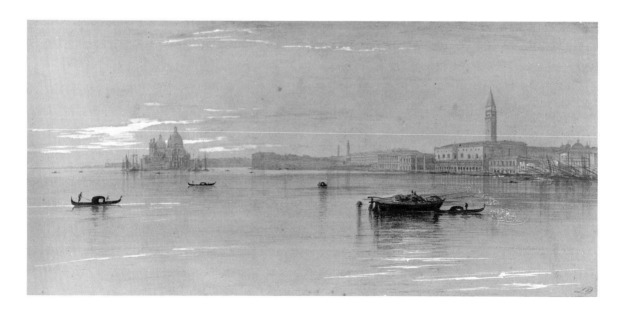

Lear, like Thackeray, found Venice over-exposed in exhibitions and theatres, but he returned in 1865 with a commission to paint an oil for Lady Waldegrave. It was a cold November, but Lear found Venice more attractive on his return:

I am suffering from cold and asthma in consequence, nor must I podder any more by canal sides and in gondolas . . . Altogether this city of palaces, pigeons, poodles and pumpkins (I am sorry to say also of innumerable pimps – to keep up the alliteration) is a wonder and a pleasure.

While in Venice Lear worked on watercolours which he intended to sell, rather than use as the basis of larger oils. These watercolours he called his 'Tyrants' and they vary considerably in quality and finish.

In May 1868 an English party descended upon the ever-popular Hotel Europa. Arriving via Calais, Paris, Nice and the Italian Riviera, Myles Birket Foster with his wife, his niece Miss Brown and her mother were accompanied by the Scottish artist, William Quiller Orchardson. Awaiting them in Venice was Fred Walker, who had arrived in Genoa by steamer and continued to Venice by train. The party met up on 25 May, as Walker recorded:

The Fosters and Orchardson are here in this very hotel. Yesterday morning I was coming in to lunch, when I found the whole party on the steps. They had arrived on Sunday night without my knowing anything of it; the other hotel they intended putting up at was full. The Fosters are very jolly and kind, and all going first rate.

Mrs Brown noted in her diary on the following day:

Here we are really at Venice. No one can form any ideas of the grandeur of the place without really seeing it . . . St Mark's Square was magnificent, and the people of all nations, tongues and climes promenading about made it a wonderful sight. We all agreed that Venice far exceeded our most sanguine expectations.

Walker, Birket Foster and Orchardson worked together in a gondola, but Foster 'found it impossible to do much work, as the heat was so overpowering'. Fred Walker had been advised by Rawdon Brown to take care in the sun:

At R.B.'s advice I bought a small white sunshade or umbrella, the usual thing here; for a 'coup de soleil' is by no means an impossibility, without some little precaution.

Their gondolier was called Antonio, and Walker found him:

. . . very quick and obliging . . . He undertakes to procure me any native as model, such as I may require; taking them to the place, as I may want them, in the gondola, then returning for me – I am going to have a pair of children on the stone steps in my new watercolour . . .

Walker felt at ease in the enclosed cabin of a gondola:

The little cabin of the gondola forms a miniature room, with a sliding window in each side, cushioned and easy, and I feel sure that I shall do some creditable work now.

The group visited the Lido, which was still as unspoilt as in Byron's time, and Chioggia, where the inhabitants were unused to tourists, as Mrs Brown recorded:

I really did feel a foreigner, and was never so much stared at in my life. The people stood in crowds to look at us. It is a very picturesque place, but so queer and dirty that I was glad to return to the steamboat.

Fred Walker (1840–1875) had trained at the Royal Academy Schools and as a wood engraver, but the main influence upon his watercolour style was Birket Foster, who took a fatherly interest in the younger man. His painting method, both in oil and watercolour, was painstaking. He struggled for perfection and worked for long periods until his pictures finally reached his self-imposed standards. While in Venice he produced water-colour sketches, which he later worked into finished water-colours by using body-colour and stippling. *The Gondola* was, however, the only Venetian subject he exhibited at a London society (at the Old Water-Colour Society in 1868). He suffered ill-health and depression brought about by a combination of over-work and incipient consumption. Walker returned to Venice in 1870, partly to restore his health, arriving on 8 June and staying until 27th:

. . . well, it's just lovely here, and I am quite well again, my appetite returned, and thoughts of work coming upon me.

MYLES BIRKET FOSTER

A Flower Stall, Venice
Watercolour, $8\frac{1}{4} \times 11\frac{3}{4}$in
(21×29.9cm)
Photograph courtesy of
Sotheby's, London

Unfortunately his health continued to decline and despite a convalescence in Algiers in the winter of 1872, he died in 1875 aged 35.

Myles Birket Foster (1825–1899) had also trained as an illustrator and only turned to easel painting in the late 1850s. He was a keen traveller and had attempted to reach Venice in 1866, only to be prevented by the conflict between Austria and Italy. His visit of 1868 stimulated his lasting interest in Venice, and he was fortunate in obtaining a commission to paint 50 water-colours of Venice for Charles Seely, a wealthy London corn merchant and Member of Parliament. This commission, which was worth £5,000 – a huge sum for the period – enabled Foster to return to Venice most years between 1871 and 1877. Sadly, the collection was never shown publicly, since it was acquired around 1928 by the British Printing Corporation and subsequently sold at Christie's in a series of sales in 1966. Thus, while we know the titles of many of them, we have no reactions from

EDWARD PRITCHETT
The Grand Canal
Oil on canvas, $11\frac{3}{4} \times 18\frac{1}{4}$in
(29.9×46.4cm)
Photograph courtesy of
Thomas Agnew and Sons

contemporary critics. Foster's Venetian watercolours often lack the more cloying sweetness of his English scenes, and he superbly captured the colour and sunlight of Venice. His watercolour technique, which entailed laying-in Chinese White before applying the watercolour pigment, added to the brilliance and luminosity of his work.

Another artist close to Fred Walker and Birket Foster was Helen Allingham (1848–1926), whose work was admired by Ruskin. She had met many of the Pre-Raphaelites through her marriage to the poet William Allingham in 1874, and when they settled in Witley in Surrey, she came into close contact with Birket Foster who lived nearby. She visited Italy in 1868, but only discovered Venice in 1901. Her Venetian watercolours have an intensity of colour and light, but possibly lack the density of her more typical English scenes.

Many High Victorian artists visited Venice and made reputations for themselves, partially or wholly, through Venetian scenes. Edward Prichett (exhibited 1820s to 1860s) specialized in Venetian views, which at times show a lively and

impressionistic handling, while the best works of Alfred Pollentine (exhibited 1860s to 1880s) share a similar approach; both painters, however, were capable of producing pot-boilers, and as there was a healthy market for their work their output rose to satisfy it. Edward Angelo Goodall (1819–1908) visited Venice on numerous occasions, painting both in oil and watercolour, but while his work can be sensitive and atmospheric, his oils are sometimes harsh in colour and line. William Lake Price (1810–1891) trained as an architect before studying watercolour with de Wint; he travelled extensively abroad and produced charming watercolours of Venice, often quite large. He also illustrated a book *Interiors and Exteriors of Venice*, published in 1843, which was one of the first devoted solely to Venice. Other artists who responded well to Venice include Edward Cooke (1811–1880), who produced some of his most sensitive work in Venice during the 1850s and 1860s, some of

WILLIAM LAKE PRICE
Courtyard of the Casa Salviati
1839
Watercolour, $13\frac{1}{4} \times 18\frac{3}{4}$in
$(33.6 \times 47.5$cm$)$
Victoria and Albert Museum,
London

EDWARD WILLIAM COOKE

The Canal of the Giudecca
Oil on canvas, 35 × 54in
(88.9 × 137.2cm)
Tate Gallery, London

THOMAS BUSH HARDY

Venice from the Lagoon
Watercolour, $12\frac{1}{4} \times 19\frac{1}{2}$in
(31.1 × 49.5cm)
Photograph courtesy of
Thomas Agnew and Sons

which was done entirely on the spot; and Thomas Bush Hardy
(1842–1897), best known as a marine artist, who responded to
the brilliant light and colour of Venice to produce some of his
most distinctive work. When Ruskin wrote of Venice,
'Nobody could draw her but John Lewis' he was referring to a
comparatively minor aspect of the work of John Frederick
Lewis (1805–1876), who probably only visited Venice briefly
once in 1827 and again in 1837 or 1838. He painted a number of
watercolours in Venice and worked up some more important
oils, but his great reputation rests upon his work in Greece,
Spain and Egypt.

One aspect of High Victorian art that was stimulated by contact with Venice and those Italian, Austrian and German artists who were working there was the so-called 'Venetian genre'; idealized paintings of flower girls, gondoliers and other Venetian characters in picturesque settings. The two most successful exponents of this were Sir Luke Fildes (1845–1927), and his brother-in-law, Henry Woods (1846–1921). Much of the correspondence between the two has survived and provides a fascinating insight into the life of a British artist in Venice.

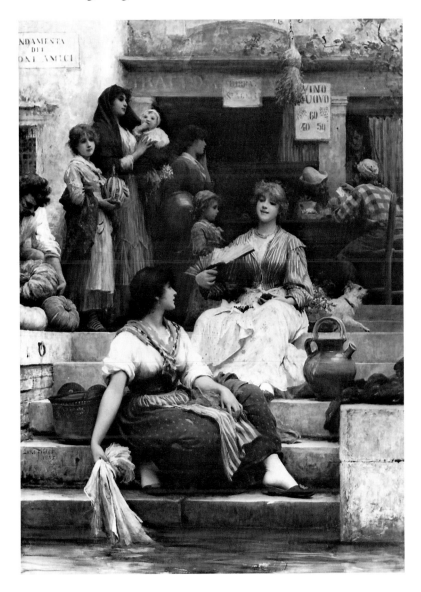

SIR LUKE FILDES

Venetians 1885
Oil on canvas, 91 × 65¼in
(231 × 165.7cm)
Manchester City Art Gallery

Both studied at Warrington School of Art, Liverpool, before going on on to the South Kensington School of Art, London. In 1874 Fildes married Fanny Woods, having returned from his first trip to Venice in the company of the painter Marcus Stone and his wife Laura. Fildes was enchanted with Venice and wrote to Woods:

You can go out for a walk or a row and spot at least half a dozen pictures, beautiful ones, in an hour. . . The shipping is splendid, too, such colour. You can have a gondola which is . . . splendid to paint from as it is so beautifully fitted up, for a day and a man for 5 lire – 4/2d of our money – and 6d for himself.

Fildes returned with his wife in 1876 for a few weeks. He had embarked upon Venetian canal scenes and was receiving good money for them. His brother-in-law was having little success with his English subjects, and Fildes urged him to go to Venice in the following year. In 1878 Woods settled in Venice, staying at first in the Casa Zabeo near San Trovaso, where many artists lived:

HENRY WOODS
Campo SS Giovanni e Paolo
Oil on canvas, 17 × 27½in
(43.2 × 70cm)
Royal Academy of Arts,
London

I am next door to the Church close by San Trovaso . . . quite in the thick of the studios . . . I met Mark Twain and have had a walk with him in the evening.

Woods met many artists who were working in Venice, and his style and subject matter were influenced by them, in particular Eugene de Blaas, Franz Leo Ruben, Thoren, Van Haanen and the Russian artist Wolkof, whom Woods introduced to Whistler in 1879. Woods dislike Whistler's conceit although he recognized and admired his ability:

I could do with Whistler very well, but for his confounded conceit and everlasting seeking for notoriety. I cannot stand it. He has started two 'moonlights' entirely from memory. They are, I must admit, remarkably true as far as they go . . . His etchings will be very good I think.

Woods greatly enjoyed Venice and found the climate excellent. In an amusing exchange with Fildes who had written to complain about '. . . the most awfully dark and hopeless winter that has ever been known in London', Woods replied: 'I was basking in a warm sun on the Zattere when the postman handed me your letter.' Wood's cheerful personality ensured that he was at the centre of English and American society in Venice and met most visiting artists:

Sat with Sargent for a while at Florian's . . . His colour is black, but very strong painting. [1880]

In March 1881 Fildes rejoined Woods and worked hard on two Venetian canvases. He returned to London for the opening of the Royal Academy, but was back in Venice in May accompanied by his wife, young son and nurse. His son later recalled those days:

The day's work began early and by mid-afternoon my father and uncle were ready to take the steamer out to the Lido . . . waiting on the sands at the *stabilimento* would be my mother, myself and my nanny, who had spent most of the day there, picnicking.

In the following year Woods moved into the ground floor of a palazzo on the Grand Canal, which was approached from the Campo San Maurizio. His studio was a small pavilion in the

garden of the Palazzo Vendramin; this arrangement was to last for over 30 years with Woods making brief trips to London in the spring and Fildes, often accompanied by his family, staying with Woods in the summer or autumn. Woods was noted for his athletic prowess – he swam from Fusina on the mainland for two miles towards Venice, landing on the island of San Giorgio in Alga – 'I think I could have gone on to Venice but it was getting dark'. He also organized walks from Fusina down the Brenta Canal to Padua, visting the Palladian villas *en route* – a walk of nearly 20 miles. He was a welcomed guest at the homes of Mrs Bronson, doyenne of American society in Venice, and Sir Henry and Lady Layard, Sir Henry being the archaeologist who had discovered Nineveh and latterly British Ambassador in Constantinople, and who had bought the Ca' Cappello on the Grand Canal. Woods was in demand as an organizer of theatrical evenings, scene painter and costume designer.

In 1883 Fildes came to Venice with a commission worth 2000 guineas to paint a major Venetian work for John Aird. He remained from August until shortly before Christmas and at the 1884 Royal Academy he exhibited the result of his labours, *Venetian Life*. In addition to this, John Aird also bought Woods's *Il Mio Traghetto*. These large, highly finished pictures did not impress Ruskin who described them as 'useless cleverness . . . I say emphatically that this is not art'. Fildes continued to work in Venice throughout the 1880s, but in the following decade became popular as a portrait painter to the nobility and royalty. He resumed work in Venice after 1900, by which time Woods had moved to the ground floor of the Casetta Rocca, a delightful house set in its own garden on the Zattere, where the Rio di San Vio joins the Giudecca.

Venetian genre is represented by two other High Victorian painters. Marcus Stone (1840–1921) was a close friend of Luke Fildes and Henry Woods; he visited Venice in 1874 with Fildes. He later established a reputation for highly finished genre, often set in eighteenth-century costume, depicting lovers in a garden or elaborate interior. His Venetian work, which was painted earlier in his career, was less sentimental, and similar in content to Woods and Fildes, showing pretty girls by a canal or in a Venetian garden. William Logsdail (1859–1944) had studied at Lincoln School of Art, probably meeting Frank Bramley as a

student, and although he was never connected with the Newlyn School, he was influenced by their approach to *plein air* painting and by their subject matter. He became known for his large, realistic views of London streets and he applied the same formula to Venice, where he lived for a period during the late 1880s and early 1890s. He painted broad panoramas of the Piazza and views along the Riva degli Schiavoni.

MARCUS STONE

A Street Door in Venice 1874
Oil on canvas, 43 × 29in
(109.2 × 73.7cm)
Photograph courtesy of
Sotheby's

WILLIAM LOGSDAIL
The Island of San Michele
Oil on canvas
Photograph courtesy of
Sotheby's

By the 1880s Venice had become a paradise for many diverse reasons. It was cheap, and good lodgings with staff were readily available; there was a community of artists of many nationalities who helped each other, and discussed events in the art worlds of London, Paris, Munich and Vienna, so no artist felt isolated from the mainstream; models were available and the distinctive dress of the Venetians provided interest and variety; working out of doors was much easier than in London or Paris and faithful gondoliers with a variety of craft suitable as outdoor studios could be hired cheaply. Above all, Venetian pictures sold well in London and in other cities in Europe and America. Venice possessed many pictorial aspects which appealed to High Victorian taste: its architecture, its flower markets, its romantic undertones, its beautiful young girls uncorrupted (at least in the Victorian imagination) by industrialized society, and always its slightly exotic flavour, poised between the real danger and dirt of the Middle East and the more prosaic landscape of Europe. However, a contrary impression from W.D. Howells was that:

As to Art, the Venetians are insensible to it and ignorant of it, here in the very atmosphere of Art, to a degree absolutely amusing. I would as soon think of asking a fish's opinion of water as of asking a Venetian's notion of architecture or painting.

5 The butterfly on the lagoon

Whistler in Venice 1879–80

Whistler arrived in Venice in the autumn of 1879 a man crippled financially and nearly broken in spirit. The last two years in London had been unhappy, culminating in the disastrous lawsuit against Ruskin in which Whistler, posing as a latter-day Don Quixote, had tilted against the Establishment. While Whistler had legally won the case, the damages of one farthing awarded against Ruskin, with no expenses paid, had left Whistler a bankrupt, forcing him to sell the famous White House in Tite Street and many of his recent paintings. In the previous years (1877), Whistler had greatly angered his long-suffering patron, Frederick Leyland, by his outrageous behaviour in the decoration of Leyland's London house at 49 Prince's Gate. The room in question had been decorated by Thomas Jeckyll in red and brown leather which Leyland wanted slightly changed. While Leyland was away, Whistler completely altered the colour scheme, painting the entire room in a deep turquoise-blue and gold. While Leyland might have tolerated the colour, he was not prepared to tolerate Whistler's rudeness towards his wife, and his demands for extra payments. Leyland was finally forced to write:

The fact is your vanity has completely blinded you to all the usages of civilized life, and your swaggering self-assertion has made you an unbearable nuisance to everyone who comes in contact with you.

Whistler had been considering a trip to Venice since 1876 when he had recorded in his ledger book the first orders for a series of etchings of Venice planned for that autumn. He hoped that the

commission from Frederick Leyland would cover the cost of the trip, but the ensuing argument with his patron meant postponing the project. In the summer of 1879 he was approached by Ernest Brown on behalf of the Fine Art Society to produce 12 etchings of Venice and was given an advance of £150, with the proviso that he would return with the plates by 20 December. On 16 September 1879 Whistler arrived in Paris with his mistress, Maud Franklin, and on the 18th he took the

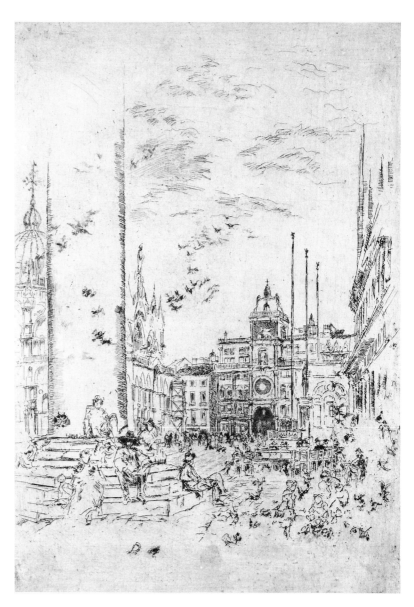

JAMES MCNEILL WHISTLER

The Piazzetta
Etching from *The Venice Set*,
10 × 77in (25.4 × 17.8cm)
British Museum, London

night train to Venice in order to find lodgings for them both. On his arrival he found rooms in the Palazzo Rezzonico on the Grand Canal, a seventeenth-century palace which had been converted into rooms and studios, and in which John Singer Sargent and Giovanni Bodini were to live and work during the following year. Maud Franklin left Paris for Venice on 18 October, to join Whistler in the Palazzo Rezzonico.

Otto Bacher, a young American artist, met Whistler near the Accademia shortly after his arrival in Venice:

. . . a curious, sailor-like stranger coming down the steps of the iron bridge that crosses the Grand Canal . . . short, thin, and wiry, with a head that seemed large and out of proportion to the lithe figure. His large, wide-brimmed, soft brown hat was tilted far back, and suggested a brown halo. It was a background for his curly black hair and singular white lock . . . I was fascinated with his pleasant face, voice, keen, nervous eyes, and long shapely head . . . His talk was full of surprising touches . . . and always keen and witty.

By the end of December the Fine Art Society was expecting the plates, but Whistler had no intention of returning so soon. Not only did he plan many more than 12 plates, but he had also embarked upon a series of pastels. The winter was bitterly cold and Whistler, despite outward appearances, was concerned about his financial position in London:

It has been woefully cold here – the bitterest winter I fancy that I ever experienced, and the people of Venice say that nothing of the kind has been known for quite a century . . .

On 14 January 1880, Marcus Huish, a director of the Fine Art Society, wrote an angry letter lamenting the delay in publishing the etchings. Whistler replied, blaming the icy weather for the delay:

I can't fight against the gods – with whom I am generally a favorite – and not come to grief – so that now – at this very moment – I am an invalid and a prisoner – because I rashly thought I might hasten matters by standing in the snow with a plate in my hand and an icicle at the end of my nose . . . I am frozen – and have been for months – and you can't get hold of a needle with numbed fingers, and beautiful work cannot be finished in bodily cold – Also I am starving . . . You

had better send me fifty pounds at once and trust to a thaw which will put us all right.

However he placated Mr Huish by promising more work than originally commissioned and of greater interest:

Venice, my dear Mr Huish, will be superb – and you may double your bets all round . . . I have learned to know a Venice in Venice that the others never seem to have perceived, and which, if I bring back with me as I propose will far more than compensate for all the annoyances, delays and vexation of spirit . . . The etchings themselves are far more delicate in execution, more beautiful in subject, and more important in interest than any of the old set.

Other artists in Venice were impressed by Whistler's energy and determination to work despite the appalling conditions. Henry Woods recalled:

I remember his energy – and suffering – when doing those beautiful pastels, nearly all done during the coldest winter I have known in Venice, and mostly towards evening when the cold was bitterest! He soon found out the beautiful quality of colour there is here before sunset in winter.

Despite the cold Whistler was acutely aware of the beauty of Venice, as he wrote to his mother:

Perhaps tomorrow will be fine – and then Venice will be simply glorious . . . After the wet, the colours upon the walls and their reflections in the canals are more gorgeous than ever – and with the sun shining upon the polished marble mingled with rich-toned bricks and plaster, this amazing city of palaces becomes really a fairy land – created one would think especially for the painter . . .

The spring brought with it better weather and new friends. Frank Duveneck arrived from Munich with a group of young American art students whom Whistler called the Duveneck Boys. Their youthful enthusiasm and gaiety not only provided Whistler with an audience but lifted his sagging spirits. One of the group, Otto Bacher, later recorded their life with Whistler in two articles in the *Century Magazine*. The group had rented rooms in the Casa Jankovitz, a building on the Riva degli Schiavoni situated near the Via Garibaldi. Signor Jankovitz, the

proprietor, was an old Italian mender of clocks and compasses, while Signora Jankovitz rented out the rooms above his little shop. The view from their rooms was excellent, one window looking out across the lagoon towards San Giorgio and the Salute, the other looking down the Riva towards the Public Gardens.

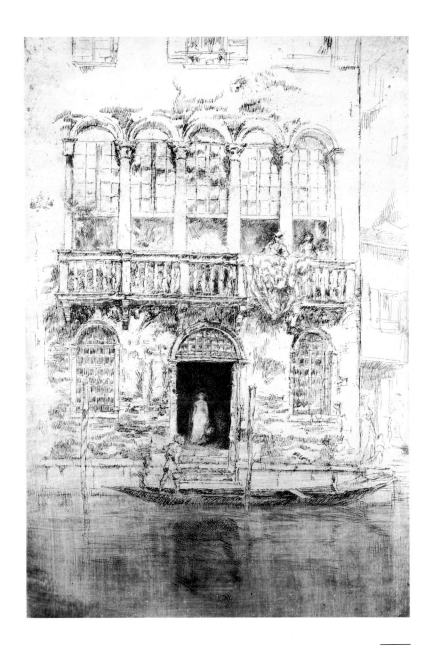

JAMES McNEILL WHISTLER

The Balcony
Etching from *Twenty-Six Etchings*, $11\frac{3}{4} \times 8$in
(29.9 × 20.3cm)
British Museum, London

He liked our surroundings, was charmed with the vistas from our windows, and asked permission to come and sketch them: . . . Sometimes he would work from one window with pastels, and from another window would begin a subject for late afternoon work, upon which he worked several afternoons until it was finished.

Otto Bacher had an old, but workable, press in his rooms at the the Casa Jankovitz and Whistler made use of it to try out his plates. He soon decided to leave his rooms near the Frari and moved into the Casa Jankovitz. Although he obviously enjoyed being 'the Master' amongst his youthful companions, and at times encouraged outrageous behaviour, Whistler worked hard and consistently, as Bacher recalled:

He rose early, worked strenuously and retired late. He seemed to forget the ordinary hours for meals and would often have to be called over and over again.

To work the canals thoroughly Whistler used a *barca*, a larger and more stable gondola, and like Ruskin employed a gondolier to row him about. Bacher recorded:

He would load his gondola, which was virtually his studio, with materials, and the old gondolier would take him to his various sketching points . . . He always carried two boxes of pastels, an older one for instant use, filled with little bits of strange, broken colours of which he was very fond, and a newer box with which he did his principal work. He had quantities of vari-coloured papers, browns, reds, greys, uniform in size.

Searching out new subjects was an important occupation, and Whistler suffered the problem of many artists in Venice – too many subjects. Miss Edith Bronson, later Countess Rucellai, later recalled:

He used to say Venice was an impossible place to sit down and sketch, 'there was something still better around the corner'.

Once he found a good subject he tended to keep it secret:

What would be the use, he would ask, of his ferreting out some wonderful old bridge or archway, and thinking of making it immortal, if some second-rate painter-man were to come after him and make it commonplace with his caricatures? On the other hand, if some friend of his discovered an ideal spot . . . he would not scruple

for an instant to say 'Come, now, this is all nonsense , your trying to do this. It is much too good a subject to be wasted on you. You'd better let me see what I can do with it.

Harry Quilter, the art critic of *The Times*, who had bought the White House after Whistler's bankruptcy, recalled a friendly row over a Venetian doorway:

I had been drawing for about five days, in one of the back canals, a specially beautiful doorway, when one morning I heard a sort of war-whoop, and there was Whistler in a gondola, close-by, shouting . . . 'Hi, hi! What! What! Here, I say, you've got my doorway!' I replied, 'It's my doorway, I've been here for the last week.' 'I don't care a straw, I found it out first.'

While Whistler worked on his etchings and pastels on the spot, his oils appear to have been painted from memory. Otto Bacher remembered:

Night after night he watched the gondolas pass singly and in groups, with lanterns waving in the darkness, without making a stroke with brush or pen. Then he would return to this rooms and paint the scene, or as much of it as he could remember, going again and again to refresh some particular impression.

Whistler was a brilliant debater and conversationalist, and unlike Ruskin, he had a fluent command of French and Italian. In the evening, when their work was done, Whistler would lead his companions down the Riva degli Schiavoni towards the Piazza San Marco to eat in a trattoria or to sit and talk in Florian's or Quadri's. Ralph Curtis, Sargent's close friend and relation, recorded:

Very late, on hot sirocco nights, long after the concert crowd had dispersed, one little knot of men might often be seen in the deserted Piazza, sipping refreshments in front of Florian's. You might be sure that was Whistler in white duck, praising France, abusing England, and thoroughly enjoying Italy.

To save money they often ate in a little trattoria, La Panada, near the Via Garibaldi, and Whistler himself sometimes cooked in the Casa Jankovitz, his speciality being breakfasts of Polenta à l'Américaine. Mortimer Menpes, who became a pupil of Whistler during the 1880s, visited La Panada some years later:

The Panada had a sanded floor and was the noisiest restaurant in Venice. It was not clean; there was a great deal of smoke, and so much talk! The guests seemed to be screaming and talking at once in all the languages of the world . . . They dressed like artists and talked like artists . . . The waiters were also soiled and very apathetic – toes turned inwards, heads bent slightly forward . . . All was soiled at the Panada – the waiters, the artists and the linen.

The artists who went to the Panada were those who had 'let themselves go' – who had been taken hold of by the sirocco and had settled down to loafing. They nearly all had had exhibitions in Bond Street which had been 'great artistic successes' – in other words, they hadn't sold any pictures. Another advantage about the Panada that appealed to the artist was that his bills could run up indefinitely.

Whistler often swam in the Lagoon early in the morning, and spent time teaching the young artists how to dive properly from his *barca*:

It would hold ten of us comfortably, including the faithful old gondolier, who was always careful to keep one place dry for Whistler's spotless white, well-laundered shirt, waistcoat and trousers, in readiness of il signore to don after his bath.

Despite being chronically short of money, Whistler insisted on being well dressed. Otto Bacher described his appearance at this time:

Whistler was always scrupulously dressed, ordinarily wearing a sack-coat, white shirt with turned down collar, and white duck trousers; but on rainy days he donned trousers to match his coat. A brown felt hat completed his costume.

He was always careful to let his famous white lock of hair show beneath his hat:

The white lock, dry and crisp, shot high up and out of a mass of black, curly hair that usually had the appearance of having an over-application of hair oil. It was a birthmark, so he told me.

For many years after Whistler's departure from Venice, stories circulated about his practical jokes, some true, some no doubt exaggerated. One of the most famous relates to John Wharlton Bunney, the artist employed by Ruskin to make detailed studies

of Venetian architecture. Whistler commented on the irony that both he and Bunney were in Venice because of Ruskin: Bunney working for Ruskin, and Whistler escaping the bankruptcy that he considered Ruskin had caused. While Bunney was up a scaffold studying and measuring the façade of St Mark's, Whistler pinned a card to his coat reading, 'I am totally blind'. The poor artist spent the rest of the day at work oblivious to his label. Another story, recounted by Bacher tells how Whistler was annoyed by the irregular ringing of the bells of the church of San Biagio, which stood beside his room in the Casa Jankovitz:

Whistler timed the bells one day by his watch, and found they were running overtime. Reaching out from his window, he succeeded in silencing them by holding on to the rope with a crooked nail fastened into the end of a pole!

Having made his point he later made his peace with the parish priest.

A further story concerns the Russian artist Alexander Roussoff, known as Wolkoff, who claimed that his pastels were just as good as Whistler's, and made a bet that a jury of artists could not distinguish between their work. The jury, which included Duveneck, Bacher, Woods and Ralph Curtis, met at the Casa Jankovitz and began looking through the pile of pastels. They immediately spotted Wolkoff's work and he lost the bet. At the dinner that followed, Wolkoff commented to Whistler, 'You know, scratch a Russian and you find a Tartar', to which Whistler replied, 'I've scratched an artist and found an ama-Tar'.

Not everyone found Whistler amusing, and his – probably tongue-in-cheek – habit of referring to himself in the third person when talking to friends certainly irritated some. Another criticism, relating to his perpetual lack of money, is summed up by the artist Henry Woods, who had obviously not fallen for Whistler's charm:

Whistler, I hear, has been borrowing money from everybody, and from some who can ill afford to spare it. He shared a studio for five or six months with a young fellow named Jobbins. Jobbins never could work there with him in it. He invited people there as to his own place,

and has never paid a penny of the rent. He used all the colours he could lay his hands upon; he uses a large flat brush which he calls 'Mathew', and this brush is the terror of about a dozen young Americans he is with now. Mathew takes up a whole tube of cobalt at a lick; of course the colour is somebody else's property . . . There is no mistake that he is the cheekiest scoundrel out . . . I am giving him a wide berth.

However, despite these misgivings, Henry Woods appears to have spent considerable time in the company of Whistler and his young American entourage.

Regardless of his shortage of money and the time spent in company, Whistler produced an amazing amount of work in Venice; oils, pastels and etchings, many of which are amongst his most successful works. He probably painted about ten oils, but only two of these are known to us today. In pastels he was more prolific, producing about 100 during his 14 months in Venice. These pastels, invariably worked on the spot, capture the brilliance of a Venetian sunset or the tranquillity of a small canal, and created a critical and public success when shown at the Fine Art Society in 1881. Frederick Wedmore wrote that *The Riva, Sunset*:

. . . is one of the most successful examples of a power to reject everything that is superfluous, to select everything that is entirely necessary . . . A few touches of pastel in various colours, and somehow, the sky is aglow and the water dancing. The thing has been wrought as it were by pure magic.

Otto Bacher recalled that:

Whistler lifted pastels from the commonplace to a very artistic medium . . . In beginning a pastel, he drew his subject carefully in outline with black crayon upon small sheets of tinted paper. A few touches with sky-tinted pastels produced a remarkable effect . . . At all times he placed the pastels between leaves of silver-coated paper. Even his slightest notes and sketches were treated with the greatest care and respect.

Shortage of money forced Whistler to be economical; not only did he buy paper cheaply from a warehouse near his rooms, but he also rubbed out and re-used the paper if a pastel had failed to please him. Traces of earlier works can thus be seen on a number

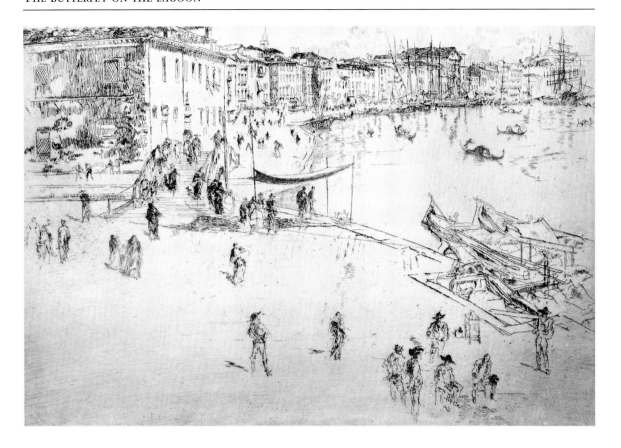

JAMES McNEILL WHISTLER
The Riva No. 2
Etching from *Twenty-Six Etchings*, $8\frac{1}{4} \times 12$in
(21×30.5cm)
British Museum, London

of pastels. This economy and informality contrasted sharply with the overworked and overfinished styles with which pastels had been long associated.

The original reason for Whistler's trip to Venice was the Fine Art Society's commission for 12 etchings, for which he was to receive £1,200 less expenses paid while he was in Venice. It was a commission which the bankrupt artist needed, and which he fulfilled superbly, although he far exceeded the three month time-scale which Mr Ernest Brown of the Fine Art Society had stipulated. On his return in November 1880, Whistler had with him some 40 plates, of which 12 were selected by the Fine Art Society (known as *The First Venice Set*) and published in 1880, while another 21 (*The Second Venice Set*) were published by Dowdswells in 1886 under the title *26 Etchings*. The remaining Venetian plates appeared individually.

Although the prints were not an immediate success, they eventually became popular with both the critics and the public,

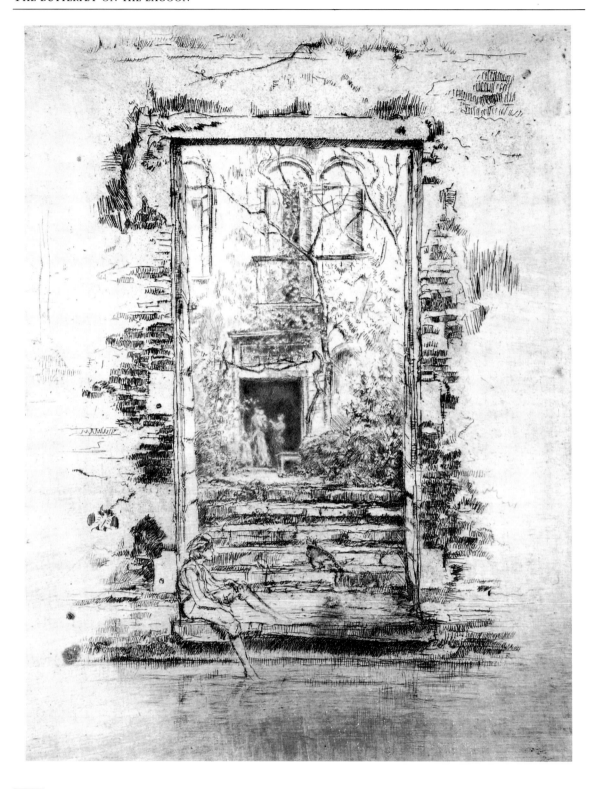

and their influence upon other artists was considerable. Whistler had created a new kind of atmospheric, even Impressionistic print. One of his critics at the time was Frederick Wedmore who later became an enthusiast of Whistler's work. Writing in 1911 he attempted to justify his earlier hostility towards *The First* and *The Second Venice Sets*:

When they were first exhibited they were unready and unripe. The critics were quite right in not accepting them enthusiastically, and Whistler was quite wrong in being angry at the reception accorded to them. He had his revenge afterwards . . .

Whistler worked on the plates on the spot, from a gondola or from the window of the Casa Jankovitz. The subjects are thus reversed in the printing process, to become mirror images. T.R. Way recalled:

He brought back the plate of the *Little Venice* only drawn with a needle. He had done it from one of the islands, to which there are excursions by steam boat, allowing an hour or two on shore before returning. The plate I saw him bite in, holding it in one hand and moving the acid about with a feather, and without any stopping out. The first impression of it printed was quite satisfactory, and he did not need to rebite it or reduce any part of it, which . . . showed not only wonderful skill in biting, but an amazing memory as well.

Mortimer Menpes also recorded Whistler's unorthodox method of making a plate:

. . . Whistler never dipped a plate into an acid bath in the usual manner. He poured the acid upon the surface of the copper, and played it about by means of a feather, for all the world as if he were at work on a black-and-white drawing – only, the feather end was used instead of the quill. Thus he produced infinite variety.

Whistler disliked professionally printed plates; he found the tones too dark and monotonous, and called them 'gummy and treacly'. Instead, he pulled his own prints with the help of assistants like Menpes and Way, making sure that the old Dutch paper he preferred was dampened to the right degree of moisture, and that the ink he used was not too black but laced with burnt umber. He continued to work on the plates while pulling, as Menpes recalled:

JAMES MCNEILL WHISTLER

The Garden
Etching from *Twenty-Six Etchings*, $12 \times 9\frac{1}{4}$in
(30.5 × 23.5cm)
British Museum, London

Much of Whistler's etched work was done on the bench while he was actually printing. I have seen him print twelve proofs, and every proof a state. He would continually keep adding dry-point and scraping, and, as he himself would say, caressing the plate into form.

The Nocturnes in particular required careful hand-printing:

How hopeless it would be to try and procure this tone by any mechanical roughening of the surface of the copper! Such a result is only possible by leaving films of tone upon the plate!

Thus Whistler's etchings were unorthodox both in the making of the plates and in the individual methods of printing, and their marvellous atmospheric effects, contrasted with their delicate detail, make them truly revolutionary in the history of print-making. However, they are as novel in their subject matter as in their technique, as Frederick Wedmore pointed out:

Some of us thought at first they were not satisfactory because they did not record the Venice which the cultivated tourist, with his guide-books and his volumes of Ruskin, goes out from London to see . . . The Past and its record were not his business in Venice. For him, the lines of the steamboat, the lines of the fishing-tackle, the shadow under the squalid archway, the wayward vine of the garden, had been as fascinating, as engaging, as worthy of chronicle, as the Domes of St Mark's.

Whistler's fortunes were greatly improved by his stay in Venice. Although the first exhibition on his return to London, consisting of the 12 etchings of the *First Venice Set*, was not a great success, the second exhibition, also held at the Fine Art Society (in January 1881), comprising 53 pastels of Venice, was rewarding both financially and critically. Whistler personally supervised the decoration of the Gallery which the architect Godwin described.

First, a low skirting of yellow-gold, then a high dado of dull yellow-green, then a moulding of green-gold, and then a frieze and ceiling of pale reddish brown. The frames are arranged on the line; but here and there one is placed over another. Most of the frames and mounts are a rich yellow-gold, but a dozen out of the fifty-three are in green-gold, dotted about with a view to decoration, and eminently successful in attaining it.

The theme of yellow was continued in the dress of the attendants who wore yellow neckties, while Whistler, sporting yellow socks, distributed yellow and white butterflies.

Maud Franklin wrote to Otto Bacher describing the outstanding success of the exhibition:

There has never been such a success known . . . All the London world was at the private view − princesses, painters, beauties, actors, everybody . . . Even Whistler's enemies were obliged to acknowledge their loveliness. The critics were one and all high in their praise . . . The best of it is, all the pastels are selling. Four hundred pounds' worth went the first day; now over a thousand pounds' worth are sold. The prices range from twenty to sixty guineas, and nobody grumbles at paying for them.

Whistler was in his element at the Private View joking with the critics and buyers, one of whom remarked that 60 guineas seemed to much for a pastel. Whistler is reputed to have replied, adapting a theme from his recent court case: 'Not at all! I can assure you it took me quite half an hour to do it!' The prices did not put buyers off, and by the end of the exhibition £1,800 worth of pastels had been sold. Not only had Whistler's financial situation improved, but the attendance of, amongst others, the Prince and Princess of Wales, re-established his position in society, a position which, despite his protestations to the contrary, Whistler took very seriously. Maud at last had some money to spend, as she wrote to Bacher:

I've been enjoying myself, I can tell you, and have managed to spend a hundred pounds on myself − what do you think of that, after the impecuniosity of Venice? Ah well, I should like to go back there all the same.

But Whistler was never to return to Venice. A third exhibition took place at the Fine Art Society in 1883 consisting of etchings of Venice and London, but Whistler fell out with the Gallery over finance, and in 1886 Dowdeswell and Dowdeswell, a London gallery, published the remaining Venice etchings. By then Whistler's attentions were turned towards France, and in the 1890s Paris became his home.

When Whistler had announced his intention to leave Venice in the autumn of 1880, his friends had organized a spectacular

farewell. An open barge, usually used to transport coal, was hired, cleaned up, and decorated with flowers, fruit, sheaves of wheat and illuminated Japanese lanterns. The hold was converted into a dining room with studio draperies, while bowls of salad and flasks of Chianti were provided for the guests. Bacher described it:

> The small decks fore and aft were manned with oarsmen, and under an American flag was placed a throne for the guest of honour.

The barge started from the Riva degli Schiavoni, moved out into the Lagoon and then went up the Grand Canal. Rain forced them to moor under the Rialto Bridge where the merry making continued, although Bacher observed, 'As daylight approached there was a slight falling off in wit, wine and song.' Replete with wine and food the company slept until the morning.

Like Turner and Sargent, Whistler had made Venice his own, and one cannot visit the city without seeing in the mind his vibrant pastels or his delicate etchings. The influence of Whistler worked on those young artists who went to Venice to study, and as late as 1909 the Pennells (Whistler's biographers) were writing:

> And yet today, when two or three artists gather together of an evening at Florian's . . . it is of Whistler they talk. When the prize student arrives and has sufficiently raved, they say 'Oh yes, but you will have to do it better than Whistler!'

Whistler's courage has to be admired. He arrived in Venice low in spirit and finance, yet 14 months later he departed with a substantial portfolio of pastels and etchings which broke new ground in both media, as well as a number of interesting canvases. He left behind him in Venice a reputation which persisted for generations. Whistler's resilience is best described by Mortimer Menpes:

> Never once has his courage failed him; never once has he admitted himself to be in the wrong. Whistler was the sort of man who, had he been thrown out of a top window onto the pavement beneath, and were it possible for him to speak, would have said, on being picked up, 'Good jump that, wasn't it?'

6 The Duveneck boys

Americans in Venice 1850–1930

American interest in Venice did not develop much before the middle of the century when those same factors that brought British tourists and artists began attracting Americans in considerable numbers, especially in the years following the Civil War. By the 1860s an American colony existed in Venice, and the American consul during this period, William Dean Howells, who was later to become a noted novelist, wrote *Venetian Life*, one of the most interesting and informative accounts of nineteenth-century Venice. His predecessor, Edmund Flagg, American consul during the 1850s, had also written an account entitled *Venice: City of the Sea*, published in two volumes in 1853. This literary tradition was continued by Henry James who first visited in 1881. He described his envy at meeting a young American artist in the Piazza:

. . . to spend one's mornings in still, productive analysis of the clustered shadows of the Basilica, one's afternoons anywhere, in church or campo, on canal or lagoon, and one's evenings in starlight gossip at Florian's, feeling the sea-breeze throb languidly between the two great pillars of the Piazzetta . . . this, I consider, is to be as happy as one may safely be.

One of the first Americans to paint Venice was Sanford Robinson Gifford (1823–1880) who first came to Europe in 1855 to see paintings by Turner and to visit Ruskin. He arrived in Venice in June 1857 and stayed at the Hotel Luna near St Mark's until 22 July. In 1869 he returned from New York

planning to spend a few days in Venice; in the event he remained for several weeks, deeply impressed by its nostalgic decay:

I did not know till now, when I am about leaving Venice forever, how strong a hold this dear, magnificent, dilapidated, poverty-striken city has taken on my affections. Even in her rags and tatters and old age the 'Bride of the Sea' is the loveliest, the most glorious and the most superb of cities.

Although Gifford became a leading figure in the Hudson River School, comparatively few of his Venetian oils are known today.

William Stanley Haseltine (1835–1900) was also an early American arrival. He first came to Europe in 1855 to study in Düsseldorf and then Rome, where he finally settled in 1869 and where he was a close friend of Mariano Fortuny. Each year he would spend some time working in Venice, where he was well known in British and American society. His daughter described his working methods:

WILLIAN STANLEY HASELTINE
Santa Maria della Salute, Sunset
Oil on canvas, 23 × 36in
(58.4 × 91.4cm)
Metropolitan Museum of Art,
New York

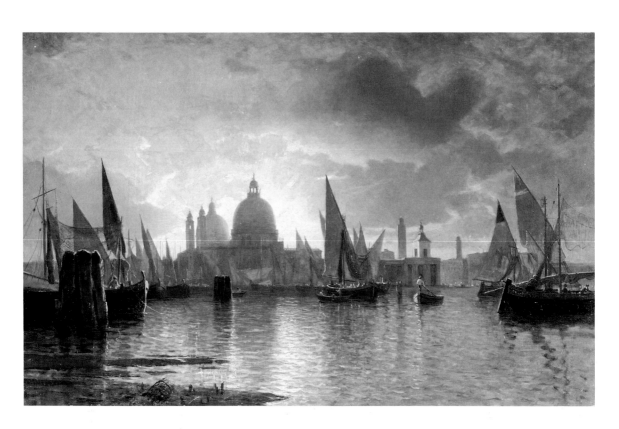

He was always out before the sunrise . . . Sometimes in the late afternoon, when the sky, the lagoons were like a Mexican opal, he went to one of the islands . . . hardly a sound broke the stillness, save the distant voices from out-going fishing boats; at these moments W.S.H. touched supreme contentment; his sketch-book on his knee, his colour-box beside him, he worked without speaking.

Like Haseltine, John Rollin Tilton (1828–1888) had settled in Rome and taken a studio in the Palazzo Barberini in 1852, thus becoming a permanent expatriate. He was influenced by the Venetian School and was known as 'The Tintoretto of Rome'. Tilton painted widely in Italy as well as in Spain, Greece and Egypt, and his work became popular with both British and American tourists. His views of Venice were influenced by Turner and he worked in both watercolours and oils, staging an exhibition entitled *Lagoons of Venice* in Philadelphia during the Centenary Year celebrations of 1876. His style was, however, outmoded and younger American artists ridiculed his unadventurous approach to painting.

In common with many American artists, Charles Caryl Coleman (1840–1928) was based in Rome, but visited Venice regularly. He had taken a studio in Venice around 1864, but finding that 'Venice swarms with artists', he had returned to Rome where his studio in Via Margutta was described by Walter Crane as

. . . the most gorgeous studio of bric-a-brac of any. He loved splendour generally, but was a most kindly and genial host.

He later bought the Villa Narcissus on Capri where he painted, and died some 50 years later. His work is precise, detailed and has the glowing colours of the Pre-Raphaelites; it met with considerable success in Paris and London as well as in America.

William Gedney Bunce (1840–1916), known as 'Old Bunce' or 'The Bishop' also lived in Rome and visited Venice regularly to paint. He became a friend of Frank Duveneck and met many of the younger American artists in Duveneck's entourage. His paintings revolve around the theme of fishing boats, often at sunset, handled loosely and poetically. The critic Roger Cortissoz wrote that Bunce's

characteristic design was composed of a long, horizontal line

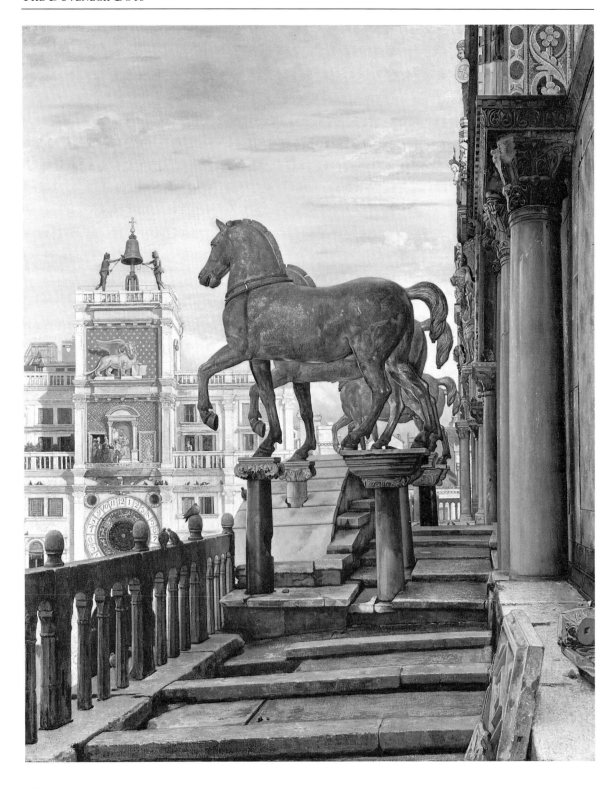

WILLIAM GEDNEY BUNCE

Early Morning, Venice
Oil on canvas, $12\frac{1}{2} \times 16\frac{1}{4}$in
(31.8×41.3cm)
Metropolitan Museum of Art,
New York

CHARLES CARYL COLEMAN

*The Bronze Horses of San
Marco* 1876 (opposite)
Oil on canvas, $40\frac{1}{4} \times 32\frac{1}{2}$in
(102.2×82.6cm)
Minneapolis Institute of Arts

separating a tremulous lagoon from a vibrating sky, with a campanile or two lifted into the air and a group of sailboats shrewdly placed to right or left in the foreground. Out of these few materials he fashioned the most amazing opalescent effects.

The major influx of American artists came in the late 1870s with the arrival of Frank Duveneck (1848–1919). He had made a short visit to Venice in 1873; he returned for nine months with William Merritt Chase in 1877, but finding it difficult to make any money in Venice, he moved to Munich where he established his own art school. This became popular with American art students and from 1879 Duveneck took his students, termed by Whistler 'The Duveneck Boys', to Venice, to paint during the summer months. One of the group, Otto Bacher, later recalled:

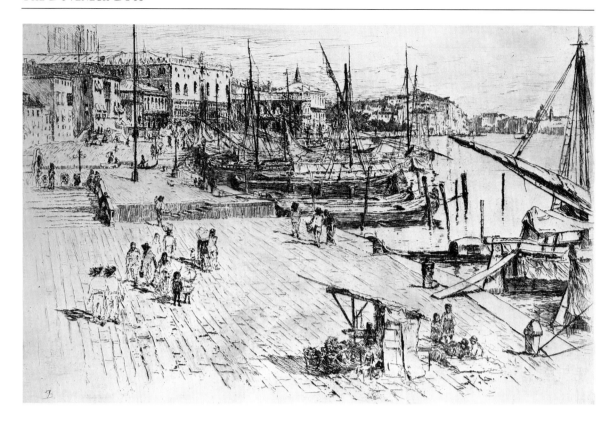

FRANK DUVENECK
The Riva
Etching
Museum of Fine Arts, Boston

We led the average student life, all working enthusiastically in a vast field of new subjects, some of which could be reached only in our own little boats, which also served us well for a frolic in the lagoons when the day's work was over. None of us was burdened with money . . . As a rule we dined 'down-town' as we called any place near St Mark's and preferably at the restaurant where we would find Duveneck.

They lived cheaply at the Casa Jankovitz where Whistler joined them. Duveneck's style was rooted in late-nineteenth-century realism; he painted the people of Venice in their everyday clothes as can be seen in his major oil *Water-Carriers of Venice* of 1884, painted on the Riva degli Schiavoni near the Casa Jankovitz. W.D. Howells explained that:

. . . water for drinking and cooking . . . is drawn from public cisterns in the squares, and carried by stout young girls to all houses. These 'bigolanti' all come from the mountains of Friuli . . . The cisterns are opened about eight o'clock in the morning, and then their day's work begins with chatter and splashing . . . The water is very good.

When the level fell too low contractors brought water in from Fusina, by boat, in large white tubs. This all ended, however, in 1884 when water was piped across from the mainland; Duveneck was thus recording the last of the *bigolanti*.

In addition to working in oil, Duveneck also produced etchings. He had been impressed by the etchings of Whistler and those of his own pupil, Otto Bacher, and during the period from 1879 to 1885, when he spent most summers in Venice, he produced some 30 etchings. They have deeper, richer blacks than Whistler's more ethereal works. In 1886 Duveneck married Elizabeth Boott, an American who had been brought up in Italy and had subsequently studied art in Paris. She was a friend of Henry James and appears as Pansy in *Portrait of a Lady*. A contemporary wrote that for Henry James, 'La cara Lisa became a link with Italy, an exquisite Italian memory. The quiet, gentle, lovable, cultivated, laborious lady.' She kept a sketchbook of the places she visited and the people she met who included the Brownings. Elizabeth died in Paris in 1888 and Frank Duveneck returned to Cincinnati, making only one further visit to Venice, in 1894.

FRANK DUVENECK

Canale Grande, Venezia 1885
Etching, 9 × 19½in
(22.9 × 49.5cm)
The Fine Arts Museum of San Francisco, Achenbach Foundation for Graphic Arts

Otto Bacher (1856–1909) first saw Venice in 1880 as one of Duveneck's students and soon met Whistler, who made use of Bacher's old wooden printing press that he had brought with him from Munich. Bacher was already an experienced etcher, although he was influenced by Whistler's fresh and unacademic approach to the medium. In all, about 40 of Bacher's Venetian etchings are known and he also produced some oils. He returned to Venice in 1882/3 and 1885/6, and in 1909 he published the autobiographical and very informative *With Whistler in Venice*.

Another of the Duveneck Boys was Robert Blum (1857–1903), who was born in Cincinnati, the son of German immigrants. Like Bacher, his first visit to Venice was in 1880, and he made regular trips back throughout the 1880s. Like Bacher again, his etching style was influenced by Whistler. Blum's work in Venice demonstrated his extreme sensitivity, but his output was small. Roger Cortissoz wrote in 1925:

No painter of Venice has surpassed Blum in the fragility of his impressions, in their delicacy of fibre, in their ravishing precision.

Blum's most important work is *Venetian Lacemakers* in which he emphasizes the beauty of the girls rather than stressing their social condition. It is executed in a highly accomplished oil technique despite the fact that he found the medium 'nasty', preferring the delicacy of watercolour and etching. Blum particularly like Venice in the winter, as he wrote in a letter of 1885:

OTTO BACHER

A Wet Evening in Venice
Etching and drypoint, 5 × 12in
(13 × 30.5cm)
The Fine Arts Museum of San
Francisco, Achenbach
Foundation for Graphic Arts

Lots of foggy effects now, don't have to draw in so damned much detail, just sort of blurr over the thing and there you are . . . We are seeing some pretty lively times here what with the cholera and the earthquake we had last night.

In fact, despite the 'lively times' Blum found the winters quite lonely:

ROBERT BLUM

Canal in Venice, San Trovaso Quarter
Oil on canvas, 34 × 23in
(86.4 × 58.4cm)
Smithsonian Institute,
Washington

Well I'm . . . pretty lonely now . . . and don't know what to do with my evenings . . . So after dinner at the Capellonero which I spin out as long as a cheap dinner can be, I saunter forth chewing a toothpick and ogle Raggazzi for a while up and down the Mercerie then for a cup of Capuchina at the Orientale and then home . . . I'm at work on a 'lace makers' picture but am hardly progressing with it.

The picture was finished in New York where it was exhibited in 1887 with great success, also being shown in the Royal Academy and in Paris. He painted a pendant *The Italian Bead Stringers* which was also well received by the public. Blum's work is notable for its extreme elegance and good taste and it is not surprising that he was attracted by Japanese art and welcomed the opportunity to visit Japan in 1889, being one of the first American artists to do so.

John Henry Twachtman (1853–1902), like Blum, was born of German parents in Cincinnati and studied under Frank

WILLIAM MERRITT CHASE

Gray Day on the Lagoon
Oil on canvas, 13 × 19in
(33 × 48.3cm)
Museum of Fine Arts, Boston

Duveneck at McMicken's School of Design. He was greatly impressed by Duveneck and in 1875 accompanied him to Munich, where he was influenced by the rich tonality of the Munich School. In 1877 he visited Venice with Duveneck and Chase, but at this stage Twachtman's paintings were dark and lacking in atmosphere. On his return to Venice in 1880 he was influenced by the elegant style of Whistler. As a result his brushwork became more fluid, his paint became thinner and was often applied to fine French linen; he absorbed the light and atmospheric effects of Venice. He returned only once more to Venice, in 1881, and his reputation rests upon his later work in the United States.

William Merritt Chase (1849–1916), on the other hand, returned as a mature artist to Venice in 1907, 1910 and 1913, often bringing students with him. In 1913 he stayed at the Hotel Monaco and Gran Canale and painted from the balacony with its magnificent view towards San Giorgio, the Dogana and the Salute. Although the titles of some 20 Venetian works by Chase are known, only about ten can be traced today, and most of these are comparitively small, intimate works.

Childe Hassam (1859–1935) also visited Venice briefly at this time. He made his first tour of Europe in 1883, arriving in Venice from Spain, but it seems that the city had less impact on him than other European cities, in particular Paris. He made a number of watercolours, and some years later illustrated an edition of Howells's *Venetian Life* in watercolour.

As a young man, William Graham (1832–1911) had taken part in the 1849 Gold Rush and had made some money. He visited Venice and Rome in the late 1860s, eventually settling in Venice around 1878, taking rooms near the Church of SS Giovanni e Paolo. He was a retiring and modest man, 'A dear Fellow, gentle as a child' (Whistler), and his quiet, tonally balanced oils reflect his character. He made little money, and lived in some poverty, but his work and company were appreciated by Whistler.

Joseph Pennell (1860–1926) with his wife Elizabeth was to devote much of his life to furthering the Whistler's cause and the art of etching. He had first seen Whistler's etchings at an exhibition of the *First Venice Set* at Pennsylvania Academy and in 1883 he was sent to Italy to work on etchings for W.D.

Howells's *Tuscan Cities*, to be published in *Century Magazine*. In June he arrived in Venice, and met Duveneck and Bunce, and in a letter to his future wife he recorded his first impressions:

Oh what an awful sell it is . . . and that beastly black hearse to get into – which rocks like a hammock (I hate hammocks) and smelly canals . . . and St Mark's all polished up and looking like a new town house . . . those were my first impressions of Venice . . . But one morning I woke up and it all came – lovely – lovely light and everything . . .

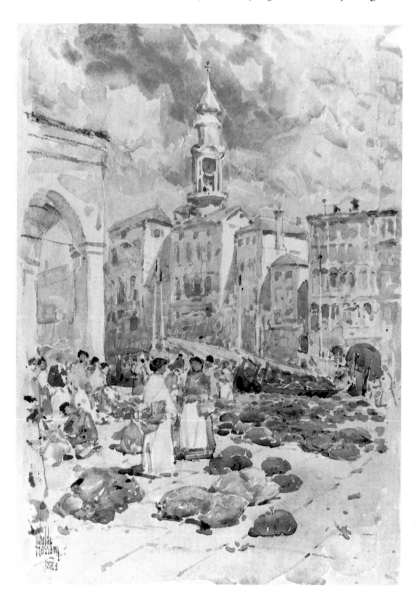

CHILDE HASSAM

The Rialto Market 1883
Watercolour, 14 × 9½in
(35.6cm × 24.1cm)
Mead Art Museum, Amherst
College, Massachusetts

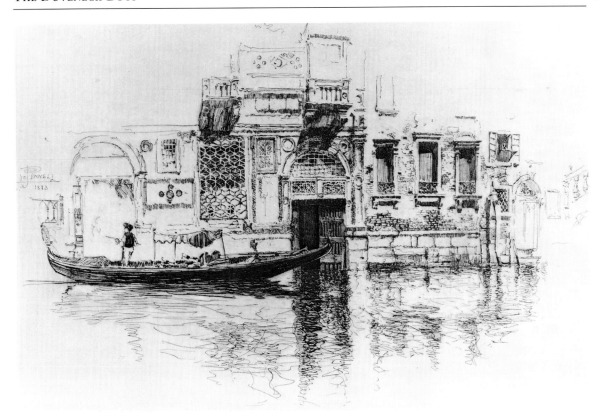

JOSEPH PENNELL

A Watergate in Venice 1883
Etching, 8 × 11⅝in
(20.3 × 29.5cm)
The Fine Arts Museum of San
Francisco, Achenbach
Foundation for Graphic Arts.

While in Venice he worked on illustrations for an article entitled *The Artist in Venice* by Julia Cartwright, published in *Portfolio* in 1884. In the same year he married Elizabeth and in 1885 they met Frank Duveneck again, during a tour of Europe for which their principal means of transport was a tandem bicycle. For nearly 30 years the Pennells lived in London, making trips to Italy and Venice, and producing etchings, books on etching, and illustrations for books, including Marion Crawford's *Gleanings from Venetian History* and Joseph Pennell's own *Venice. The City of the Sea*. Jointly they wrote a definitive life of Whistler, published in two volumes in 1908. In some respects Pennell never really escaped from Whistler's shadow and his etchings, drawings, pastels and lithographs all show the influence of 'The Master'.

Donald Shaw MacLaughlan (1876–1938) should also be mentioned as an etcher of Venice. He was Canadian by birth but grew up in Boston. He first saw Italy in 1899 and lived there for ten years prior to the First World War, visiting Venice each year

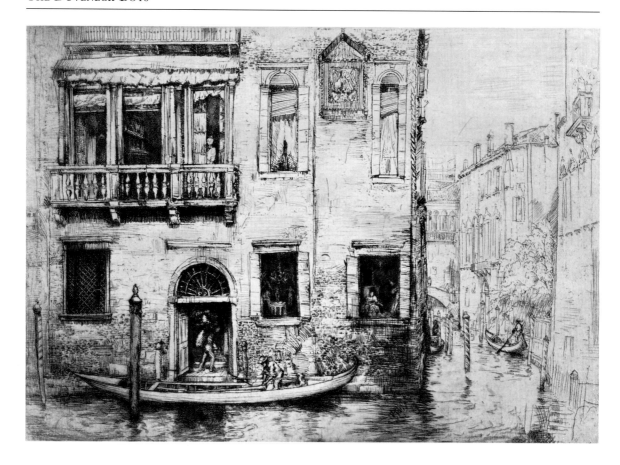

DONALD SHAW
MACLAUGHLAN

The Canal of the Little Saint
Etching, 8 × 11½in
(20.32 × 29.2cm)
The Fine Arts Museum of San
Francisco, Achenbach
Foundation for Graphic Arts

between 1908 and 1913. He owed much to Whistler, especially his practice of working on a copper plate on the spot, but in general his etched line is firmer and less broken than Whistler's and he made greater use of chiaroscuro.

'Venice is an inexhaustible mine of pictorial treasures for the artist and of dreamy remembrance to those who have been fortunate enough to visit it', wrote Thomas Moran (1837–1926) in a letter of 1888. He had been born in Lancashire, but aged seven, settled with his parents in Maryland. It was a very artistic family; his brothers were involved in painting, photography and print-making, and his own wife and children were also talented, the family sometimes being known as 'The Twelve Apostles'. In 1861 Moran visited England with his brother Edward, a painter, and was greatly impressed by the work of Turner. He possibly visited Venice in 1878 or 1879, but his first extended visit came in 1886 when he stayed at the Grand Hotel

on the Grand Canal for May and June, making preliminary sketches and watercolours which he he later worked up into larger oils. He returned to Venice in 1890, taking an elegantly carved gondola back to his house near East Hampton. Over the 40 years that Moran was associated with Venice he painted some 100 canvases, often large in scale, and all influenced by a Turneresque nostalgia. He rarely painted topographically accurate views, preferring to make composite panoramas of the city, often seen in a golden light from the Lagoon. His work was effective and became popular with the public who saw Moran as *the* American painter of Venice. In 1898 a Venetian scene by Moran was used for a calendar illustration and the publishers rightly estimated Moran's appeal by printing and selling millions of copies.

Another artist closely involved with Venice over a long period was Francis Hopkinson Smith (1835–1915), an engineer who had built the sea walls around Governor's Island and the pedestal for the Statue of Liberty. He was a self-taught artist who turned to watercolour around 1870, often using his work to illustrate the books he wrote, the most famous being *Gondola*

FRANCIS HOPKINSON SMITH
Venice, Canal Scene 11
Watercolour, 13 × 24¼in
(33 × 61.6cm)
Museum of Fine Arts, Boston

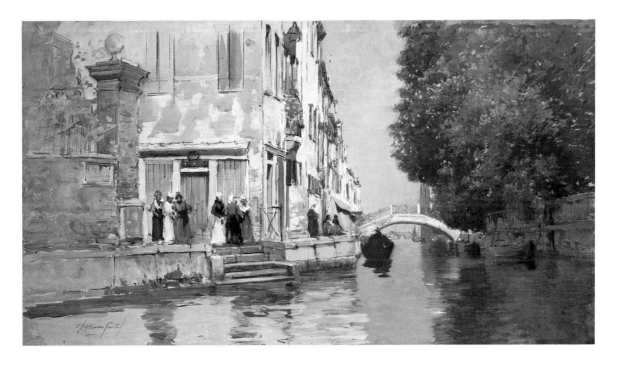

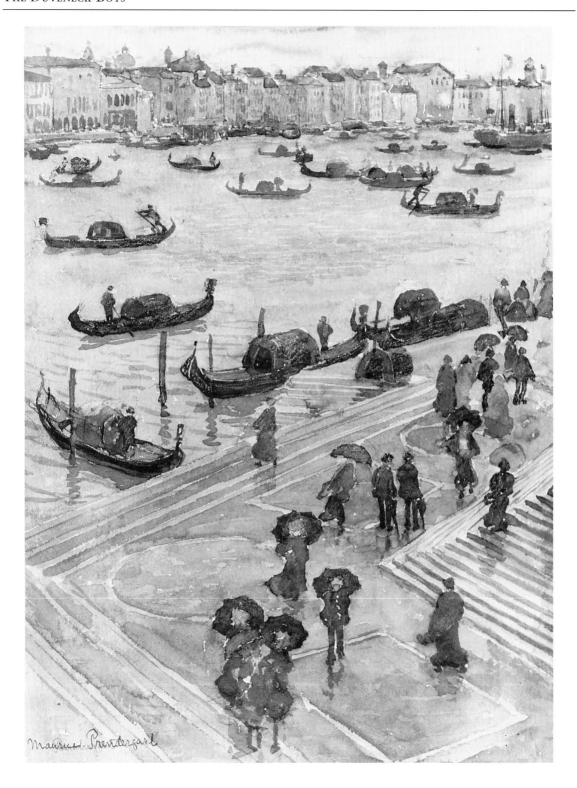

Days, which describes life in Venice in the 1890s. In the preface he wrote with a surprisingly modern attitude:

If I have given to Venice a prominent place among the cities of the earth it is because in this selfish, materialistic, money-getting age, it is a joy to live, if only for a day, where a song is more prized than a soldo; where the poorest pauper laughingly shares his scanty crust; where to be kind to a child is a habit, to be neglectful of old age a shame.

His watercolours are often on a large scale, but finely detailed and carefully executed. He avoided the main sights of Venice, preferring to paint quiet, back canals and, like Whistler, he enjoyed Venice's secret gardens. He used his gondola as a floating studio and he ensured that it was well provisioned with:

. . . the sketch trap, extra canvas, fresh siphon of seltzer, ice, fiasco of Chianti, Gorgonozola, all but the rolls which he [the gondolier] will get at the baker's on our way over to the Giudecca where I am to work on the sketch begun yesterday.

One of the most original painters of Venice was Maurice Prendergast (1859–1924) whose first visit to Italy lasted 18 months in 1898/9, when he stayed on the Giudecca with his brother Charles, and William Gedney Bunce:

It has been the visit of my life. I have been here almost one year and have seen so many beautiful things . . .

He studied Venetian painting and discovered the work of Carpaccio, 'It makes me ashamed of my own work when I see such glories'. During this first stay Prendergast produced a series of watercolours which are strikingly original both in technique and composition. *Piazza San Marco* is extraordinary for its unusual viewpoint combined with vivid touches of colour and a loose handling of watercolour, but whilst appearing to have been spontaneously executed, it was obviously well planned and conceived. In some watercolours Prendergast chose a viewpoint just a few feet higher than the crowd, while in others he painted people slightly higher than himself as they crossed one of Venice's many bridges. He loved the bustle of Venice – tourists crossing the Ponte della Paglia or Rialto, a mass of umbrellas springing up as the rain begins to fall, or a *festa* in the Piazza. He created interesting and unusual patterns with everyday elements

MAURICE PRENDERGAST

Rainy Day, Venice
Watercolour, $16\frac{1}{2} \times 12\frac{1}{2}$in
(41.9×31.8cm)
Wichita Art Museum, Kansas.

– steps, patterned pavements, people and umbrellas, and not only was his composition experimental but so was his technique, especially his use of monotypes or one-off prints taken from oils painted onto copper plates. During this stay he was taken ill and spent two months in the Venice Cosmopolitan Hospital.

Prendergast returned to Venice again with his brother, in September 1911, taking rooms at the Casa Frollo on the Zattere (where Walter Tyndale often stayed) but the results of this trip, which lasted until 1912, are less interesting. He produced less work, possibly because of poor health, and the watercolours of this second visit lack the vibrancy and vivacity of the earlier work. Another regular visitor to Venice during this period was William S. Horton (1865–1936) who had studied in Paris in the 1890s when he had met Monet. He first saw Venice in 1906, returning in 1910, 1913, 1920, 1921, 1922 and 1928. He produced many Venetian paintings, of which the critic Louis Vauxcelles wrote:

The Venetian scenes, the real property of Horton, are different from those of the masters of yesterday and today.

Many American artists came to love Venice, and as they returned across the Atalantic to a country developing its industry and cities faster than any other in the world, they may well have read W.D. Howells's own reflections upon leaving his post as American Consul in Venice:

She was . . . a phantom of the past, haunting our modern world – serene, inexpressibly beautiful, yet inscrutably and unspeakably sad.

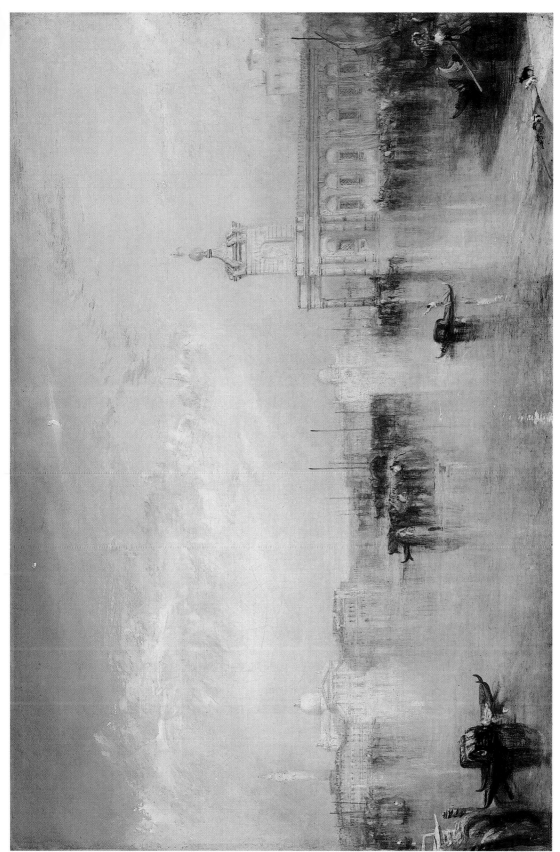

JOSEPH MALLORD WILLIAM TURNER, *The Dogano, San Giorgio, Citella, from the Steps of the Europa* (RA 1842)
Oil on canvas, 24½ × 36½in (62.2 × 92.7cm). Tate Gallery, London

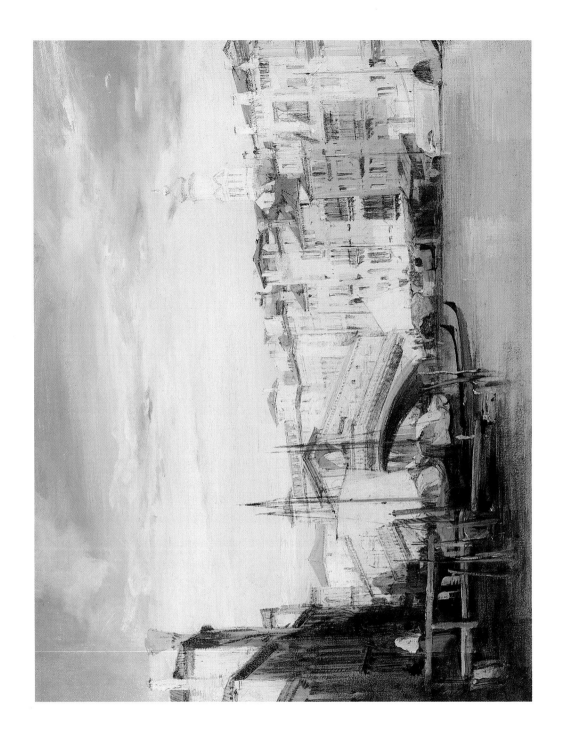

RICHARD PARKES
BONINGTON
The Grand Canal looking
towards the Rialto
Oil on millboard, 10½ ×
12½in (26.7 × 31.8cm)
Photograph courtesy of the
Fine Art Society

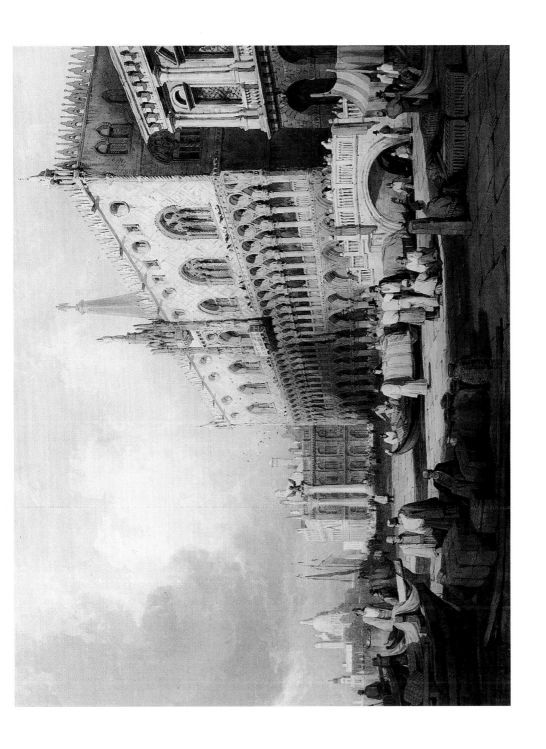

SAMUEL PROUT
*The Doge's Palace and the
Grand Canal*
Watercolour, 17 × 22¼in
(43.2 × 56.6cm)
The Royal Watercolour
Society, London

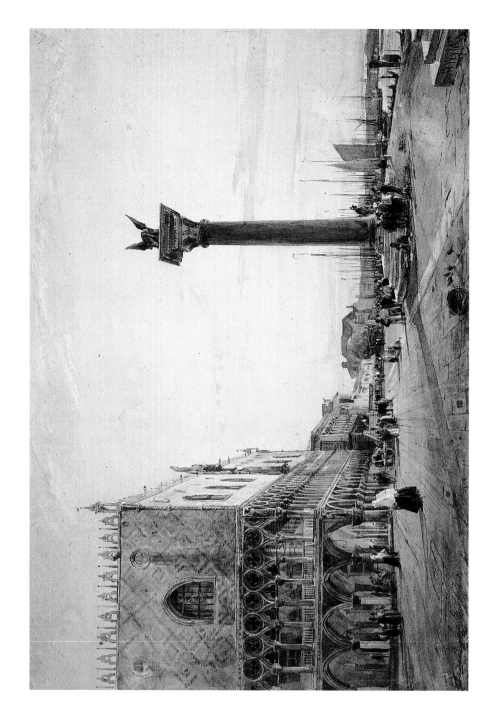

WILLIAM WYLD
The Doge's Palace,
Venice, 1833
Watercolour, 11½ × 16¾in
(29.2 × 42.6cm)
Whitworth Art Gallery,
University of Manchester

(Below) JAMES DUFFIELD
HARDING

The Grand Canal
Watercolour and bodycolour,
30½ × 41¾in (77.5 × 106.1cm)
Yale Center for British Art,
Paul Mellon Collection

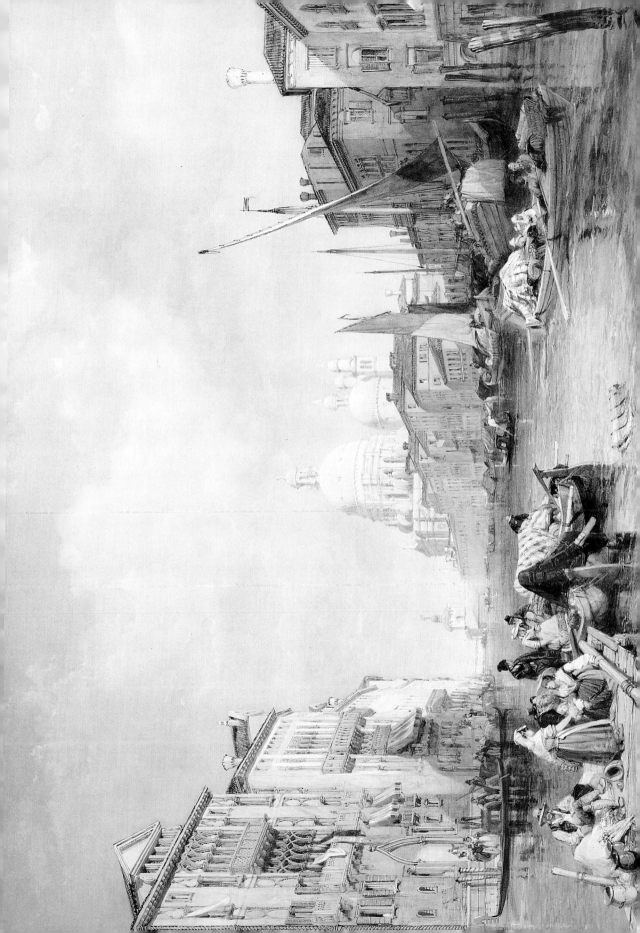

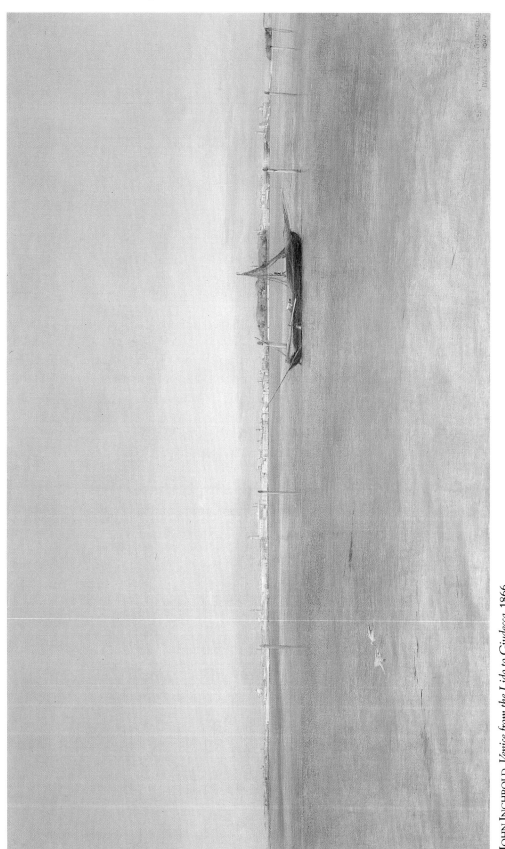

JOHN INCHBOLD, *Venice from the Lido to Giudecca*, 1866
Oil on canvas, 20 × 34in (50.8 × 86.4cm). Private collection

(Below) ALBERT GOODWIN, *Venice from the Riva degli Schiavoni, Sunset*
Watercolour, 9¼ × 13¼in (23.5 × 33.7cm). Photograph courtesy of Chris Beetles Ltd

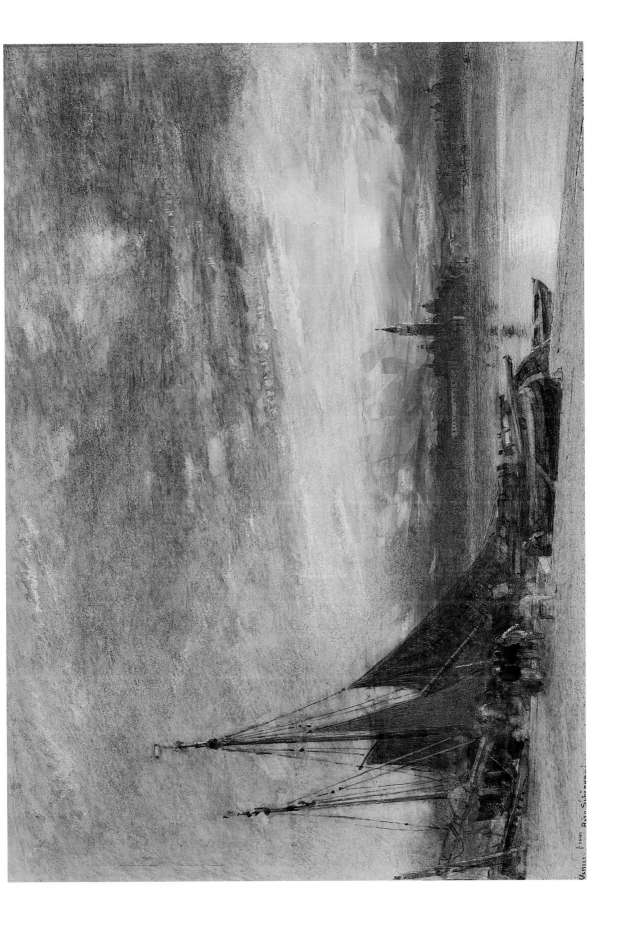

Venice from Riva Schiavoni

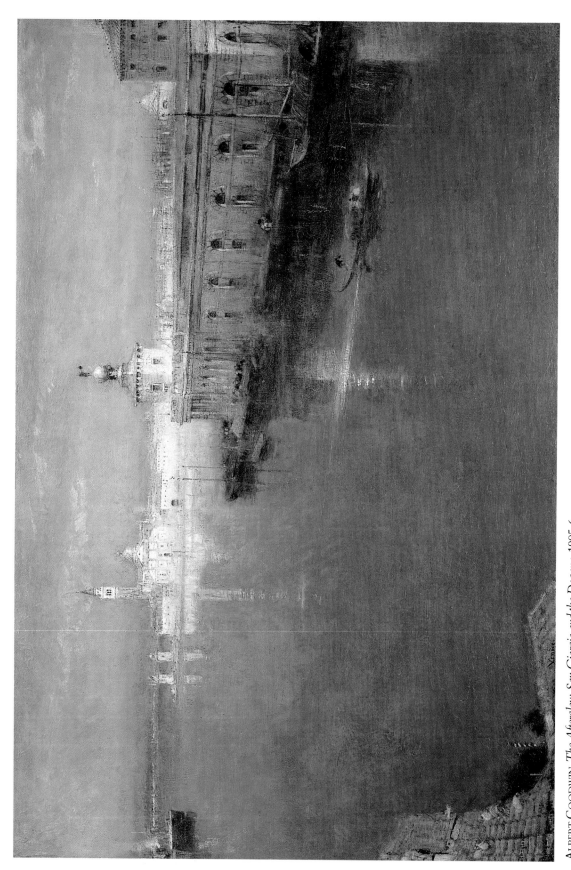

ALBERT GOODWIN, *The Afterglow, San Giorgio and the Dogana*, 1905-6
Oil on board, 23½ × 35in (59.7 × 63.5cm). Photograph courtesy of Chris Beetles Ltd

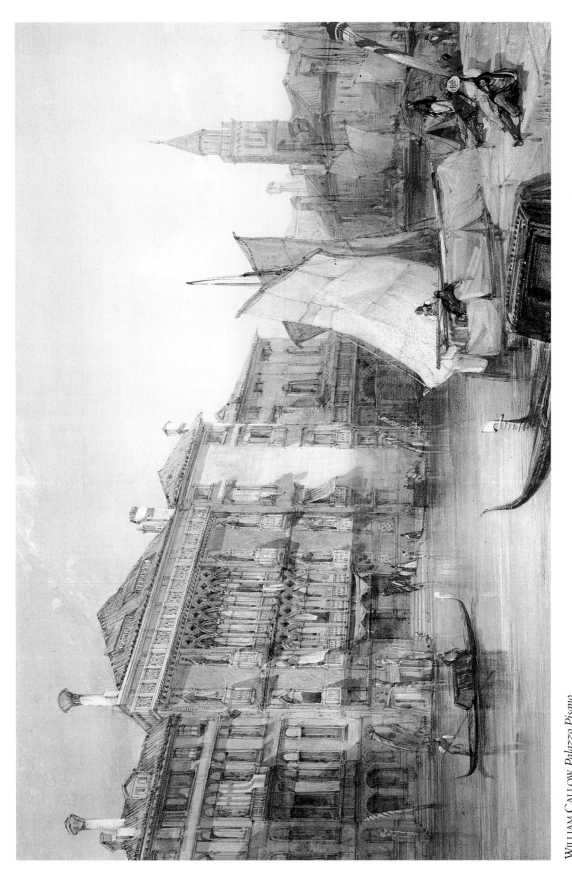

WILLIAM CALLOW, *Palazzo Pisano*
Watercolour, 12¼ × 18½in (31.1 × 47cm). Photograph courtesy of Thomas Agnew and Sons

WILLIAM CALLOW, *The Piazzetta from St Mark's*, 1877
Watercolour, 13 × 18¾in (33 × 47.6cm). Birmingham Museums and Art Galley

JAMES HOLLAND, *A Venetian Backwater*, 1846
Watercolour, 10¼ × 16¼in (26 × 41.3cm). Photograph courtesy of P. and D. Colnaghi and Co.

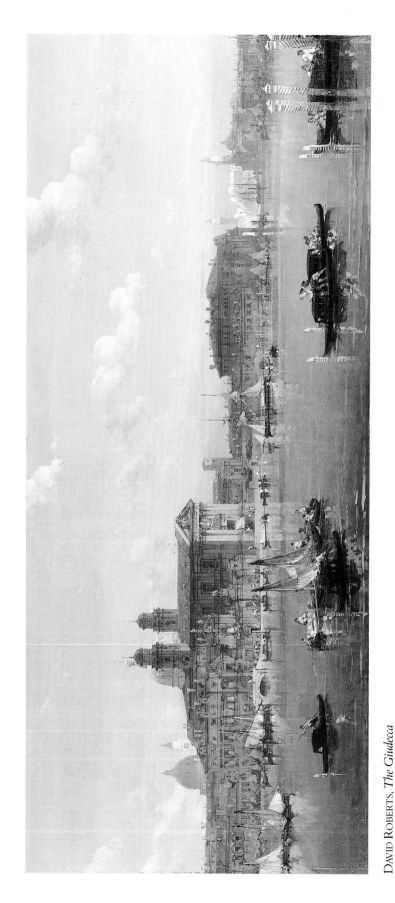

David Roberts, *The Giudecca*
Oil on canvas, 22 × 51in (55.9 × 129.5cm). Yale Center for British Art, Paul Mellon Collection

(Below) Frederick Walker, *The Gondola*
Watercolour and bodycolour, 12¼ × 17in (31.1 × 43.2cm). Birmingham Museums and Art Gallery

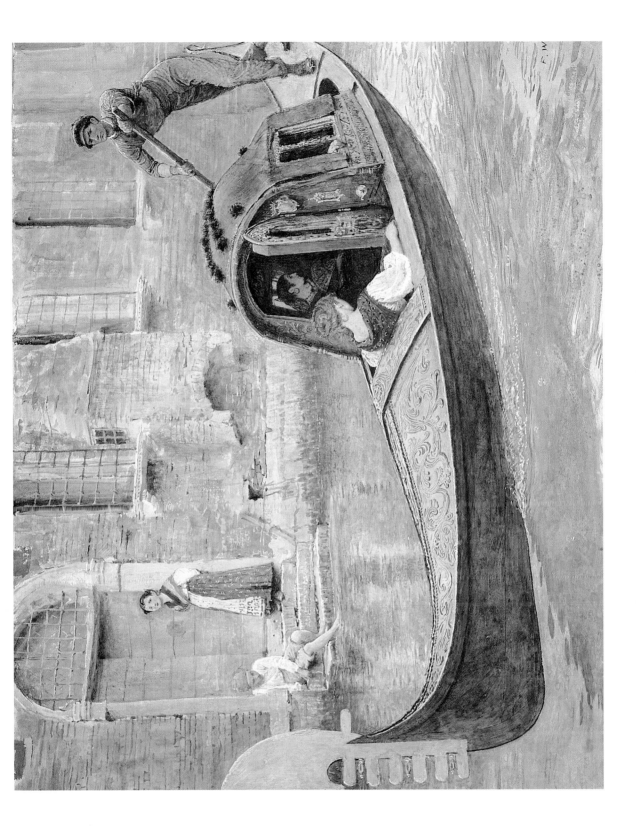

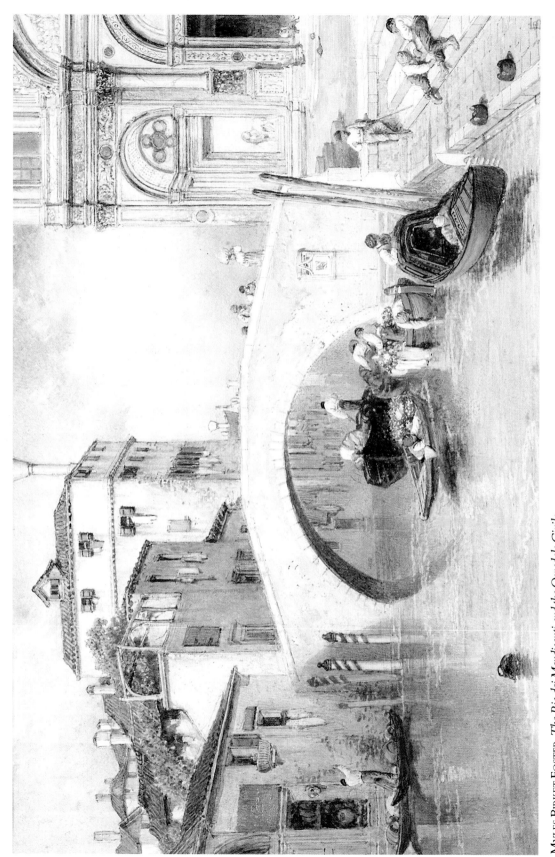

MYLES BIRKET FOSTER, *The Rio dei Mendicanti and the Ospedale Civile*
Watercolour and bodycolour, 7¾ × 11¾ (19.7 × 29.9cm). Photograph courtesy of Sotheby's, London

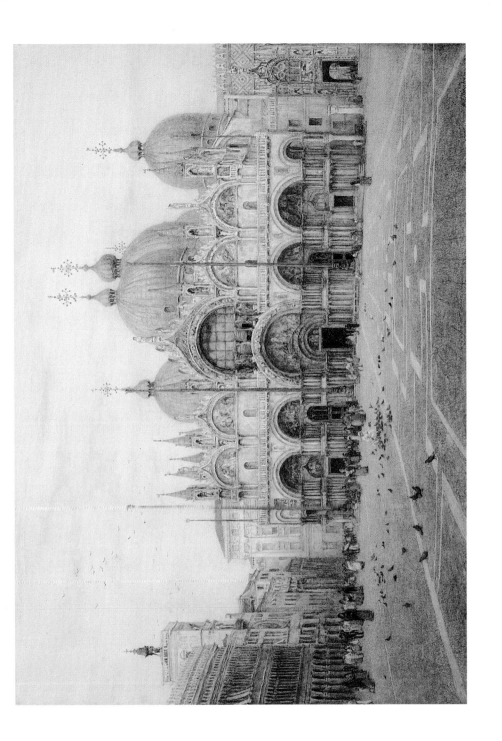

HELEN ALLINGHAM
St Mark's from the Piazza
Watercolour, 15 × 21in
(38.1 × 53.3cm)
Private collection

(*Overleaf*) JAMES MCNEILL WHISTLER, *Nocturne in Blue and Silver: The lagoon, Venice*, 1880
Oil on canvas, 20 × 25¾in (50.8 × 65.4cm). Museum of Fine Arts, Boston

7 'Fontaine de Jouvence'

John Singer Sargent and his circle at the Palazzo Barbaro

To John Singer Sargent Venice was a spiritual home, a place to escape from the pressures of painting portraits or, as he called them, 'mug shots', and from the persistent and exacting demands of his clients. His relationship with the city spanned more than four decades from his first visit in the early 1870s to his last in 1913, and over this period he became a popular figure in the American, British and Italian circles within Venetian society. Here Sargent was able to paint what and how he liked, and the results are amongst the freshest and most stimulating of his pictures.

Sargent's parents were American expatriates who lived a peripatetic life in Europe; his father had trained as a doctor but had been persuaded by his wife to abandon medicine and live off her modest income, moving around Europe on a protracted Grand Tour. Sargent was born in Florence in 1856 and studied art briefly in Florence and Rome, but in 1874 the family moved to Paris so that their son could study under Carolus Duran. Success soon followed and in 1878 Sargent exhibited for the first time at the Paris Salon.

There remains some doubt as to the date of Sargent's first visit to Venice. It seems likely that the family visited the city in 1870 and again in 1874, but both visits were brief. His first protracted stay came in September 1880 when the family moved into the Hotel d'Italie, now the Bauer-Grünwald, near the extravagant baroque church of San Moisè. Sargent's sister, Emily, wrote to Vernon Lee:

He expects to remain on here indefinitely, as long as he finds he can work with advantage, and has taken a studio in the Palazzo Rezzonico, Canal Grande, an immense house where several artists are installed, and where one of his Paris friends has also taken a room to work in.

The Paris friend was Ramon Subercaseaux, the Chilean consul in Paris and an amateur painter. Another artist installed in the Rezzonico in 1880 was the Italian Giovanni Boldini, and although Sargent was not initially influenced by Boldini's bravura, it seems certain that his dashing images of Venice were impressed on Sargent's visual memory. After his parents had left, Sargent took lodgings at 290 Piazza San Marco, by the Clock Tower, remaining in Venice until the spring of 1881.

In 1882 Sargent returned, staying this time at the Palazzo Barbaro, the newly acquired home of Mr and Mrs Daniel Sargent Curtis who were related to the Sargents. The Palazzo Barbaro, which is still owned by the Curtis family, is situated on the Grand Canal near the Accademia Bridge. It comprises a Gothic building with seventeenth-century additions, and in 1882 the Curtis family bought the two upper floors. Sargent was particularly close to their son Ralph, who had been a fellow art student in Paris and who was to remain a lifelong friend. Another friend at this time was Edward Darley Boit (1840–1916), who first visited Venice in 1867 when he stayed at the Hotel Europa. He was interested in art and took up water-colours in 1871, often painting Venetian views. He did much to promote Sargent and one of Sargent's most enchanting portraits is of Boit's four daughters, painted later in Paris.

During these two visits to Venice, between 1880 and 1882, Sargent created some of the most successful and original works of his career. Their main theme is of working Venetian girls seen in the cool light of shuttered interiors. The heat outside suggested by subtle rays of light; the tonal values inside are brilliantly orchestrated. There is nothing romantic about these pictures. The girls engaged in boring and reptitive work such as stringing beads or working with glass have no contact with the world of sightseeing and grand hotels beyond the shuttered windows, and in their emphasis upon the ordinary people of Venice, the pictures relate to the Realist Movement. Henry

James wrote about one of these canvases in *Harper's New Monthly Magazine* in October 1887:

. . . a pure gem, a small picture . . . representing a small group of Venetian girls of the lower class sitting in gossip together one summer's day in the big, dim hall of a shabby old palazzo. The shutters let in a clink of light; the scagliola pavement gleams faintly in it, the whole place is bathed in a kind of transparent shade; the tone of the picture is dark and cool . . . The figures are extraordinarily natural and vivid . . . the whole thing free from that element of humbug which has ever attended most attempts to reproduce the Italian picturesque.

Venetian Interior was considered by Sargent to be the best work of his career, with its virtuoso play of light and subtle and monochromatic tones. Gigia Viani, Sargent's favourite Venetian model is amongst the group. Sargent was influenced by Whistler not only in his searching out of untypical and unromantic aspects of Venice, but also in his thin and elegant handling of oil, as well as his restrained palette. Evan Charteris, Sargent's biographer and friend, recalled that:

Sargent used to say that Whistler's use of paint was so exquisite that if a piece of canvas were cut out of one of his pictures one would find it was in itself a thing of beauty by the very texture and substance into which it had been transformed by his brush.

During this period Sargent did not paint the obvious views. The Piazza and the Molo held no appeal for him; instead he painted the lesser known *campi* and *calli*, with girls by a well drawing water or chatting to young men in a doorway. These are mostly executed in oil, but a number of watercolours from this period also exist.

Watercolour was to become Sargent's main medium on later trips to Venice, as it enabled him to capture the sparkling light and movement with spontaneity and verve. He settled in London in 1884 where he became the leading portrait-painter of his day, but this, as his friend Jacques-Emile Blanche recalled, had its problems:

Hardly ever could he paint what he himself desired except when he rushed off to Italy, to Spain, or to the Tyrol to do watercolours – yet

he was like a surgeon who leaves his cases accumulating against his return. There were sitters awaiting him in London, there were tiresome portraits and ceremonies which a Royal Academician cannot avoid.

To escape from these pressures Sargent would retreat to the Palazzo Barbaro which he described in 1898:

The Barbaro is a sort of Fontaine de Jouvence, for it sends one back twenty years, besides making the present seem remarkably all right.

Life in the Barbaro is recorded in Sargent's famous group portrait *An Interior in Venice* which Blanche has described in detail:

JOHN SINGER SARGENT

An Interior in Venice, 1899
Oil on canvas, $25\frac{1}{2} \times 31\frac{3}{4}$in
(64.8 × 80.7cm)
Royal Academy of Arts,
London

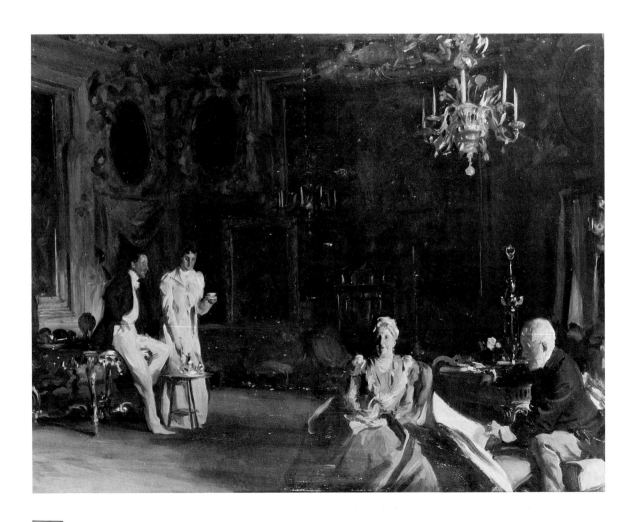

Sargent had painted a family group of the leaders in the American Colony at Venice with whom he stayed each autumn; this was a thanks-offering . . . His two old friends sat in their armchairs; they had just celebrated their golden wedding and would never again leave the scene of their voluntary exile – they were far from sky-scrapers, motor-horns, far from Progress.

Ralph Curtis and his youthful wife, belonging to the young and brisk Riviera-born generation, always ready for a cruise to India and Japan, in the picture stand in the background of the *sala*. They have their flat in Paris, a villa near Monte Carlo and another at Deauville. Ralph appears to be examining the crease of his trousers, his wife the cut of her Redfern skirt, before going to the Lido. I think that this picture grips one more than any other he ever painted because in depicting these good people, he has shown a *milieu* in which he felt himself at home. He always went there to refresh his spirit when he was not tied to London by Chicago millionaires who went to have their portraits painted.

The Curtis family actually disliked the picture and would not buy it; Sargent later used it as his Diploma picture for the Royal Academy. Mrs Curtis believed that the portrait made her look too old, and found Ralph's nonchalant attitude inconsistent with the deportment observed in the Palazzo Barbaro. Henry James was a regular visitor to the Palazzo and in a letter to his sister dated 6 June 1890 wrote:

Venice continues adorable and the Curtises the soul of benevolence. Their upstairs apartment (empty and still unoffered – at fourty pounds a year – to any one but me) beckons me so . . . The great charm of such an idea is having, in Italy, a little cheap and private refuge independent of hotels etc, which every year grow more disagreeable and German, and tiresome to face – not to say dear.

Sargent was also relieved not to have to share hotels with 'the swarms of larky smart Londoners whose goings on fill the *Gazette*'.

Another meeting place for Anglo-American society was the Casa Alvisi, near the Hotel Europa on the Grand Canal. This was the home of Mrs Arthur Bronson, an American who had made Venice her home since the 1860s. Henry James, Ralph

Curtis and Sargent were regular visitors to the Bronson household and their daughter Edith, who later married Count Rucellai and settled in Florence, was, according to Robert Browning:

. . . the best Cicerone in the world; she knows everything and teaches me all she knows. There never was such a guide.

Robert Browning and his sister were favourite guests, as was Browning's son 'Pen', and Mrs Bronson made rooms available for them in the nearby Palazzo Giustiniani. In 1887 'Pen' – Robert Barrett Browning – who was an amateur sculptor, married a Miss Coddington from New York and spent their honeymoon in Venice. In the following year he bought the Palazzo Rezzonico which he proceeded to restore, keeping the upper rooms as a memory to his mother Elizabeth Barrett Browning. The restoration impressed Henry James, 'What Pen Browning has done here . . . with the splended Palazzo Rezzonico transcends description for beatuty'. It was here in 1889 that Robert Browning died and a commemorative plaque was erected on the façade by the City of Venice.

The Palazzo Dario, a beautiful, early Venetian Renaissance gem on the Grand Canal, opposite the Palazzo Barbaro, was also a rendezvous for artists and writers. Rawdon Brown had bought the palace in 1838, but had nearly bankrupted himself restoring it, and had been forced to sell it in 1842. Now two ladies at the centre of Venetian society lived there – the Comtesse de Baume and Madame Bulteau. Their regular *conversazioni* were attended by Sargent, Sickert, Vernon Lee, and the poet Comtesse Anna de Noailles, in addition to the resident artists like the Montalba sisters and Henry Woods. Sargent's charm, wit and modesty (despite his international fame), made him a popular guest in Venetian society.

'To live with Sargent's water-colours is to live with sunshine captured and held', was how Evan Charteris summed up the extraordinary vitality and luminosity of Sargent's work. Yet, while dazzling our eyes with light and reflections, Sargent succinctly and accurately sums up the architectural setting. He painted the Salute many times, often from a low viewpoint as seen from the gondola in which he worked; and usually painted just a detail of the façade rather than attempting broader, more

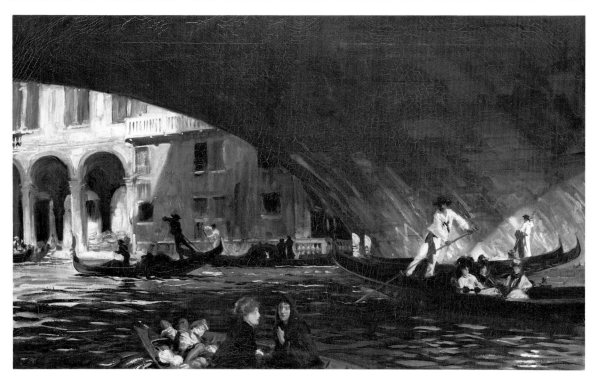

JOHN SINGER SARGENT

The Rialto 1911

Oil on canvas, 22 × 36in

(55.9 × 91.4cm)

Philadelphia Museum of Art

conventional views. He sums up the complex architecture of Longhena's façade with masterly assurance, combined with deceptive ease. Other subjects which caught his attention in Venice include the hulls of moored boats and their complex reflections in the water, the white façades of the Venetian baroque buildings, gondoliers working through shaded canals, and tourists strolling down the Riva. During his early visits to Venice in the early 1880s, Sargent had painted a number of comparatively tight watercolours and it is possible, as has been suggested, that his technique loosened up after meeting Hercules Brabazon Brabazon around 1887. However, his most brilliant work in watercolour came later, after 1900. It is more likely that his friendship with Arthur Melville, one of Sargent's few equals in the medium, opened his eyes to the potential of freely applied watercolour. He worked on damp paper, quickly running in colour washes and then adding Chinese White as he worked up his details. While leaving bare paper or thin washes in some areas, in others he added highlights of Chinese White, sometimes mixed with pigment, to give opaque colour. Sargent liked to work in the open air, often seated under a canopy in a

gondola, and he liked the strong midday sun, rather than morning or evening effects. The watercolours were painted for pleasure and it was only with difficulty that he was persuaded to sell. Nevertheless, American collectors did begin to buy and in 1909 Knoedler held an exhibition of watercolours in New York, an exhibition shared with old friend Edward Darley Boit. The Brooklyn Museum, whose President was an enthusiastic admirer of Sargent, bought 80 out of the 86 watercolours on offer, and in 1912 the Museum of Fine Art in Boston bought a group of 45. Other American museums followed suit, including the Metropolitan and Worcester. Sargent painted watercolours

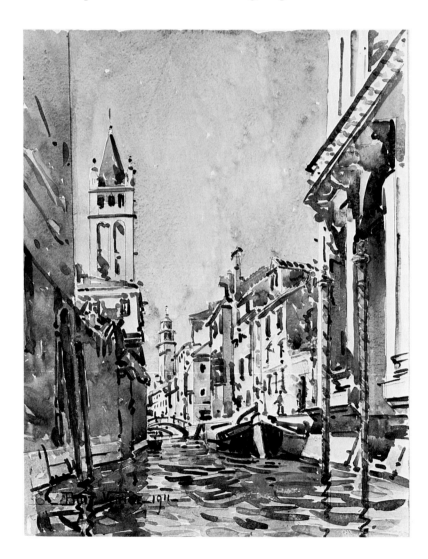

EDWARD DARLEY BOIT

Rio di San Barnaba
Watercolour, 19 × 14in
(48.3 × 35.6cm). Museum
of Fine Arts, Boston

for himself and they provide an insight into a personality which his portraits, however accomplished, often fail to reveal.

Bliss for Sargent was working in a gondola in Venice; but even greater happiness resulted from being there with friends. One of his closest friends was Wilfrid de Glehn (1870–1951) who was born in London of Estonian parents. In 1904 de Glehn married an American, Jane Emmet, who had worked with Sargent on the Boston Public Library decorations. Between 1904 and 1914 the de Glehns accompanied Sargent and his sister Emily on many painting holidays in Spain, Corfu, the Alps and Venice. De Glehn's Venetian watercolours owed much to Sargent, in their rendering of the sparkle of Venetian light; his wife Jane also painted Venice in watercolour, and in 1913 they

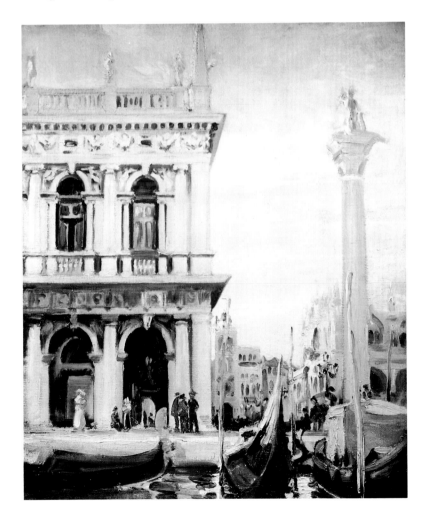

WILFRID DE GLEHN

The Piazzetta
Oil on canvas, 30 × 25in
(76.2 × 63.5cm)
Photograph courtesy of David
Messum Fine Paintings,
London

WALTER GAY

Interior of Palazzo Barbaro
Oil on canvas, $35\frac{1}{2} \times 39\frac{1}{2}$in
(90.2 × 100.3cm)
Museum of Fine Arts, Boston

held a joint exhibition at the Fine Art Society. Both Sargent and de Glehn also painted Venice in oil, although today the watercolours are better known. Walter Gay (1856–1937) was also to be seen in this company. Born in Massachusetts, he had settled in Paris, having studied there under Bonnat, where he painted in an Impressionistic style. He became a close friend of Ralph Curtis, and in 1902 painted the interior of the Palazzo Barbaro. The etcher Donald MacLaughlan and his wife, the artists Adrian and Marianne Stokes, Edward Boit, Eliza Wedgwood, Ralph Curtis and the minor portrait-painter Lawrence Harrison and his wife, who were London neighbours of the de Glehns, made up the circle of close friends amongst whom Sargent felt truly at ease.

The First World War was to end this idyll; Sargent's last visit to Venice was in 1913, he died in 1925; and although Anglo-American society was to reassemble in Venice after the First World War, this happy and creative group centred on the Palazzo Barbaro was never to reunite in Venice.

8 A golden age

Sickert and his Contemporaries in Venice 1880–1939

The period between 1890 and the outbreak of the First World War in 1914 marked a 'golden age' for modern Venice; the poverty of the earlier part of the century had been alleviated by tourism, and the revival of many of the older crafts such as bead making and stringing, glass working and lace making; new hotels were opening and the Lido had become internationally smart, with sumptuous hotels such as the Excelsior and the Grand Hotel des Bains. Venice had become chic and was visited not only by writers and composers but increasingly by leading society figures such as the Astors, the Desboroughs and Lady Ottoline Morell, who could be seen bathing on the Lido or strolling in the Piazza. The establishment in 1895 of the International Exhibition, soon to be called the Biennale, brought prestige and visiting dignitaries to Venice, which became one of the leading centres for contemporary art, albeit often rather conservative in taste. It was to be, however, a transient elegence arising out of the decay of the early nineteenth century and descending into mass tourism in the late twentieth century.

In May 1895, Walter Richard Sickert (1860–1942) and his wife arrived in Venice and took rooms at 778 Zattere near the Gesuati Church. For the next 15 years Sickert was to paint Venice, sometimes in Venice, sometimes in London and at other times in Dieppe. He was largely impervious to the sparkling Venetian light and colour, and many of the views he chose were either of little-known quarters of Venice or well known landmarks seen from an unusual point of view. Despite his

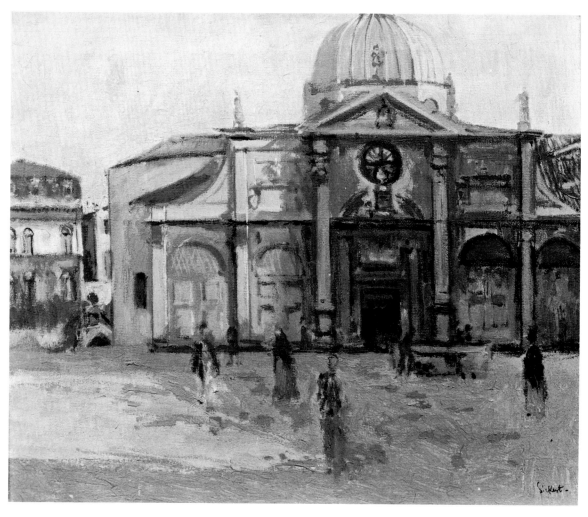

WALTER RICHARD SICKERT

Santa Maria Formosa
Oil on canvas, 19 × 22in
(48.3 × 55.9cm)
Photograph courtesy of
Thomas Agnew and Sons

original and refreshing approach to Venice, his pictures have had a considerable influence on many twentieth-century British painters in Venice, an influence which can be perceived even today.

Sickert's background gives a clue to his fresh approach to Venice. He was one of the most cosmopolitan of British artists; born in Munich, the son of a Danish artist, he was brought up in London, but in 1885, after his marriage, he settled in Dieppe which was to become a second home until the 1920s. His French was excellent and while in Venice he acquired good Italian. Sickert had no formal art training, having spent only a short period at the Slade before joining Whistler as a pupil in 1881.

'The Master' practised unorthodox teaching methods and his other pupil at the time, Mortimer Menpes, complained that they worked on menial tasks such as preparing copper plates for etching.

Whistler was working on his Venetian etchings when Sickert joined his studio and his first encounter with Venice was through the vivacious and no doubt exaggerated reminiscences of 'The Master'. Whistler introduced Sickert to Degas thus establishing a relationship that was to last for many years and have a direct influence upon Sickert's paintings and attitude towards art. Sickert had always loved the theatre and for a time toyed with the idea of making the stage his career. During the later 1880s Sickert concentrated upon music-hall scenes where the duality of his complex character could thrive; in society suave, charming, handsome, erudite and extremely witty, but equally at home in the streets of London and the noisy smoke-filled vulgarity of the gaiety halls. He sometimes walked home to Hampstead at night after an evening in the East End, and it tickled his theatrical ego that girls mistook him, armed with his colour box, for Jack the Ripper. Thus Sickert came to Venice from a very different background from most British artists, and this is reflected in his Venetian work.

Why Sickert chose to visit Venice in 1895 is unknown, but his marriage was failing and he hoped a trip abroad might save it. He was also, no doubt, curious to see the city where Whistler had achieved so much, and he probably needed to satisfy his *wanderlust* which made it difficult for him to stay in any one place for very long. How long he stayed in Venice on this occasion is not clear; his friend and biographer Robert Emmons, writing in 1941, suggested that he stayed a few months, but more recent writers, including Wendy Baron, believe that he stayed for nearly a year, until May 1896, with possibly a break in London during the winter. His wife left him in February 1896 and they met up in Fluellen on Lake Lucerne in May, but the marriage was irreparable and broke up in September of that year.

Venice suited Sickert well as he wrote to his friend Wilson Steer:

Venice is really first-rate for work. A friend has lent us a 'very nice flat'

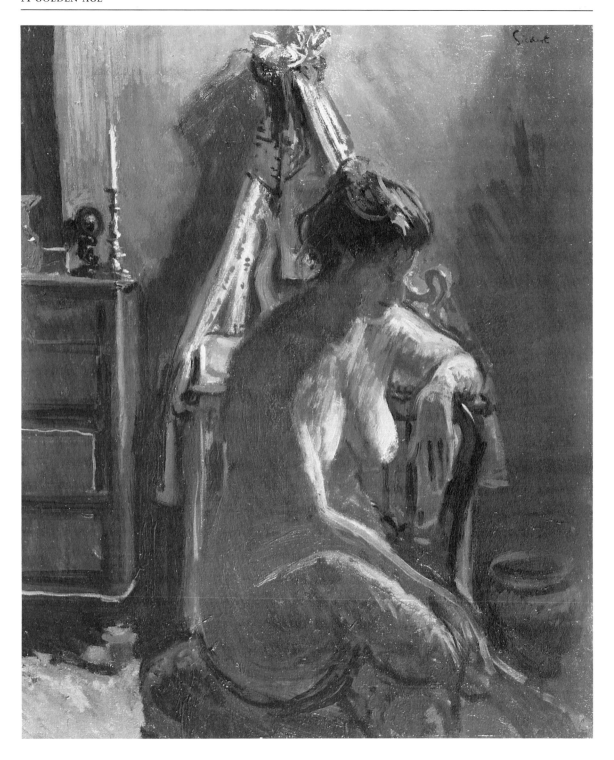

as George Moore would say . . . with a south aspect over the Zattere, next door to the Montalbas. Good food, good wine, good cook (nearly sat on a *scorpion* in the w.c. Thought of you at once: of what you would say)

The friend was Miss Leigh-Smith, and the Montalbas, who lived nearby in the delightful Campo Sant'Agnese, made excellent neighbours. Old Mrs Montalba had four daughters, Clara, Ellen, Hilda and Henrietta and a son, Augustus. Clara Montalba (1842–1929), was born in England, was an accomplished watercolourist and oil painter and was already a member of the Royal Watercolour Society when Sickert first met her. Both Ellen and Hilda painted, mainly Venetian views, while Henrietta was a sculptress. Augustus dabbled in art, but was above all an excellent cook. Henry Woods recalled Sundays spent at the Montalbas' beach hut on the Lido enjoying lunch prepared in the hut by Augustus.

Early in 1896 Sickert moved to 940 Calle dei Frati – a building which still stands between the Rio San Trovaso and the Zattere – and this was to be his home on subsequent trips. It lies in a quiet part of Venice, even today largely untouched by tourists, but at that time a popular area for artists. The ground floor was a bar and Sickert's room was at the top of the building; a simple room with a wooden bed and a washstand which had a canopy decorated with pink ribbons. The room and its furnishings, including a framed map of Venice, features in many paintings. Unlike many artists who simply painted the views, Sickert took an interest in Venetian art and architecture and did not share Ruskin's dislike of the Renaissance:

St Marks is engrossing and the Ducal Palace and 2 or 3 Renaissance gems, the Miracoli and San Zaccharia and the Scuola di San Marco.

On his return to London in the autumn of 1896 Sickert continued to paint Venetian pictures based on drawings and photographs. Only one painting of the 1895 to 1896 visit is dated; he did paint a number of large studies of the façade of St Mark's in 1896 and 1897, but it is often difficult to date Sickert's Venetian pictures. These years were not happy for him, with the break-up of his marriage and financial instability and in 1898 he left London for Dieppe where he was to be based for the next seven years. His second visit to Venice was during the summer

WALTER RICHARD SICKERT
The Beribboned Washstand
Oil on canvas, $22\frac{1}{2} \times 17\frac{1}{2}$in
(57.2×44.5cm)
Photograph courtesy of
Thomas Agnew and Sons

of 1900, but he was back in Dieppe by November and in the following month he held his first one-man show in Paris at Durand-Ruel. Of the 40 oils and six drawings on show, seven were Venetian subjects, including a portrait of Horatio Brown. They were apparently well received and this encouraged Sickert to return to Venice shortly after the exhibition closed, arriving in January 1901 and remaining for about six months.

He was well received by Anglo-American society who appreciated his humour and wide knowledge. Amongst his friends were William Stokes Hulton and his wife Costanza, who lived in the Calle della Testa near SS Giovanni e Paolo. Frederick Eden, who was related to Sir William Eden, one of Sickert's patrons in England, had a house with a beautiful garden on the Giudecca, which Henry Woods had painted on several occasions. Sickert was a welcomed guest of the Edens, as he was of Horatio Brown who was a neighbour, living in the Ca' Torresella where the Rio San Vio joins the Zattere.

Brown had been born in Nice in 1854 of Scottish parents and after an education at Clifton and New College, Oxford, had settled in Venice where he enjoyed a wide social life and where attitudes towards homosexuality were more relaxed than in England. He was a friend of John Addington Symonds whose important work, *The Renaissance in Italy* published in seven volumes did so much to redress Ruskin's implacable hostility to the arts of the Italian Quattrocento. Symonds rented rooms next to the Ca' Torresella and was often in Brown's company, as were many visiting British artists whom Brown would entertain and help, including Sickert, Henry Tuke and Walter Tyndale. He wrote several books on Venice of which *Life on the Lagoons* (1884) and *Venetian Studies* are the best known.

Sickert's favourite rendezvous was the home of Madame Fortuny, widow of Mariano Fortuny, the painter and designer, and her son Marianito and daughter. They lived in the Gothic Palazzo Pesaro Orfei at San Benedetto, now the Fortuny Museum, and it is likely that a romantic liaison had sprung up between Sickert and Mademoiselle Fortuny, whom he described as, 'a perfect gem, the cleverest, most intelligent female ever born'. Sickert felt particularly at home with the Fortuny family and Marianito often accompanied him on painting expeditions. He wrote:

The Fortunys are really charming people with a fascinating cordiality which remains discreet and well-mannered.

Sickert was also friendly with Baron Giorgio Franchetti who had bought the Ca' d'Oro, and was restoring the damage done by its previous owners. He probably also bumped into Frederick Rolfe alias 'Baron Corvo', although we have no record of his reaction to this extraordinary character. His company was also in demand at the Palazzo Dario where he met Sargent and other artistic and literary figures. It is understandable why Venice, with its warm hospitality and interesting personalities, appealed so much to Sickert.

WALTER RICHARD SICKERT
The Church of the Carmine
Oil on canvas, $14\frac{1}{2} \times 17\frac{1}{2}$in
(36.8×44.5cm)
Photograph courtesy of
Thomas Agnew and Sons

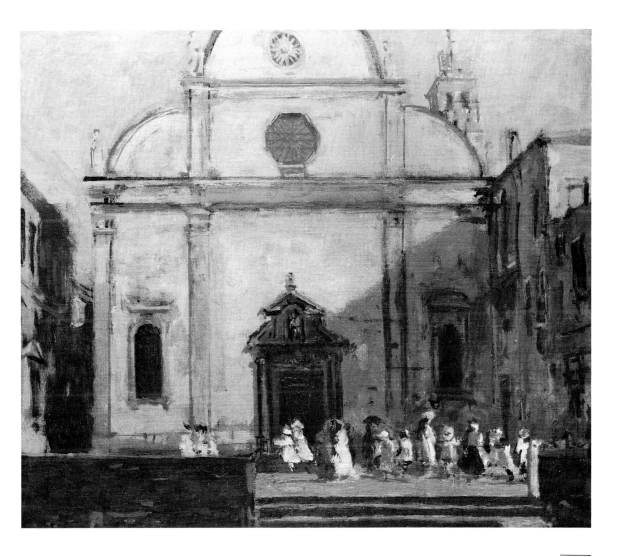

It has been suggested that Sickert made a brief visit to Venice in the autumn of 1902; this is possible, although there is no evidence. His next and final trip came in September 1903 and lasted until the summer of 1904. His new dealers in Paris, Bernheim-Jeune, were keen to have more Venetian pictures and, in addition, his work had been selected for the Biennale. During the poor winter weather, Sickert turned to painting portraits and nudes in the simple interior of his studio. He often ate at a small trattoria at San Silvestro, 'The Giorgione', and with his fluent Italian he soon knew the local clientele. The owner, Signor de Rossi and his wife, both sat for portraits and he was able to employ a number of local prostitutes as models. His favourite was La Giuseppina, who introduced Sickert to her friend Carolina dell' Acqua and who also provided her own mother as a model for *Mamma Mia Poveretta*. The young girl Inez appears in several pictures as does Maria Bionda. His models are not posed in the traditional sense, but are seen in natural positions in very ordinary surroundings. He avoided idealized beauty and finish, using instead broken brush strokes and restrained and dusty colours which create an intimate atmosphere. He would attempt to complete each picture in two sessions, working from life and painting fast:

I have learnt many things . . . To state general tones once and *once only*. And when the first coat is dry, to *finish*, bit by bit.

These experimental pictures look forward to his later Camden Town interiors. He also placed his models outside, in the Piazza, or along the Zattere, often creating unusual compositions, but he disliked working on the spot:

What are the truths you have gained, a handful of tiresome little facts, compared to the truths you have lost?

Thus his views of Venice were constructed from drawings and photographs, although some canvases were started on the spot. Sickert liked to distance himself from the subject he was painting, as he had written in 1901 from Dieppe:

I have just been doing a new batch of Venice subjects and better away than on the spot, so it is time I came to Venice to do some more Dieppe ones.

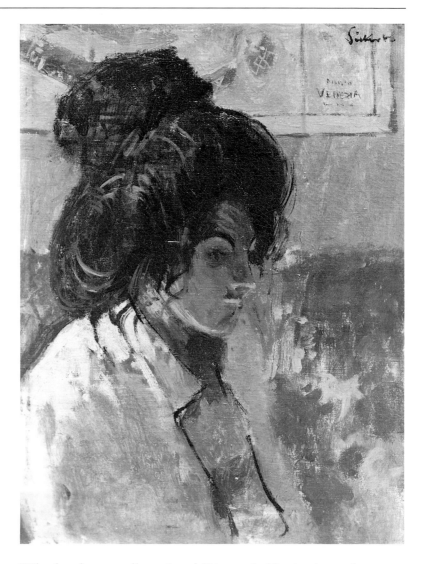

WALTER RICHARD SICKERT
Giuseppina – La Bague
Oil on canvas, 18 × 15in
(45.7 × 38.1cm)
Photograph courtesy of
Thomas Agnew and Sons

Whether he actually painted Dieppe in Venice is not known.

Sickert liked to work on several paintings at the same time. He wrote to his friend Jacques-Emile Blanche that he had 12 or 15 canvases half painted in his Venice studio, and these unorthodox working methods help to make his paintings so different from those artists who had preceded him to Venice. His emphasis upon construction, using black for outlines and detail; his usually restrained palette working within a close tonal range; his choice of unusual views and subjects – often little-known churches and *campi* such as the Carmine, Santa Maria Formosa, the Archangel Raphael or San Barnaba; his eschewing

of the prettier aspects of Venice, such as its sunsets and its sparkling reflected light – all these give Sickert a unique place in the painting of Venice. It was as if he saw Venice through the eyes of an inhabitant rather than those of a visitor.

When Sickert left Venice in the summer of 1904 he expected to return before long; keeping his studio and apparently storing his furniture at the Fortuny's house. He was, however, never to return, and although his work was shown in the 1930 Biennale, there is no evidence that he visited Venice for the exhibition. He continued, nevertheless, to paint Venice and as late as 1915 wrote to Ethel Sands:

When I have done St Mark's and the Rialto I shall be through with his chewing of old cud under which I chafe. But it is necessary to constitute bulk and without bulk no commercial painter can be made.

In 1939 Adrian Allinson noted that Sickert was at work on 'a sombre Venetian memory of yesterday'. Sickert also produced a number of very fine etchings based upon drawings and paintings done in Venice. He greatly admired Whistler's etchings, '. . . in scenes like *The Long Lagoon* or *The Rialto*, there is a flower-like charm, a magical breath of life and immediateness', and his own etchings, while much more complex than Whistler's, capture Sickert's own atmospheric vision of Venice.

Towards the end of the nineteenth century many younger artists moved away from Victorian formalism, to search for greater freedom, and less insistence upon finish and academic qualities in their work. This move can clearly be seen in the work of many of Sickert's contemporaries in Venice, and in many respects the atmospheric qualities of Venice were ideally suited to the new taste. One of the most extraordinary figures of this period was Hercules Brabazon Brabazon (1821–1906) who came from a wealthy family and was essentially a self-taught artist, often copying artists like Turner and Velasquez as a means of instruction. Although he travelled widely, Venice held a great appeal for him and he returned there often to capture its flickering light and movement, in rapidly executed but brilliantly observed watercolours. As a young man he had travelled with Samuel Prout and James Holland, and Ruskin admired his sense of colour:

Brabazon is the only person since Turner at whose feet I can sit and worship and learn about colour.

Later he worked alongside Francis James, a watercolourist of similar freedom, Arthur Severn and Sargent, who became a close friend. His watercolours were rapidly executed and all irrelevant detail was eliminated, to give an impression rather than a statement. He often used tinted paper combined with Chinese White, both to highlight and to give greater vibrancy to his colours, and although he did not hold his first-man exhibition until 1892, when he was 71, he was admired by many of the younger artists including Claude Monet, Sargent and many members of the New English Art Club. Sargent, who was not given to verbal expression, wrote in his introduction to Brabazon's exhibition of 1892:

Each sketch is a new delight of harmony and the harmonies are innumerable and unexpected . . . only after years of the contemplation of Nature can the process of selection become so sure an instinct; and handling so spontaneous and so freed from the commonplaces of expression is final mastery, the result of long artistic training.

Some of the finest images of Venice in this period were painted in watercolour, rather than oil. A new 'wet' or 'blottesque' technique derived from the broken colour used by the Impressionists had been developed by artists associated with the Glasgow School. Arthur Melville (1855–1904) and Robert Weir Allan (1851–1942) had both studied in Paris in the later 1880s and had seen the work of the Impressionists. Melville visited Venice in the early summer of 1894, but was at first disappointed with the lack of excitement, having been used to working in some remote areas of the Middle East, and the number of tourists also upset him. However he produced a number of large and impressive watercolours of the Salute and the Rialto using the coloured sails of Venetian vessels as key elements in the composition, and some exquisite nocturnal scenes including views of the Piazza at night illuminated with Chinese lanterns, and *The Music Boat* which shows the Rialto at night. These nocturnes, in which detail is dissolved into shade, and in which artificial light is brilliantly used, are amongst

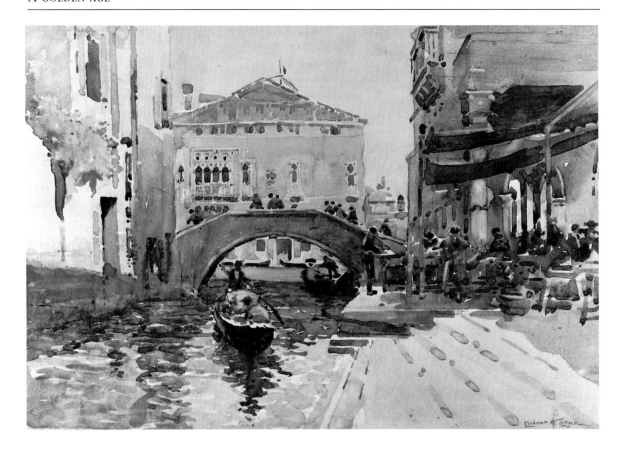

ROBERT WEIR ALLAN

Rio della Beccarie by the Rialto Market
Watercolour, 14 × 20in
(35.6 × 50.8cm)
Private collection

Melville's most daring and effective watercolours. It is interesting to speculate upon the influence of Melville's friend Sargent, who had made use of Chinese lanterns and artificial light in *Carnation, Lily, Lily, Rose* painted at Broadway in 1885/6. Robert Weir Allan's contribution is maybe less original, but he visited Venice regularly over a long period and painted many 'blottesque' watercolours. Emily Paterson (1855–1934), a Scot who had settled in London, also painted loose and often colourful watercolours of Venice, as did Moffat Lindner (1852–1949), some of whose best work was executed in Venice. Other watercolourists who painted in Venice in a relaxed and loose style include Wilfrid Ball (1835–1917), George Haité (1855–1924), Henry Scott Tuke (1858–1929) and Frank Mason (1876–1965). Sickert's friend Walter Bayes (1869–1956) painted Venice over a long period from 1900 sharing Sickert's interest in tonal values. In 1932 his book *A Painter's Baggage* was published,

EMILY PATERSON

Shipping on the Zattere
Watercolour, 10 × 13¼in
(25.4 × 33.7cm)
Private collection

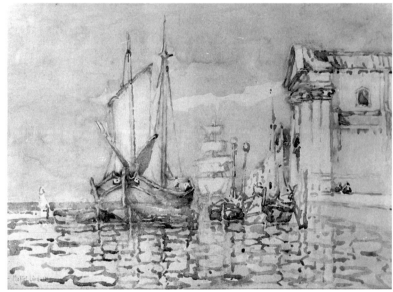

PETER MOFFAT LINDNER

The Church of the Gesuati on the Zattere
Watercolour, 10½ × 14in
(26.7 × 35.6cm)
Private collection

giving a lively account of an artist's life in Venice between the wars.

In 1893 the son of Thomas Bush Hardy, Dudley Hardy (1867–1922) visited Venice with his friend Frank Richards, a somewhat shadowy figure briefly connected with the Newlyn School. Richards was preparing an article *Venice as a Sketching Ground* for *Studio* magazine, which gives an amusing insight

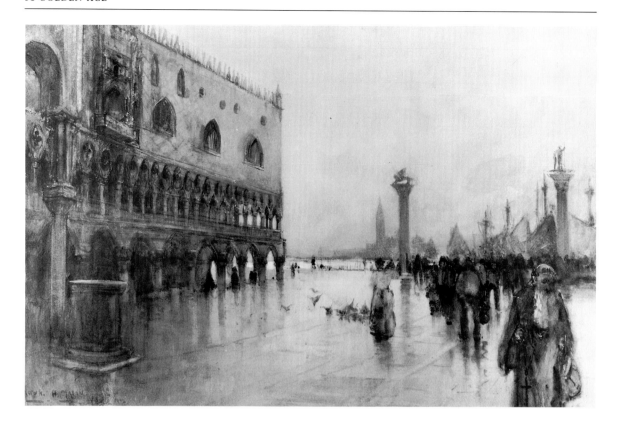

FRANK HENRY MASON
The Piazzetta, Rainy Day
Watercolour, 19½ × 29½in
(49.5 × 74.9cm)
Private collection

into the delights and problems of working in Venice in the
1890s:

One gets used to a Venetian crowd whilst sketching; the only
objectionable part being that sometimes an admirer will claim the
picture, or rather sketch, to be more of his own doing than the actual.
painter, taking the canvas off the easel whilst the painter's back is
turned . . .

Moreover:

The flower-girls who ply their daily business in the Piazza San Marco
are a great nuisance, and if you once take any notice of them . . . they
will pester you everyday . . .

They noticed that Venice was full of artists but as a result:

There are two or three very good colour shops in Venice, so one need
take but few sketching materials . . the brushes, however, are nothing
to boast of . . .

The problem with models had worsened since earlier in the century:

It is very difficult to get really good models, unless one is thoroughly accustomed to the place – the regular professional sitters being as a whole fat, coarse-looking women. We employed none of them, but used to go about with our gondolier and engage models as we came across them . . . We always found it most satisfactory to arrange terms beforehand . . . for no matter how badly a novice would pose, he usually expected full pay at the end of a séance.

Richards gave the prospective painter of Venice a final piece of advice:

. . . let me advise you not to wear knee-breeches in Venice if you want to do any work, for the natives stare at them and pass such remarks, that to the nervous man it would prove fatal.

With the growth in tourism came a renewed demand for travel books, particularly as good colour reproductions could now be made. Mortimer Menpes (1860–1938) had been Sickert's fellow student in Whistler's studio, before he, like many others, had fallen out with 'The Master'. He produced many fine water-colours and etchings during the course of his travels, which took him throughout Europe, the Middle East, India, Burma, Japan and South America. In 1901 A. & C. Black published Menpes's *War Impressions*, an illustrated account of a visit to the theatre of the Boer War. The book met with so much success that Blacks launched a series of travel books illustrated in colour with original watercolours. Menpes illustrated a number of this series, usually with texts by his daughter Dorothy, and a volume devoted to Venice appeared in 1904. Father and daughter enjoyed the cheap restaurants filled with argumentative artists: 'belonging to different sects – some antagonistic, some sym-pathetic; Dottists, and Spottists, and Stripists'. Like many before them, they found living in Venice very cheap: 'One can procure a marvel of a palace in Venice for the price of a garret in London.'

The illustrations that Menpes painted for this volume are amongst his best works, especially the portraits of Venetian working girls in their black shawls, set against the canals or seen in the Piazza. Menpes de-romanticized the subjects so dear to

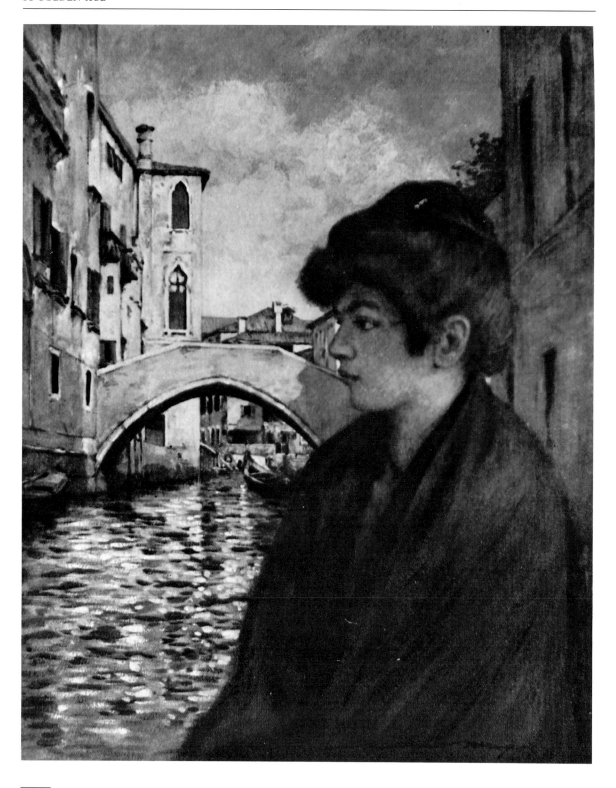

MORTIMER MENPES

Crossing the Piazza (right)
Watercolour from *Venice* by
Mortimer Menpes, published
by A. and C. Black 1904

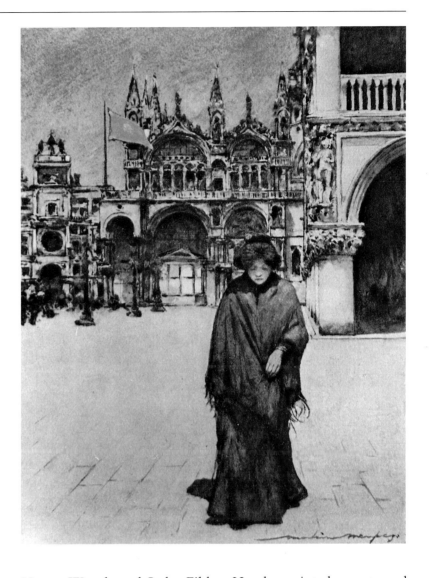

MORTIMER MENPES

Marietta (opposite)
Watercolour from *Venice* by
Mortimer Menpes, published
by A. and C. Black 1904

Henry Woods and Luke Fildes. He also painted sunsets and nocturnes, where the influence of Whistler can be seen in the economy of line and detail. His long apprenticeship with Whistler also ensured a consistent quality in his etchings of Venice, some of which are outstanding, achieving a delicate balance between fine detail and areas of dense ink. Menpes was probably most successful, however, at painting the everyday people of Venice, particularly the women whom his daughter describes:

Nothing can surpass the grace of the shawl-clad figures seen down the

REGINALD BARRATT

Courtyard of the Ducal Palace
Watercolour from *Venice*
illustrated by Reginald
Barratt, published by Chatto
and Windus 1907

perspective of the long streets, or about some old stone well in a campiello . . . A shawl is thrown round her shoulders, and her jet-black hair is fastened by a silver pin. She wears a deep crimson bodice . . . Their shawls are seldom gaudy, generally blue or a pale mauve; vivid colours are reserved for the bodice.

The success of the A. & C. Black series spawned similar publications. In 1907 Chatto & Windus produced a book on Venice illustrated by Reginald Barratt (1861–1917), who had also travelled extensively in the Middle East. He visited Venice in 1896, 1903 and 1906, painting detailed and densely coloured watercolours which look back to the nineteenth century rather than towards the looser style of the new century. They have, nevertheless, great intensity and a real sense of place. Some of Barratt's views of a still uncrowded Piazza with the façade of St

Mark's complete with flower girls in the foreground are similar in composition, but much less 'sweet' than those of David Woodlock (1842–1929) who worked in Venice around this time.

In 1913 Hodder & Stoughton added to the growing travel literature with a beautifully produced book, *An Artist in Italy* written and illustrated by Walter Tyndale (1855–1943). Born in Bruges, he came to England aged 17, and subsequently studied in Antwerp and Paris; like Menpes and Barratt he travelled widely in the Middle East, Africa and Japan, painting in a detailed yet fresh watercolour style which was influenced by his friend and neighbour in Haslemere, Helen Allingham. He first visited Venice in 1879, returning regularly after 1900 and finally settling there in 1922. He became a close friend of Horatio Brown, and his studio on the Zattere became a centre for many visiting artists including Ursula and Walter Tyrwhitt, Reginald

WALTER TYNDALE

The Dogana
Watercolour from *An Artist in Italy* by Walter Tyndale, published by Hodder and Stoughton 1913

WALTER TYNDALE

In the Piazzetta
Watercolour from *An Artist in Italy* by Walter Tyndale, published by Hodder and Stoughton 1913

Barratt, Graham Petrie and Henry Simpson. The Montalbas were also friends and neighbours. Tyndale worked consistently, preparing watercolours for exhibitions first at Dowdeswells and later at the Fine Art Society. His watercolours, with their well-judged use of warm tones, radiate heat and *joie de vivre* without becoming too sweet, and his interiors of St Mark's or exteriors of the Ducal Palace with figures represent the end of a long tradition stretching back to Samuel Prout.

Life presented some complications for Tyndale; in 1926 he arrived at Victoria Station with new watercolours for his exhibition at the Fine Art Society, and had to pay import duty to the customs. His case was taken up in Parliament and finally he received an apology and refund from the Chancellor of the Exchequer, Winston Churchill. An entry in his diary for earlier that year was also somewhat dramatic:

The New Year found Evelyn and I both down with influenza! She had to keep to bed. I just able to crawl around to my studio to try and complete some of my drawings for my forthcoming show in London. At 7.10 p.m. very much startled by the earthquake. I feared my studio was coming down. Very little damage done to Venice.

Venice continued to attract and influence younger artists. In 1910 F.C.B. Cadell (1883–1937), an Edinburgh artist, arrived in Venice. His work at that time was loosely impressionistic, his

EBENEZER WAKE COOK

The Loggetta, St Mark's
Watercolour, 15 × 20¾in
(38 × 52.7cm)
Photograph courtesy of
Michael Bryan

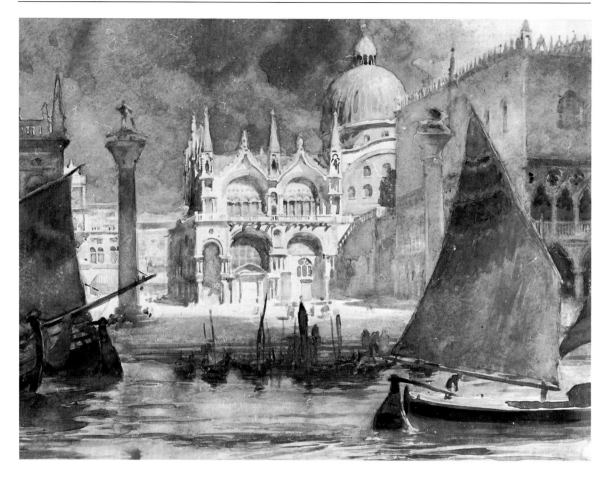

CHARLES MACKIE
St Mark's 1908
Watercolour, 16¾ × 22¼in
(42.6 × 56.5cm)
Perth Museum and Art
Gallery

watercolours influenced by Melville. Venice opened his eyes to a new range of brilliant colours, and his studies of people seated in Florian's with the façade of St Mark's as a backdrop are quite revolutionary for British painting of the period. He produced both watercolours and oils in Venice, looking forward in style to the Colourist period. Sadly Cadell never returned to Venice, as it would have been fascinating to see how he would have painted it during his maturity in the 1920s. Another Scottish Colourist, George Leslie Hunter (1879–1931), worked in Venice in 1922 and his pen-and-ink drawings, sometimes with added chalks or watercolour, are both vibrant and original. James McBey (1883–1959) was another Scottish artist who saw Venice through fresh and unencumbered eyes. He visited Venice in September 1924 and again in October 1925, this time accompanied by his close friend Martin Hardie. McBey produced loose watercolours of Venice in which the outline in

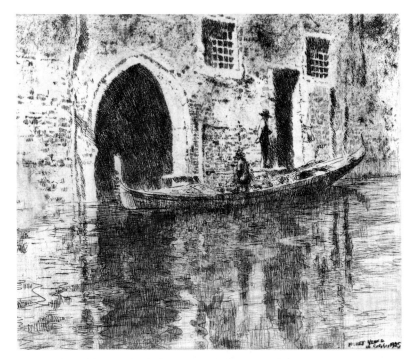

JAMES MCBEY
The Deserted Palace
Etching, 8 × 9¾in
(20.3 × 24.8cm)
Aberdeen Art Gallery and
Museums

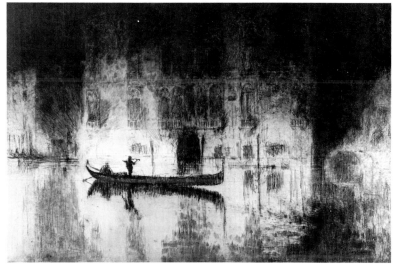

JAMES MCBEY
Venetian Night
Etching, 10¾ × 17½in
(27.3 × 44.5cm)
Aberdeen Art Gallery and
Museums

pen-and-ink plays an important part, but perhaps more memorable are his exquisite etchings of the boats, buildings and people of Venice. Martin Hardie described his unflagging energy:

He began at dawn; he spent hours at the end of the Rialto or at a table under the shady colonnade of the Chioggia Café in the Piazzetta

SIR FRANK BRANGWYN

The Dogana 1897
Oil on canvas, $48\frac{1}{2} \times 49\frac{1}{2}$in
(123.2×125.7cm)
William Morris Gallery,
Waltham Forest, London

making pen and ink notes of figures; or in a gondola on the canals or the Giudecca, making studies of shipping or buildings and their reflections; at night he would be out again in his gondola, working on a copper plate by the light of three tallow candles in an old tin! Never has anyone been less dependent on the orthodox paraphernalia of this craft. Never was an artist more indefatigable.

Several English artists also brought a new and refreshing

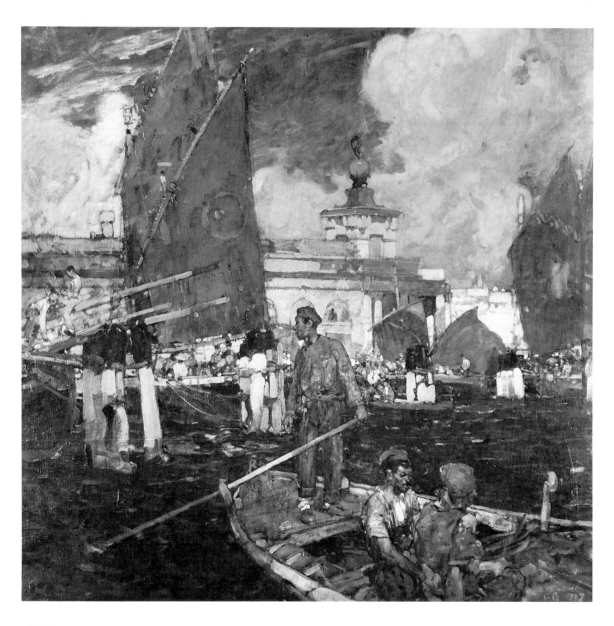

approach to the painting of Venice. Sir Frank Brangwyn (1867–1956), one of the most original artists in Britain at this time, visited Venice in 1896 to discuss a commission for a mural decoration. Although he had travelled extensively, visiting Spain in 1892 with Melville, and Morocco in 1893 with Dudley Hardy, he was enthralled with the colour and atmosphere of Venice, filling several sketchbooks with drawings which he worked up into oils on his return to London. In 1905 he was commissioned to paint four murals for the Venice International Exhibition depicting English working people – potters, blacksmiths, excavators and steelworkers. The exhibition had first taken place in 1895, originating from an idea of Professor Antonio Fradeletto to hold a biennial art show in Venice. The idea was a success and the original exhibition hall was soon complemented by pavilions built by individual nations – the Belgians in 1907, the British, Germans and Hungarians in 1909 and the Swedish and French in 1912.

Until 1910 the official taste of the Biennale, as it came to be called, was conservative. Fradeletto disliked Art Nouveau, favouring the more traditional styles which Brangwyn so well exploited; the Gustav Klimt one-man show in 1910 marked a radical move towards more progressive taste. In 1907 Brangwyn was again asked to decorate the British Room, but this time he was determined to use Venetian subjects. He successfully completed two subjects – *Venetian Serenaders* and *Venetian Commerce* – but the committee insisted on British subjects for the remaining two panels and Brangwyn chose the themes of *Steelworkers* and *Agricultural Workers*.

While in Venice for the 1907 exhibition, Brangwyn again made drawings for future paintings and spent time with his friends John Singer Sargent and Alfred East. He later recalled the Venetian hospitality:

When I was in Venice, as a delegate at the great International Conference, we used to have meetings, dinners, suppers and musical-parties on the water. We had a grand time – ending up with a feast given by the Sindico in the 'Palazzo Ducale'.

Back in London Brangwyn produced large oils, watercolours and etchings of Venice. His earlier oils had been painted in a restrained palette, but the later works became richer in colour

SIR FRANK BRANGWYN

The Bridge of Sighs
Etching, $17\frac{1}{2} \times 27\frac{1}{2}$in
(44.5×69.9cm)

and more dramatic in composition. He was particularly good at depicting crowded squares, *campi* and bridges, or the excitement of a market. His etchings capture an unusual viewpoint or a dramatic effect of light. He liked to paint working men – gondoliers, porters carrying fruit or unloading boats – and in his

SIR FRANK BRANGWYN

Santa Maria della Salute
Etching, $31\frac{1}{2} \times 21\frac{1}{4}$in
(80×54cm)

WILLIAM WALCOT

The Rialto 1942
Pencil, charcoal and gouache,
$24\frac{1}{2} \times 33\frac{1}{4}$in ($62.2 \times 84.5$cm)
Photograph courtesy of the
Fine Art Society, London

watercolours, which are often on a large scale, he creates fluidity
and movement. Good examples of his work can be seen in *The
Pageant of Venice* by Edward Hutton published in 1922.
Brangwyn's last trip abroad was to Venice in July 1928, after
which he became more reclusive.

A similarly talented artist was William Walcot (1874–1943),
who was born in Russia of an English father and had studied in
St Petersburg and Paris. He was sent to Venice and Rome by the

Fine Art Society who held an exhibition of the resulting pictures in 1910. He continued to visit Venice between the wars and, like Brangwyn, he could work effectively in oils, watercolours and etchings. He also tended to dramatize by exaggerating the scale of the architecture and the depth of the shadows. Many interesting artists were working in Venice at this time, and today their work is being reassessed. While it would be impossible to mention them all, the strong and often quite large oils of Charles Oppenheimer (1875–1961) and Terrick Williams (1860–1936) deserve attention, while John Reinhard Weguelin's (1849–1927) sumptuous watercolour *Venetian Gold* is a memorable expression of imagined Venetian luxury. Alfred

CHARLES OPPENHEIMER
Venetian Barges
Oil on canvas, 20 × 24in
(50.8 × 61cm)
Photograph courtesy of
Bourne Fine Art, Edinburgh

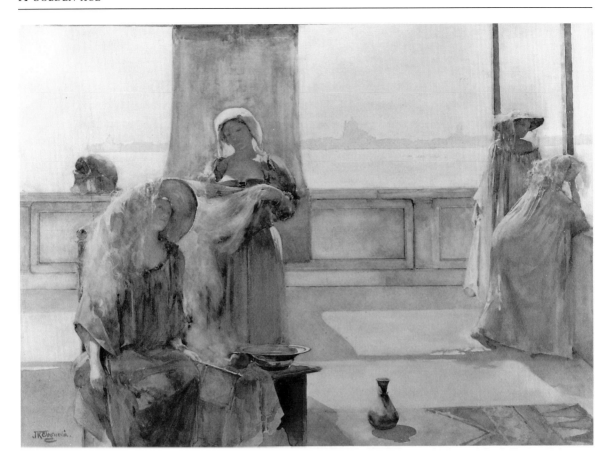

JOHN REINHARD WEGUELIN
Venetian Gold
Watercolour, 21 × 28½in
(53.3 × 72.4cm)
Royal Watercolour Society,
London

Hayward (1875–1971) should also be mentioned for his luminous watercolours of Venice, which he first visited in 1909.

A totally different vision of Venice was provided by Joseph Southall (1861–1944), who had studied in Birmingham and had been influenced by the teachings of Ruskin. He first visited Venice in 1883 armed with *St Mark's Rest*, in which Ruskin extolled the virtues of painting in tempera:

. . . I am disposed to think that ultimately tempera will be found the proper material for the greater number of most delightful subjects.

Southall was greatly impressed by the Italian Primitives, and the unique style which he developed owed much to them and to the Pre-Raphaelites. In 1890 he returned to Venice for three weeks, and during the early years of the century he was often in Tuscany, although he did not return to Venice until 1909. After the war he visited Venice regularly and enjoyed painting the

water and boats, creating interesting patterns while observing details with great accuracy. He also liked to paint the crowds in the Piazza, dressing them in contemporary fashions while employing Renaissance techniques, often using tempera. He was a man of strong political and social convictions who totally opposed the war. Maxwell Armfield (1882–1972), a fellow artist and painter of Venice, well summed up his work in 1944:

Southall must . . . be considered as an artist who, in an age of disbelief and negation, held some sort of belief and made his own very forcible affirmation of it . . . It is not an emotional work, but one that is calculated to induce emotion – a very different thing.

Whistler was responsible for a great revival of interest in etching. He lifted the art from being simply a means of reproducing great paintings for the general public, to being considered an art form in its own right. His influence was not

SIR DAVID YOUNG CAMERON

Palazzo Dario 1901
Etching, 12¾ × 6½in
(32.4 × 16.5cm)

SIR DAVID YOUNG CAMERON

St Mark's, No. 2 1900
Etching, 12 × 7½in
(30.5 × 191.1cm)

SIR MUIRHEAD BONE

Calle Pescheria
Etching, $6\frac{3}{4}$ × 10in
(17.2 × 25.4cm)
Aberdeen Art Gallery and
Museums

confined solely to his own methods and style of etching, but
extended to the rebirth of many different techniques and styles
of print-making during the late nineteenth and early twentieth
centuries. Several artists discussed in this chapter took part in this
rebirth – the dramatic etchings of Brangwyn are amongst the
finest representations of Venice, as are the delicate plates of
McBey.

In addition the Venetian etchings of Sir David Young
Cameron (1865–1945), some of which were produced for a
'North Italian Set' of 1895/6 and some in 1900/1, are interesting,
as are the many fine etchings and drawings executed by Sir
Muirhead Bone (1876–1953) which capture the drama of
Venetian architecture. Sir Henry Rushbury (1889–1968) began
visiting Italy in the early 1920s, producing crisp line and wash
drawings, etchings and dry-points. His rendering of architec-
ture was particularly fine, as Campbell Dodgson, Keeper of

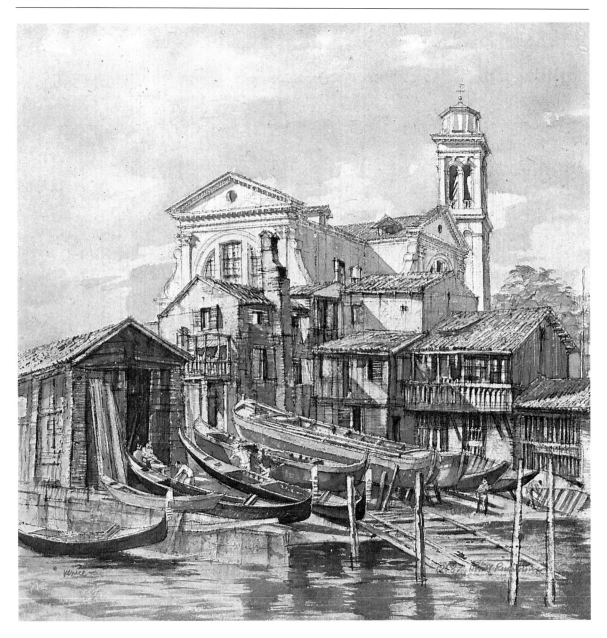

SIR HENRY RUSHBURY

Boat-Building, Venice (Rio di San Trovaso) 1958
Pencil and watercolour,
14½ × 14½in (36.8 × 36.8cm)
Private collection

Prints and Drawings at the British Museum, wrote in 1925: 'In his treatment of plain surfaces of white stone in contrast with deeper shadows he has few rivals amongst then numerous contemporary etchers of architecture'. Rushbury continued to visit Venice until 1956. In many respects this was a great period of draughtsmanship and the graphic work of Brangwyn,

Cameron, McBey, Muirhead Bone and Rushbury has few rivals today.

In 1913 Walter Tyndale commented upon the changes taking place in Venice:

Venice has certainly become more noisy since the early eighties; steamers disturb the reflections in the Grand Canal, and the hooting or the squeal of a siren echoes in the arches of the Doge's Palace . . . But in spite of these things Venice is less changed than any city I know . . . You can still walk along its streets without the fear of being knocked down by a motor car, and its small canals are too narrow to allow of steam navigation. Motor boats are, however, becoming a

SIR HENRY RUSHBURY

Cannaregio 1931
Drypoint, $7\frac{1}{2} \times 9\frac{1}{2}$in
(19.1 × 24.1cm)
Birmingham City Museum
and Art Gallery

nuisance to those who still prefer the gondola; – let us hope that the price of petrol may check this growing evil.

He also lamented the effect of tourism on Venetian cuisine:

It is in the cosmopolitan hotels, where the foreigner demands what he has been used to, that a poor and characterless meal is often served. A sporting element adds to the amusement of discovering a *trattoria* where the Venetian epicure goes for a particular *frittata* or a dish of *frutti di mare*.

In the following year the First World War broke out and once again Venice found itself under threat from the Austrians. Most of the Anglo-American colony departed – Horatio Brown to Penicuik outside Edinburgh, Henry Woods to London and Sargent to the USA. After the war many of the colony returned, but during the 1920s some of the leading figures died – Horatio Brown in 1926 at Belluno on the mainland, Henry Woods in 1921 in his studio and Clara Montalba in 1929 in the Palazzo Trevisan dell'Olivo on the Zattere. Venice was attracting, in their place, a wealthier and younger set. Henry Melchett, son of Alfred Mond, First Lord Melchett and founder of ICI, could be found with his wife Gwen at the Casa Leone, a luxurious villa which they rented on the Giudecca, where Augustus John, Cecil Beaton and Edward Seago were guests. Duncan Grant and Vanessa Bell, central to the lively Bloomsbury Group, also discovered the charms of Venice and made several trips there in the 1920s to paint.

In 1934 Adolf Hitler came to Venice, meeting Mussolini for the first time at a fateful conference in the Villa Pisani on the Brenta Canal. Italy's move towards a German alliance combined with the British sanctions in 1936 changed the atmosphere towards the British, and Walter Tyndale, still working in his studio on the Zattere, commented in his diary upon the changing mood. A fascinating insight into the growing tension is provided by Edward Seago who, while staying in Venice in 1933, was asked by Lord Melchett to accompany him on a secret flight to meet the Austrian Chancellor Dollfuss, to discuss the problem of the Jewish refugees from Germany. Within a year Dollfuss had been assassinated and the drift towards the Second World War had commenced.

9 'That magic, enigmatic city'

Contemporary Venice

Since the war Venice has attracted many artists, although the emergence of Pop Art, Conceptual Art, Op Art, Abstract Expressionism, Post Modernism and many other movements and 'isms' has reduced the importance of specific landscape or townscape, at least in progressive circles. Painting a place as well known and picturesque as Venice would be scorned by many art colleges, and few modern paintings of Venice find their way into major art galleries on either side of the Atlantic. A study of officially sponsored art exhibitions since the war in Britain and the USA will reveal few examples of Venice, and it falls largely to commercial galleries and private patrons to support those artists who wish to paint Venice in a figurative manner. There is thus a huge gap between museum modern art and the bulk of private patronage, and it is only because of individual buying that Venice is painted at all today. Venice does not lend itself easily to exaggerated distortions, and those modern artists who have tried to impose their own style upon the city have usually produced most unsatisfactory work. It is simple to criticize those artists who paint Venice respecting the spirit of the city without imposing their own style upon it, as being safe or tame or even bourgeois, but Venice does demand a sensitive approach, and this kind of sensitivity is often lacking in modern painting. Despite this, there are important, if officially unfashionable, artists painting in Venice today.

It is unlikely that the great days of comradeship and mutual support will return, as in the days when visiting artists could become part of the Anglo–American society in Venice. Today it

is expensive and artists must arrive, work hard and depart within weeks if their trip is to be economically viable. Sadly, the age when an artist could live cheaply for many months is past, but despite this, Venice remains an attractive location for painters: unlike London or Paris, it has not been desecrated by the car; its old buildings have not been replaced by unpaintable

DUNCAN GRANT

Il Redentore 1948
Oil on panel, 22 × 15in
(55.9 × 38.1cm)
Photograph courtesy of
Christie's, London

EDWARD SEAGO

Bridge near San Zanipolo
Watercolour, $14\frac{3}{4} \times 21\frac{1}{2}$in
(37.5×54.6cm)
Photograph courtesy of Spink
and Son, London

office blocks, and despite the pollution from Mestre, the sunsets are as beautiful today as when Ruskin saw them.

Shortly after the war, artists began to return. In the autumn of 1948 Duncan Grant (1885–1978), Vanessa Bell (1879–1961) and Edward Le Bas (1904–1966) returned to paint, staying at the Pensione Seguso on the Zattere and visiting Florians in the evening to eat ice-cream and drink *grappa*. In 1953 they were back, staying at Asolo on the mainland and making day trips to Venice, where Vanessa Bell came to admire Tintoretto's *Crucifixion* in the Scuola di San Rocco; other visits followed later in the 1950s. Edward Seago (1910–1974) had his appetite for Venice whetted in 1933 and he returned in 1950, to make the first of several post-war visits. Seago's virtuoso handling of both oil and watercolour was suited to Venetian light and atmosphere, and he captured well the busy *campi* in addition to the play of light and reflections in the water. He was also attracted to the life and colour of Chioggia. Norman Wilkinson (1878–

1971) applied a similar sparkle in his oils of Venice, although they lack Seago's 'brio'.

John Piper (born 1903) first visited Venice in 1954 while working on Britten's *The Turn of the Screw*, an English Opera production being staged at La Fenice. He did not paint Venice on that occasion, but returned in 1958, 1959 and 1960 to paint pictures for an exhibition entitled *Paintings and Watercolours of Venice by John Piper* which was held at the Arthur Jeffress Gallery in London in 1960. Piper returned during the 1960s to work on illustrations for Adrian Stokes's *Venice*. Stokes knew Venice well and lived there for many years, and he introduced Piper to Venetian families. In 1973 Piper produced designs for the opera *Death in Venice* and it is interesting that he was reviving the old practice of artists like Clarkson Stanfield or William Telbin of

JOHN PIPER

Palazzo Labia
Gouache, 23 × 31in
(58.4 × 78.7cm)
Photograph courtesy of
Thomas Agnew and Sons

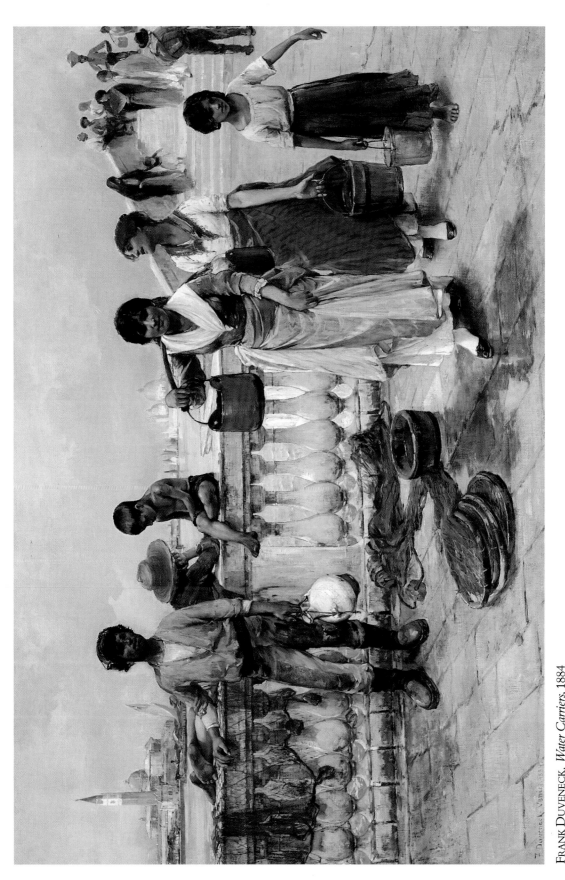

FRANK DUVENECK, *Water Carriers*, 1884
Oil on canvas, 48½ × 73½in (123.2cm × 186.7cm). Smithsonian Institute, *Washington DC*

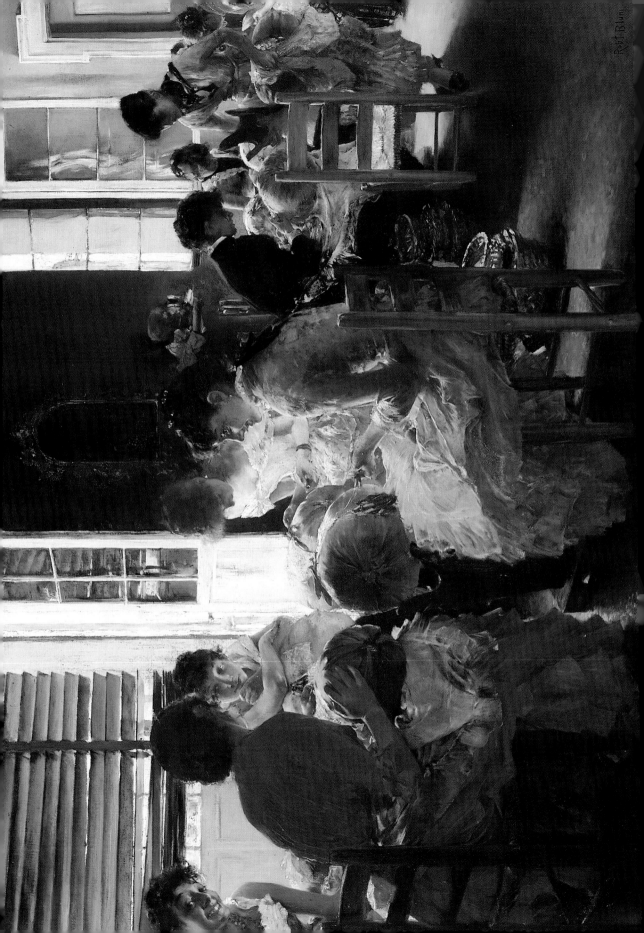

THOMAS MORAN, *Venice, Evening*, 1898
Oil on canvas, 20½ × 30in (52.1 × 76.2cm)
Photograph courtesy of Christie's, New York

(Top) ROBERT BLUM, *Venetian Lacemakers*
Oil on canvas. Cincinnati Art Museum

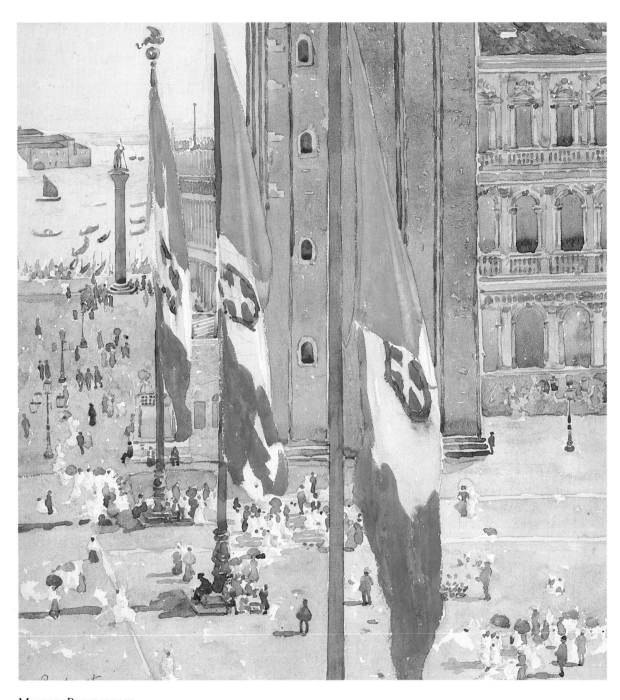

MAURICE PRENDERGAST

Piazza di San Marco
Watercolour, 16 × 15in
(40.6 × 38.1cm)
Metropolitan Museum of
Art, New York

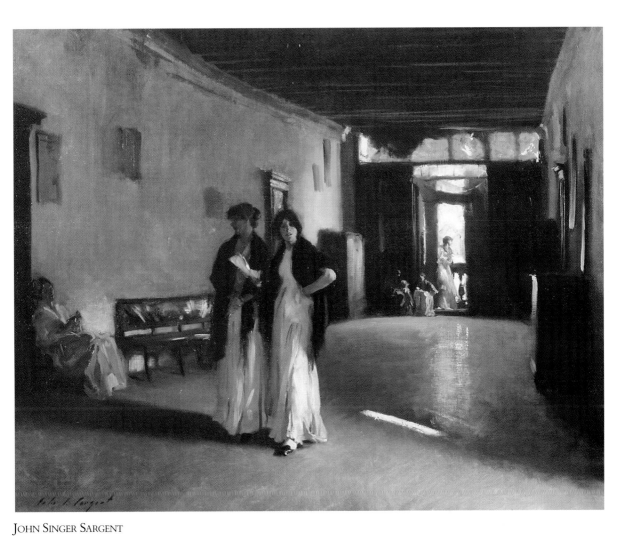

JOHN SINGER SARGENT
Venetian Interior
Oil on canvas, 27 × 34in
(68.6 × 86.4cm)
Carnegie Institute, Pittsburgh

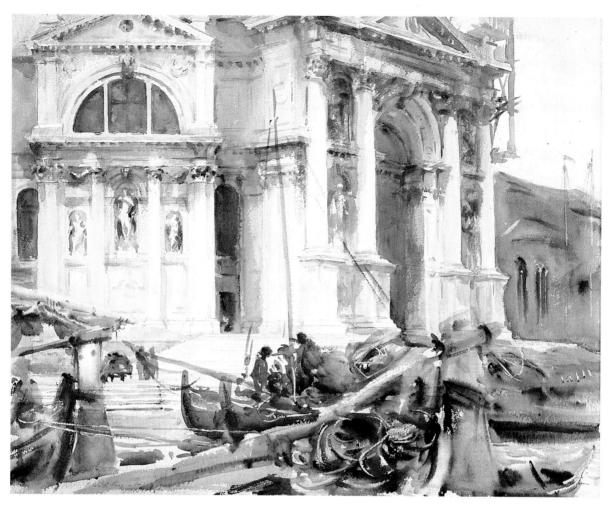

JOHN SINGER SARGENT
Santa Maria della Salute, 1904
Watercolour and bodycolour,
18¼ × 23in (46.4 × 58.4cm)
Brooklyn Museum,
New York

(Opposite) WALTER
RICHARD SICKERT

The Ospedale Civile
Oil on canvas, 26 × 18½in
(66 × 47cm)
Photograph courtesy of
Thomas Agnew and Sons

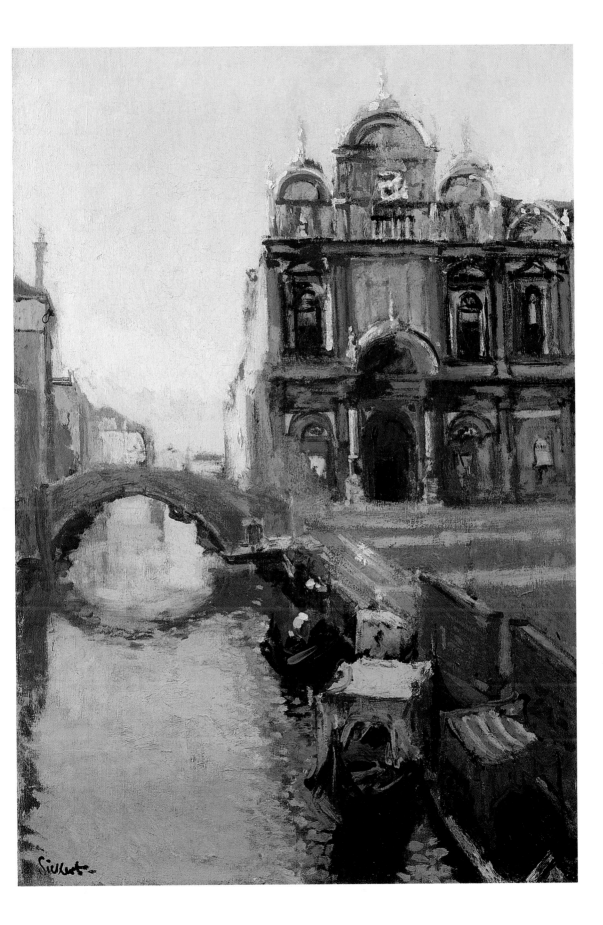

WALTER BAYES. *A Venetian Canal*, 1900
Gouache, 8¾ × 12¼in (22.2 × 31.1cm) Private collection

ARTHUR MELVILLE
The Music Boat, Venice
Watercolour, 24 × 34in
(61 × 86.4cm)
The Burrell Collection,
Glasgow

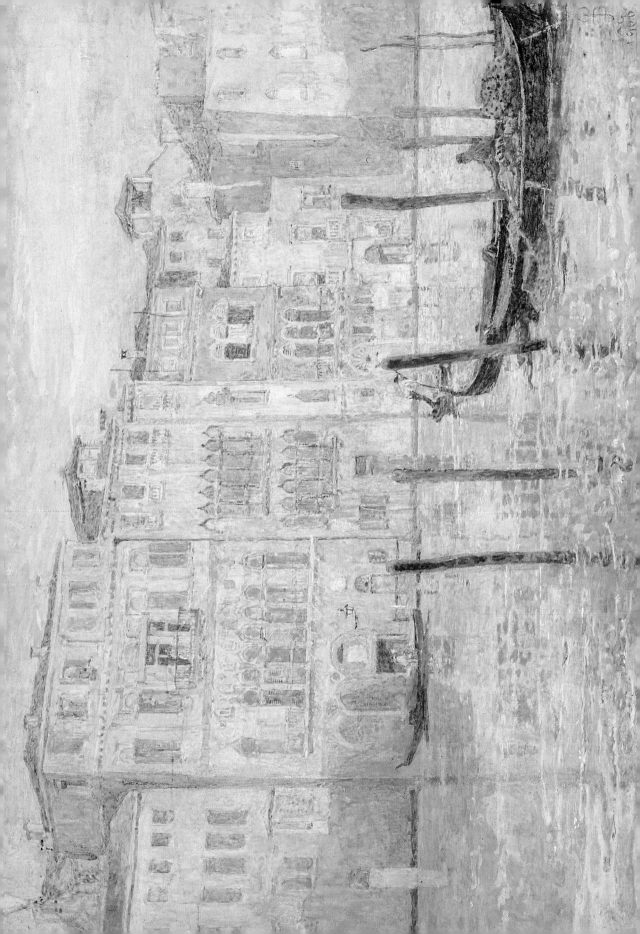

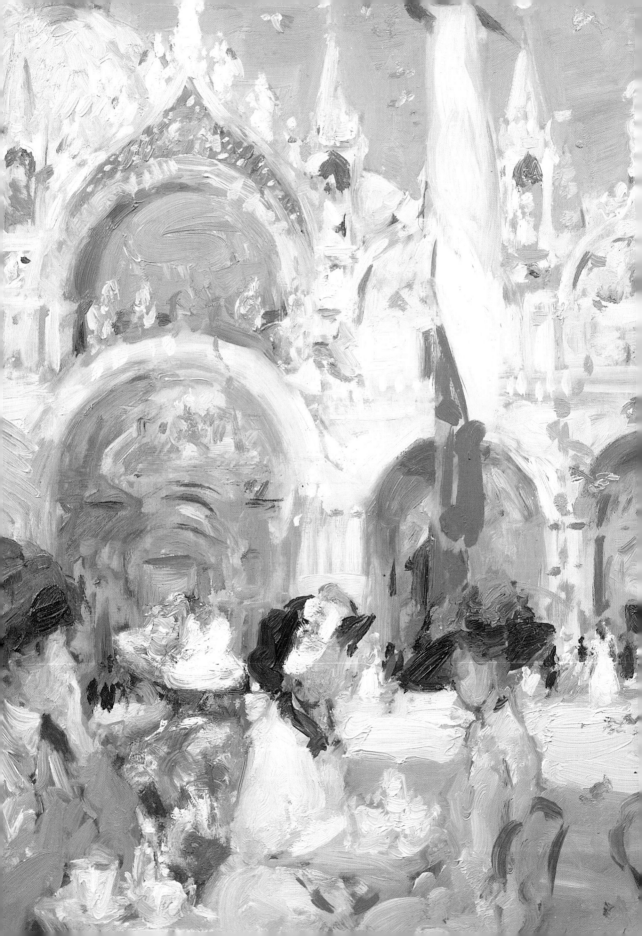

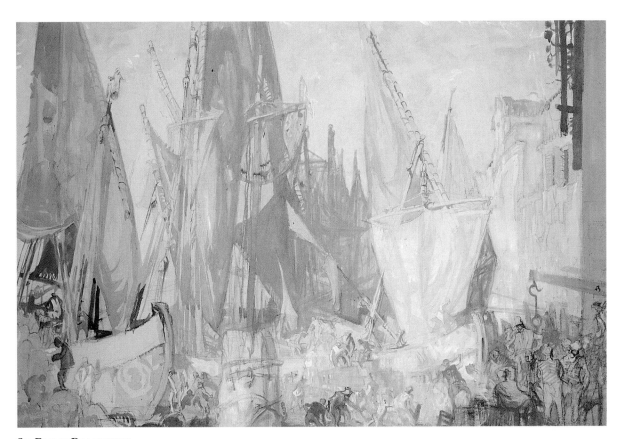

Sir Frank Brangwyn

Boats, Venice
Watercolour and bodycolour,
13 × 18¾in (33 × 47.6cm)
Birmingham Museums and
Art Gallery

(Opposite)
Francis Campbell
Boileau Cadell

Florian's Café, 1910
Oil on canvas, 18 × 15in
(45.7 × 38.1cm)
Photograph courtsey of The
Portland Gallery, London

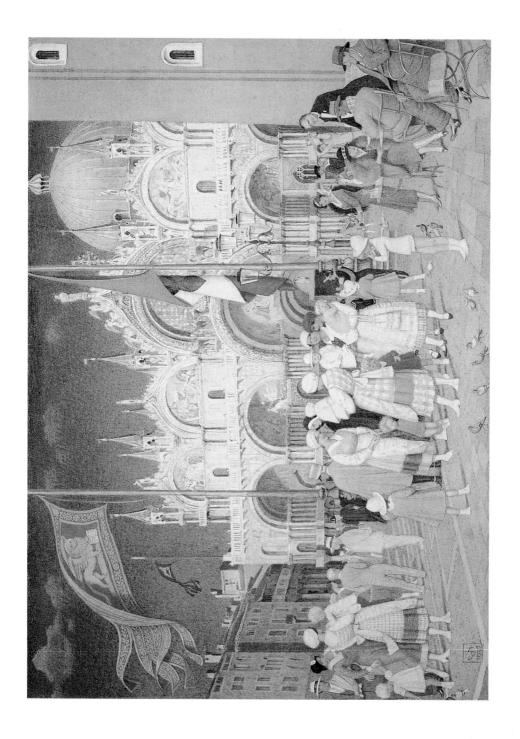

JOSEPH SOUTHALL
The Lion of St Mark's, 1932
Watercolour, 13¾ × 17¾in
(35 × 45.1cm)
Birmingham Museums and
Art Gallery

EDWARD SEAGO
The Steps of the Salute
Watercolour, 15¼ × 21¾in
(38.7 × 55.3cm)
Photograph courtesy of
Richard Green, London

KEN HOWARD
Basilica San Marco
9.30a.m. 1.10.88
Watercolour and Chinese
white, 7 × 9in (17.8 × 22.9cm)
Photograph courtesy of
Oscar and Peter Johnson Ltd,
London

(Opposite) DIANA ARMFIELD
The Molo, Venice
Oil on canvas laid on board,
9½ × 7in (24.1 × 17.8cm)
Photograph courtesy of
Browse and Darby, London

(Overleaf)
MARTIN YEOMAN

The Ca d'Oro, Grand Canal
Oil on canvas, 11½ × 16in
(29.2 × 40.6cm)
Private collection

working on both easel paintings and theatrical designs while in Venice.

Two Scottish artists made an impact on the painting of Venice. Anne Redpath (1895–1965) arrived in October 1963 with her son for a fortnight, and although she had seen Venice some forty years previously, this was her first opportunity to paint there. She was immediately enthralled by the Church and palace interiors, and her apprehensions about painting such a well-known city quickly evaporated. Her Venetian oils are exuberant, relaxed and richly painted. A highly successful exhibition of 24 Venetian oils was held at the Lefèvre Gallery in April 1964 and was to be her last exhibition. Joan Eardley (1921–

ANNE REDPATH

Courtyard in Venice 1964
Oil on canvas, 30 × 25in
(76.2 × 63.5cm)
Robert Fleming Holdings Ltd

1963) also worked in Venice during the 1950s, painting powerful, personal canvases, which nevertheless embody the spirit of the place.

A number of typically English artists also worked in Venice in the 1950s and 1960s. Mary Potter (1900–1981) painted the city with her distinctive vision using soft, closely related tones, while Rodney Burn (1899–1984) and John Aldridge (1905–1983) applied their low-key, Slade-inspired technique to Venice. Peter Greenham (born 1909) has also approached Venice in a similar, tonal manner. It is interesting that Venice, which responds so well to the high-toned virtuosity of Sargent,

KEN HOWARD
Riva degli Schiavoni, Afternoon
1986
Watercolour, 7 × 9in
(17.8 × 22.9cm)
Photograph courtesy of Oscar and Peter Johnson Ltd, London

can be painted equally successfully by artists working within a limited palette and with a purely tonal approach. Norman Hepple (born 1908) has painted Venice for many years, using a traditional approach to composition and colour.

The appeal of Venice is maybe best described by an artist who works there today. Ken Howard (born 1932) visits Venice most years in the autumn, and in an article in *The Artist* in May 1987 he sums up his approach to painting in Venice:

Venice . . . is exotic and wonderfully stimulating for short spells. During recent years I have always made an annual trip to that magic, enigmatic city. Each trip is keenly anticipated, the time there is always exciting and on every occasion I leave wanting more of it, looking forward to our next meeting . . . I well remember my first visit back in the Fifties when I was studying in Florence . . . The first sight of the city across the lagoon was like a dream, yet I didn't paint any pictures; instead I explored the place, and took everything in, especially the treasures of its great collections . . . Many years passed before my second visit when I realised that I had to return to paint there.

The first problem of course was how to do something different. So many artists who have been influential in my development have painted views of Venice: Turner with his magical evocations of the city dissolving into the lagoon and the Grand Canal, Sickert with his dark canvases which express so well the light and shade of the *campi* and churches and, more recently, painters who have become close friends; Bernard Dunstan with his lively street scenes, Diana Armfield who, with small touches of broken colour so perfectly encapsulates the water-ways and bridges, and, of course, John Ward's lively renderings of the cafés, restaurants and architecture. How could I find something original to say?

After my first working visit, which was far from successful, I decided to search for something new and painted the narrow dark alleys in the area around the Accademia and Campo San Barnaba. In fact I came home with paintings that closely resembled my paintings of Southall railway sidings . . .

After that visit I radically altered my approach; I gave up working in oils and changed to watercolours. Then, instead of imposing myself on Venice, the city began to reveal itself to me, and this of course is the true path of discovery . . .

My love for the place is on two levels – the first is visual, the second

social. From the visual point of view the greatest stimulation is the quality of light and this has become more and more my dominant inspiration . . . The *campi* and narrow streets of Venice as well as the play of light on the surfaces of the water are natural vehicles for expressing light . . .

I hope that when someone sees one of my recent watercolours of Venice for a time at least they will see Venice in my terms; a place full of light-reflecting surfaces, silhouettes against rich, warm, iridescent skies . . .

Then, of course, there is the architecture; the coming together of East and West, the ornate façades, the varied skyline. How boring our modern cities are by comparison. In England, not since the Victorians has there been such a delight in surface texture, detail and pattern. Venice is full of it. Initially the topography delighted me most; the façade of St Mark's, so wonderfully painted by Sickert, the rich ornate details of the Salute, the Palazzi on the canals. But, as visit follows visit, I feel all is becoming subjugated to the original and particular light of Venice – and not only strong sunlight but also the haze of the morning or the fog in early spring or autumn; the sunsets that one sees on the Grand Canal and the sun coming up behind San Giorgio from the Dogana.

The *campi*, which Bernard Dunstan interprets so well, are also boxes of light, filled with animation. Childred playing, the old worthies standing together discussing Communism . . . those peculiar covered Venetian wells . . . which towards midday reflect the high sun and burn with a blinding light against the mysterious shadows behind: all are pulled together and composed by the fantastic light. And then, of course, there are the churches seen across the light-reflecting water; looking across to San Giorgio one can see for a moment how Turner arrived at his sublime images.

The other aspect of Venice that is very important if I am going to find the energy to work from dawn till dusk is that I must feel 'at home' in a city. Generally speaking I love Italy – the climate, the food, the landscape – but Venice has particular characteristics which make it especially desirable. When I get onto the Vaporetto at the Piazza Roma it is a delight to know that I am saying goodbye to motor vehicles . . . and its is always a shock to be confronted by them again with their noise, the fumes and the ugly, unsympathetic shapes. Unlike the streets of London, Paris or Florence, Venice is not defaced by line upon line of ugly chrome and metal boxes and, one's nerves

are not constantly assaulted by lumbering lorries or shrill, unsilenced motorbikes. What bliss it is to live without them . . .

Venice is a gentle city. People in Venice have time, life is less hectic. In the restaurants in the evening families as well as foreigners come and eat and you quickly get to know your favourite restauranteurs. They greet you like old friends and in the back streets between the Accademia and the Piazza Roma you can find many relatively cheap places to eat around Campo San Barnaba and Campo Santa Marguerita . . .

BERNARD DUNSTAN

The Bathroom Mirror, Venice
Oil on canvas laid on board,
$16\frac{1}{2} \times 12$in (41.9×30.5cm)

When I think of Venice my mind is full of happy memories, very few sad ones, and it is this ambience that makes it such a good place to work in. I have worked in many exotic locations . . . but for me there is no greater anticipation than that of another visit to Venice. Yes, London may be my wife, but Venice will always beckon, promising more discoveries and constantly beguiling.

Bernard Dunstan and his wife Diana Armfield (both born 1920) have been going to Venice for the last 15 years in February, or March when it is less crowded. They try to stay in a hotel room with a view, in recent years the Hotel Londres et Beau Rivage on the Riva degli Schiavoni, where Dunstan can paint bedroom interiors with San Giorgio in the distance, and where they can work during bad weather. Diana Armfield prefers softer winter light:

Bright sunlight makes Venice sparkle, it becomes too shiny and you get a chippy, broken light with too much contrast and then you must stick to painting the water. The light reflects from the water making the shadows under the buildings luminous.

They usually remain in Venice itself and Dunstan concentrates on the *campi*:

On the whole we stay in Venice. We have been to Torcello and to Padua along the Brenta, but the 12–14 days, which is all we have in Venice, is not long, and there is plenty to do.

We never get tired of Venice. You wonder sometimes especially if you arrive in the rain, whether you will find anything, but you always do. I come back to the same things – it worries me sometimes, but it always happens. For example the Campo San Stefano which I keep trying to paint in different conditions, or San Bartolomeo with the statue and people. I always leave thinking there are things I would like to have done.

Favourite spots are the Molo and the Riva degli Schiavoni, the Zattere when the sun has gone round, the Giudecca in the shade and San Giorgio seen from the Giudecca. They both like to draw in the cafés and restaurants where they feel at ease:

We carry on drawing in the evening even when the light has gone. A particularly beautiful time is when the lights are just coming on; it is also great fun drawing in the Piazza at night.

DIANA ARMFIELD

Scuola di San Giorgio degli Schiavoni

Oil on canvas laid on board, 8½ × 8in (21.6 × 20.3cm)

Photograph courtesy of Browse and Darby, London

Neither wish to socialize with other British artists nor are they directly influenced by previous painters of Venice:

You find you own Venice – you must be your own person in Venice or you would worry that what you did was not good enough.

Nevertheless Dunstan acknowledges his debt to Whistler as well

as to Monet and Renoir, and they both admire Sickert's vision of Venice. Like Sickert they prefer the more intimate views of Venice, 'We like the corners, the small 'bits' of Venice, whereas other artists take in much more than we do in any one picture'. They are always sad when their two weeks working in Venice are over:

It is always sad to leave, especially when you see others arriving. We always think of Sickert leaving Venice for the last time on a cold damp morning with his bags full of drawings and his girl left behind.

Whereas Bernard Dunstan and Diana Armfield usually seek out the quiet and more intimate corners of Venice, John Ward (born 1917) who has worked in Venice for over 35 years, prefers the Piazza:

When I first told friends that I was going to Venice they urged me to seek out the odd corners, the little known places for subjects but as

JOHN WARD
Reflection of Florians
Pencil and watercolour,
15 × 22in (38.1 × 55.9cm)

PATRICK PROCKTOR

Rio di San Sebastiano
Watercolour, 18 × 24in
(45.7 × 61cm)
Private collection

soon as I'd seen St Mark's . . . I knew it would be trite not to draw what was obvious and constant visits have not moved me from that reasoning. Venice is the architectural nude, obvious but never the same and now most of my time is spent in the Piazza . . . At the entrance to the Piazza where on your left you climb the steps to the museum, I move behind the sets of pillars so that St Mark's is cut, a little of the Doges' Palace, less of the domes and I note the light on the paving stones and I know that I am arranging one of the greatest masterpieces of the world, switching the views so that they change like moods across a face.

Apart from working on views of the Piazza, often in oil, John Ward also paints exquisite watercolours of the interiors of the cafés, in particular Florian's and Quadri in the Piazza. Like Bernard Dunstan and Diana Armfield he finds that interior Venice is as exciting as exterior Venice.

In many respects Patrick Procktor (born 1936) is the most original of the British painters working in Venice today; his large and often daring watercolours capture not only the Venetian light, but also the excitement of the city, with great verve and 'brio'. Procktor first saw Venice through the eyes of Canaletto, when he admired his amazing realism and later, while at the Slade, he chose to study Turner's *Morning, returning*

from the Ball in depth. He first visited Venice in 1962 on a travelling scholarship, arriving by sea. As with so many people, the first impression of Venice had a lasting effect upon Procktor, and he returned in 1968. During the 1970s he had a studio on the Zattere, but in recent years he has stayed at the Hotel Monaco and Gran Canale, not only for the splendid views over San Giorgio and the Salute, but also for the ceaseless activity which takes place along the Grand Canal at that point. Procktor enjoys Venice in the winter, when the sea fogs close in and when the city takes on an operatic grandeur, with hazy vistas pierced by the occasional light. He also likes sunny weather when the water sparkles, and becomes a subject to paint in itself, thus removing some of the problem of painting such a well-known place. He usually paints watercolours on the spot and these often serve as the basis for larger oils which are painted in the studio.

Many younger artists, some originally taught by Greenham, Dunstan and Ward, have visited Venice to paint. Martin Yeoman (born 1953) tries to stay for at least six weeks on each visit, usually at the Pensione Calcina where Ruskin stayed on the Zattere, and he paints entirely on the spot. His sensitive studies of buildings on the Grand Canal, often painted within a close tonal range, have great luminosity. Tom Coates (born 1941) also works within a close tonal range, and his best work captures the bustle and movement of Venetian markets and cafés while Derek Mynott prefers a more contemplative approach to Venice. The art of watercolour also flourishes amongst painters of Venice. Vivian Pitchforth (1895–1982) painted loose, low-keyed wash drawings, and other watercolourists of note today include Leslie Worth, John Doyle and Christa Gaa. Nor have Scottish artists ignored Venice; both Earl Haig and Alberto Morrocco have painted there in recent years. The problems of painting Venice are as great today as they were when Turner first arrived in 1819, even if the nature of the problems has changed. It is now necessary to examine these questions in a broader, less chronological manner.

10 'This amazing city created especially for the painter'

No city has been painted as much as Venice, and few places have been so badly represented. Venice is one of the homes of bad tourist art, a thriving industry from Montmartre to Hongkong, from Bali to Cairo, and an industry which Venice helped to found. Venice has been represented in obvious, unimaginative views of the Grand Canal or St Mark's, architecture flattened against a summer sky, gondolas sitting uncomfortably on, rather than in, clear blue water; a Venice that the tourist wants to show neighbours and friends. 'Obvious Venice' was always a danger, even to artists who by training and experience had learned to avoid the obvious, as the later work of James Holland shows. The dangers of Venice lay, and still do, as much in the commercial advantages of painting the city, as in lapses in artistic sensitivity and appreciation brought about by so many painterly views. From the late 1820s onwards the commercial possibilities of Venetian views became apparent to artists and dealers, and even the greatest artists of suceeding periods were not too disinterested to cash in on the popularity of Venice.

Possibly the greatest fascination lies in the different interpretations placed on Venice by artists throughout the last two centuries, for Venice the tourist centre, the city of famous views, is but one of a series of interpretations. It is width of appeal, breadth of interpretation, which makes Venice a painters' paradise, so much so that generations of artists have painted her, without repeating the work of others. The greatest problem facing an artist, even Turner, when arriving in Venice is the weight of work which has been done by artists in the past.

Venice, more than any other city, has been preserved as an architectural museum and few painters, however uninterested in the past, can escape the historical associations which haunt every panorama, *campo* or *calle*. An artist painting Santa Maria della Salute is taking on much more than a landscape or townscape; he is taking on centuries of tradition and renderings of precisely the same view by artists as well known as Canaletto, Guardi, Whistler, Sickert, Monet or Sargent. It is thus impossible, even for the most uncultured artist, to paint Venice without an acute awareness of what has gone before.

The Venetian landmarks have become so well known that they have almost become icons of nineteenth-century landscape art. The unfortunate artist struggles to paint these secular icons; on the one hand he can simply repeat what has been done before, or what he himself has painted previously; on the other he can attempt a new interpretation. In the case of religious imagery, the church and the patrons can reject the artist's originality; in the case of Venice, the public, as aware of what has gone before as the artist, can scorn his attempts to break the mould. The topography of Venice can be as rigid as the decrees of the Council of Trent; an artist will not be excommunicated for painting the Salute in the wrong place or with the wrong dome, but he certainly risks ridicule from the public, unless, or course, he can somehow make the topography appear irrelevant, as Turner did in many of his Venetian pictures.

Breaking the mould has been the prerogative of very few painters who have worked in Venice; Turner, Bonington, Whistler, Sargent and Sickert are probably the only Anglo-American artists who broke away from the accepted traditions and went on to establish new traditions in their own right. Bonington's followers include Callow and Holland, artists who perpetuated his cool, draughtsman's approach; Whistler spawned an army of etchers and pastellists who retouched 'The Master's' original vision, often very successfully, but always within Whistler's parameters. Sargent's sparkling watercolours have had an extended influence and many artists, a hundred years later, still appear spellbound by his verve and technical virtuosity; but his earlier oils also exerted great influence, especially over his American contemporaries. Sickert's influence is still visible amongst those contemporary British

artists who have adopted his informal approach to Venice. There are, in addition, a few lesser artists who broke away from conventional representations of Venice, but whose influence on others was negligible. Amongst this category are Prendergast, Brangwyn and Goodwin. Thus the attractions of Venice are great – subjects ready-made for artists and an assured market; but the dangers are equally threatening – the weight of art-historical tradition hanging over every view, and the temptation to paint easy-selling pot-boilers.

Most artists returning to Venice after a time away have complained about changes, invariably for the worse. Ruskin was not alone in his lament about the decline of the city, but despite the railway bridge, the erection of gas lamps and the increasing noise from tourists and *vaporetti*, the general outlook of Venice changed comparatively little between 1819 and 1914. Since the First World War greater visual changes have taken place, above all the disappearance of sailing ships in the Giudecca and along the Riva. It would be difficult to imagine the etchings of Whistler, Bacher and McBey without the distinctive masts and spars of innumerable sailing vessels. The other great change which has taken place since the early 1960s is the tourist invasion, which often makes the Piazza and the Riva look more like a fairground than the elegant spaces they once were. One writer has recently lamented:

There is no elegance in Venice in these days of fat-bottomed matrons in shorts, jeaned kids with rucksacks and jokey New Yorkers on the vaporetti who ask if this bus goes to Madison Avenue.

The best artists have adapted to these changes rather than defiantly painting an empty Piazza or a Grand Canal without *vaporetti*; incorporating into their work the twentieth century with all its noise and tourism, or seeking out views where such intrusions are slight. Ken Howard boldly paints the *vaporetti* stations, while Bernard Dunstan and Diana Armfield seek out the lesser-known *campi* or paint Venice out of season. Despite all the changes, many views remain the same – the sunsets from the public gardens, the Salute in the mist, San Giorgio Maggiore sparkling in the morning sun; more has remained unchanged than any plane-load of tourists can alter.

What has changed more than the city itself are the

conceptions and interpretations placed on it by artists who are themselves often influenced by writers and political therorists. The concept of a city in decline is prevalent throughout the first half of the nineteenth century, and Turner, often fascinated by the idea of civilizations on the wane, was able to superimpose an added political dimension upon his views of Venice. It is maybe the shock of realizing that beneath what appears to be straightforward view of a Venetian fishing boat in *The Sun of Venice* lurks a blacker interpretation. Part of Turner's success in painting Venice was his ability to take the somewhat shallow view of the *vedustisti* and imbue it with a more sinister meaning; if not the fishermen sailing to their deaths, then a once-noble civilization groping towards extinction. Underlying many of Ruskin's thoughts and watercolours is the same fear for Venice's future; maybe less fear for the economic or political future, as he seemed surprisingly unconcerned about the Austrian occupation, than a fear for the future of the physical fabric of Venice. His watercolours and drawings, often themselves hesitantly executed, imply a fragile fabric, a frail physical presence which could so easily evaporate.

As the nineteenth century progressed, so the fear for Venice's future declined, and in its place came a greater interest in its people and customs. The concept of an evil Venice had its roots in Italian history, and exaggerated stories of torture, poisonings and executions often replaced genuine admiration for a successful republic. Shakespearean interpretations on canvas exploited the evil darkness of the city, and even Sargent made use of this atmosphere in paintings depicting dark *campi* in which prostitution and evil-doings are implied. By Sargent's time, however, most artists were more interested in the positive aspects of Venetian life; the attraction of *dolce fa niente* and life spent out of doors amid idyllic surroundings. Sargent's interpretation of life for the average Venetian was nevertheless more accurate than the idylls painted by Henry Woods and Luke Fildes, but even Sargent's compatriots, Duveneck and Blum, glossed over the real poverty and deprivation whch must have existed. Looking at canvases such as Duveneck's *Water Carriers* or Fildes's *Venetians* it is difficult to believe that grinding poverty was an everyday and accepted feature amongst the small canals and *calli* that lay just behind the imposing façades

along the Grand Canal. The explanation for this lack of social realism in paintings of Venice may lie in the seductive charms of the city which made idleness, which was in fact enforced through poverty and unemployment rather than chosen for preference, appear an acceptable form of *dolce fa niente* as W.D. Howells recognized:

Indeed the indolence of Venetians is listless and silent, not playful or joyous; and as I learned to know their life more intimately, I came to understand that in many cases they are idle from despair of finding work; and that indolence is as much their fate as their fault.

It is possibly in a general lack of real concern about the ordinary people of Venice that we find one answer to the question of why no real school of painting evolved amongst the Anglo-American painters of Venice. It could have been a centre for a progressive school, just as Newlyn was for Stanhope Forbes, Frank Bramly and Walter Langley, or Cockburnspath and Grez were for the 'Glasgow Boys', but one looks in vain for any unifying elements in the work of those artists painting in Venice; influences, yes, but rarely a common, shared aim. The painters of the Newlyn School did not take to Venice; Frank Bramley visited in 1882/3 and although he found the girls pretty and the models readily available, he disliked the cold winter: 'I cannot stand it any longer, but after as little while the feeling passes away.' Some years later he told Stanhope Forbes that Venice had almost killed him. Chevallier Tayler was sent to Venice in June 1887 by Tooths, but no Venetian work by him is known today, and by February 1888 he was back in Newlyn. Stanhope Forbes visited Venice after the innovative period of Newlyn was over, as did Henry Scott Tuke, and in neither case does Venice feature amongst their important work. Likewise, few of the Glasgow School painters visited Venice, and again, those that did went during the 1890s when the greatest period of innovation was over. Arthur Melville created some memorable visions of Venice, despite being disappointed with it, and although Alexander Mann's Venetian work is fine, it cannot be argued that Venice played any role in the development or achievement of the Glasgow School.

Venice was too cosmopolitan, too sophisticated, despite the poverty of its people, to provide a substitute for Newlyn or

Cockburnspath; moreover, while it did have gondoliers and bead stringers, it lacked the land workers which so appealed to the Realist painters of the nineteenth century. Most of the Realist painters, be they in Newlyn, Barbizon, Glasgow, Grez or Damvillers, deliberately avoided views, so Venice with its ubiquitous views was unlikely to appeal to them. Possibly the only artists who managed to capture the real Venice, the city of poverty and prostitution, were Sargent in his earlier oils and Sickert, who somehow managed to keep the beauty of Venice as a backdrop to more perceptive statements about its people. Venice, like Newlyn, was a centre for artists, and there can be no doubt that it had great attractions – a wealthy, English-speaking society, plenty of models, sexual tolerance, cheap food and lodgings, and a supportive and friendly international community of artists. Seduced by all this in addition to a lifestyle of *dolce fa niente* it is not surprising that few artists probed beneath the surface.

One of the original reasons for British artists to visit Venice was to make studies for theatrical backdrops and dioramas. The association between Venice and the theatre is close, but apart from inspiring stage scenery, Venice can be seen in itself as a kind of theatre. The lay-out of the Piazza and Piazzetta with framing colonnades and the pavement marked out in coloured bands, the view from St Mark's across the Piazzetta towards San Giorgio, now so often obscured by tourists and the Salute seen from the Riva degli Schiavoni are amongst the many theatrical views of Venice, and were created with the intention of spectacle.

How artists responded to this depended upon their approach to Venice; some, especially the High Victorians like Birket Foster, John Bunney or J.D. Harding, took a formal approach, painting the buildings from well-known viewpoints and often placing them centrally in their compositions, making sure not to clip, foreshorten or detract in any other way from their importance. Others, like Sickert and his more recent followers, have taken an informal approach, showing truncated sections of major buildings, to suggest place rather than state it. By doing this, the informal painters have managed to avoid the problem of views and therefore of painting the obvious. Whistler was a master of the informal view and of finding, in his

own words, a 'Venice in Venice that the others never seem to have perceived.' He did this, not so much by showing glimpses of famous buildings, as much as by searching out quiet canals, gardens and *campi*. Moreover, his technique – the apparently effortless and 'unfinished' pastels and the delicate, again apparently unfinished etchings – reinforce this informality, especially when set against the high finish of Birket Foster, or Whistler's American contemporaries like Frank Duveneck or Thomas Moran.

On the surface the architecture of Venice might appear formal, with the regular façades of Sansovino's Library, the Procuratie Vecchie in the Piazza or the mathematically calculated church façades of Palladio. To those artists more at home in the small *campi*, however, Venetian architecture is delightfully informal, with windows of differing styles, sizes and heights, irregularly placed arches and totally unexpected glimpses into spaces beyond.

Some artists, in particular Sargent and Prendergast, surprise us, not only by truncating well-known buildings, but by choosing unusual viewpoints. Prendergast's superb views down into the Piazza, or Sargent's views up towards the façades of the Salute from water level provide visual shocks – well-known views from unknown angles. Brangwyn also managed to re-state the obvious, by means of lighting and composition. Most artists have re-arranged the topography of Venice at some stage during their careers, not only to improve composition, but also to encompass wider panoramas within their canvases. Bonington was a master of that subtle re-arrangement which enhances the sense of place. One building which has constantly been re-arranged is the Salute. Turner first gave its unusually rounded dome greater height and generations of succeeding artists have done the same, making it look more like Michaelangelo and della Porta's dome of St Peter's than Longhena's singularly Venetian construction. However, whether formally or informally approached, whether re-arranged or not, Venice still retains its theatrical elements; man-made space with actors on the stage moving between well-known and carefully positioned scenery.

Many writers have drawn analogies between the veined Istrian marble used so effectively in Venetian architecture and the sea. Hugh Honour writes of Torcello Cathedral:

The interior . . . has a strangely marine appearance. The grey moiré silk of the marble columns and panelling of the main apse seem to have been patterned by the wash of waves, while the white capitals and other carvings appear to have been fashioned and blanched by the pounding of breakers; there is even a touch of seaweed green about the bases of the columns – as if they had been standing for centuries in an ocean cave.

Venice is close to nature, far closer than any other European city, and this closeness provides a scintillating interface between man's creation and the power and beauty of nature. The flickering light reflected from the water transforms the façade, making even the strictest classical detailing sparkle and dance. The great churches of San Giorgio and the Salute change hourly, flickering in the morning sun, languid in the midday heat or floating above the sea mist in the autumn evening. The sunsets transform the city into a dramatic stage, lit from behind and changing every moment; the white marble takes on a soft pink hue, and even in the most confined spaces, the evening light can be seen catching the tops of buildings or deflected from the clouds. Then the great storms, brilliantly rendered by Turner and Stanfield, bringing great ultramarine-hued clouds, which throw the marble palaces and church façades into luminous relief; or the autumn mists and sea fogs which transform Venice into an oriental landscape, selective details standing forward against a plane of blue-grey; or Venice at night, the lights on the Island of San Giorgio twinkling across the Lagoon and the navigation lights of a ship coming into view as it crosses from the Lido – a Venice that belongs to Whistler. Equally beautiful is the rain which darkens and enriches the marble columns and panels of St Mark's and turns the pavements into dull mirrors, reflecting the legion of umbrellas which have opened up. Venice is a city transformed by changes in nature, its roots as deep in the Lagoon as its piled foundations.

Venice will continue to attract artists, even though high prices and crowds of tourists make life more difficult for the painter of today. He will, however, continue to be attracted by its beauty, its mystery and its ever-changing aspects, as well as by the challenge to find something new and personal to say in such an artistically renowned spot. He will be attracted by the

Venetian way of life, and possibly by the freedom from the motor car which has destroyed not only the fabric, but also much of the social life of many cities. Ironically, although Venice was rejected by the Realist painters of the nineteenth century in favour of rural villages, Venice might in future years teach us again how to live as communities. Still centred upon the *campi* and *sestieri*, the Venetian communities meet in the evenings to socialize and discuss the day's affairs, free from the tyranny of the traffic which has split communities and broken down old social patterns of behaviour in so many cities. To a future generation of artists seriously interested in man's social welfare, Venice may well provide a fascinating model.

Once visited Venice is never forgotten, and for many people their first arrival in Venice is an experience never to be forgotten, as Charles Dickens wrote in 1844:

I have never been in my life so struck by any place as by Venice. It is the wonder of the world. Dreamy, beautiful, inconsistent, impossible, wicked, shadowy, d—able old place! I entered it by night, and the sensation of that night and the bright morning that followed is a part of me for the rest of my existence.

Select bibliography

Modern guide books

HIBBERT, C., *Venice: the Biography of a City*, London, 1988

HONOUR, H.J., *The Companion Guide to Venice*, London 1977 (still the best general guide to Venice)

MORRIS, J., *Venice*, London, 1974

NORWICH, J.J., *A History of Venice*, London, 1982

TOURING CLUB ITALIANO, *Venezia e dintori*, Milan, 1969

Contemporary books

BRINTON, S., *Venice Past and Present*, Studio Special Number, 1922

BROWN, H., *Life in the Lagoons*, London, 1884; *In and Around Venice*, London, 1905

DE SELINCOURT & HENDERSON, *Venice*, 1907 (illustrated by Reginald Barratt)

HOWELLS, W.D., *Venetian Life*, 1867, revised 1883 and 1907

MENPES, D., *Venice*, London, 1904 (illustrated by Mortimer Menpes)

SMITH, J.H., *Gondola Days*, Boston, 1897

TYNDALE, W., *An Artist in Italy*, London, 1913

Exhibition catalogues

PARKIN GALLERY, *The English in Venice*, 1976

WILDENSTEIN & CO., *Venice Rediscovered*, 1972; *Venice Observed by Contemporary British Artists*, 1976

Chapter one

BUTLIN, M., *Turner Watercolours*, 1962

BUTLIN, M. & JOLL, E., *The Paintings of J.M.W. Turner*, 2 vols, Yale, 1977

CORMACK, M., *Richard Parkes Bonington*, Oxford, 1989

FINBERG, A.J., *In Venice with Turner*, Cotswold Gallery, 1930

GEORGE, H., 'Turner in Venice', *Art Quarterly*, vol. LIII, 1971, pp.81–7

MARCHAND, L., *Byron – A Portrait*, London, 1971

PEACOCK, C., *Richard Parkes Bonington*, London, 1979

POINTON, M., *Bonington, Francia and Wyld,*, London, 1985

QUENNELL, P., *Byron in Italy*, London, 1941

STAINTON, L., *Turner's Venice*, London, 1985

TATE GALLERY, *Turner 1775–1851*, exhibition catalogue, 1974

Chapter two

BLUNT, C., *The Life and Work of William James Müller*, Leigh-on-Sea, 1948

FARR, D., *William Etty*, London, 1958

LOCKETT, R., *Samuel Prout*, London, 1985

SOLLY, N., *Memoir of the Life of William James Müller*, London, 1875

VAN DER MERWE, P., *The Spectacular Career of Clarkson Stanfield*, Tyne and Wear County Council Museums, 1979

Chapter three

BRADLEY, J.L. (ed.), *Ruskin's Letters from Venice 1851–2*, Yale, 1955

CLEGG, J., *Ruskin and Venice*, London, 1981

COOK, E.T., *Homes and Haunts of John Ruskin*, London 1912

EVANS, J., *John Ruskin*, London, 1954

EVANS, J., & WHITEHOUSE, J.H. (eds), *The Diaries of John Ruskin*, 3 vols, Oxford, 1956–9

GOODWIN, A., *The Diary of Albert Goodwin*, privately published, 1934

HEWISON, R., *Ruskin and Venice*, London, 1978

LUTYENS, M., *Effie in Venice: Unpublished letters of Mrs John Ruskin written from Venice between 1849 and 1852*, London, 1965

NEWALL, C. & EGERTON, J., *George Price Boyce*, Tate Gallery exhibition catalogue, 1987

QUENNELL, P., *John Ruskin – The Portrait of a Prophet*, London, 1949

ROYAL SOCIETY OF PAINTERS IN WATERCOLOURS, *Albert Goodwin RWS*, exhibition catalogue, 1986

RUSKIN, J., *The Stones of Venice*, 3 vols, 1851–3

SHAPIRO, H.I. (ed.), *Ruskin in Italy: Letters to his Parents 1845*, Oxford, 1972

SMITH, H., *Albert Goodwin RWS*, Leigh-on-Sea, 1977

STALEY, A., *The Pre-Raphaelite Landscape*, Oxford, 1973

STREET, A.E., 'George Price Boyce', *Old Water Colour Society*, vol. 19, 1941

UNRAU, J., *Ruskin and St Mark's*, London, 1984

Chapter four

BALLANTINE, J., *The Life of David Roberts, compiled from his Journals and other sources*, Edinburgh, 1866

CALLOW, W., *An Autobiography* (edited by H.M. Cundall), London, 1908

CUNDALL, H.M., *Birket Foster*, London, 1906

FILDES, L., *Luke Fildes RA: A Victorian Painter*, London, 1968

GUITERMAN, H., *David Roberts*, London, 1978

MARKS, J.G., *Life and Letters of Frederick Walker ARA*, London, 1896

NOAKES, V., *Edward Lear: The Life of a Wanderer*, London, 1968; *Edward Lear 1812–1888*, Royal Academy of Arts exhibition catalogue, 1985

QUIGLEY, J., *Prout and Roberts*, London, 1926

REYNOLDS, J., *Birket Foster*, London, 1984

Chapter five

BACHER, O., 'With Whistler in Venice', *Century Magazine*, 1908

EDDY, A.J., *Recollections and Impressions of James A. McNeill Whistler*, London and Philadelphia, 1903

LOCHNAN, K., *The Etchings of James McNeill Whistler*, New Haven, 1984

McLAREN YOUNG, A., MACDONALD, M., SPENCER, R. & MILES, H., *The Paintings of James McNeill Whistler*, 2 vols, Yale, 1980

MENPES, M., *Whistler as I Knew Him*, London, 1904

PEARSON, H., *The Man Whistler*, London, 1952

PENNELL, E.R., & J., *The Life of James McNeill Whistler*, 2 vols, London, 1908

Chapter six

CINCINNATI ART MUSEUM, *John Henry Twatchman*, 1966; *Robert F. Blum*, 1966

COE KERR GALLERY, *Americans in Venice 1879–1913*

LOVELL, M.M., *Venice – The American View 1860–1920*, San Francisco Fine Arts Museum exhibition catalogue

PLOWDEN, H.H., *William Stanley Haseltine*, London, 1947

SORIA, R., *Dictionary of 19th Century American Artists in Italy*, 1982

Chapter seven

BLANCHE, H.E., *Portraits of a Lifetime*, London, 1937

CHARTERIS, E., *John Sargent*, London, 1927

HILLS, P. (ed.), *John Singer Sargent*, Whitney Museum exhibition catalogue, New York, 1986

HOOPES, D.F., *Sargent Watercolours*, London and New York, 1970

ORMOND, R., *John Singer Sargent*, Oxford, 1970

WORTLEY, L., *Wilfrid de Glehn*, 1989

Chapter eight

BARON, W., *Sickert*, London, 1973

BAYES, W., *A Painter's Baggage*, London, 1932

BEETLES LTD, C., *Hercules Brabazon Brabazon 1821–1906*, exhibition catalogue (with 41 colour plates), 1986

BIRMINGHAM MUSEUMS AND ART GALLERY, *Memorial Exhibition of works by the late Joseph Edward Southall*, 1945; *Joseph Southall 1861–1944*, exhibition catalogue, 1980

BRANGWYN, R., *Brangwyn*, London, 1978

BROWSE, L., *Sickert*, London, 1943 (some interesting Venetian views reproduced in monochrome)

BUNT, C., *The Watercolours of Sir Frank Brangwyn*, Leigh-on-Sea, 1958

DE BELLEROCHE, W., *Brangwyn – as I know him*, Nottingham, 1940; *Brangwyn's Pilgrimage*, London, 1948

EMMONS, R., *The Life and Opinions of Walter Richard Sickert*, London, 1942

GOODMAN, J., *Edward Seago: The Other Side of the Canvas*, London, 1978

HEWLETT, T., *Cadell*, London, 1988

HUTTON, E., *The Pageant of Venice*, London, 1922 (illustrated by Brangwyn)

LILLY, M., *Sickert – The Painter and his Circle*, London, 1971

SHONE, R., *Walter Sickert*, Oxford, 1988

SUTTON, D., *Walter Sickert – A Biography*, London, 1976

Chronology 1819–1914

1819 Turner's first visit (September)

1820

1821 William Brockedon probably in Venice

1822 William Etty in Venice for two to three months, from 22 November

1823

1824 Samuel Prout's first visit (September) for three weeks

1825 Prout exhibited three Venetian views at OWS

1826 Bonington in Venice (April to May); Wilkie in Venice during the spring; Prout exhibited two Venetian scenes at OWS and one at RA

1827 Prout's second visit; J.F. Lewis in Venice; Bonington exhibited two Venetian scenes at the British Institution

1828 Bonington exhibited one Venetian scene at RA

1829 Bonington's Memorial Exhibition in London

Augustus Wall Callcott during early 1830s

1830 Clarkson Stanfield (October)

1831 James Duffield Harding's first visit

1832

1833 Turner's second visit (September); William Wyld; Turner's two Venetian scenes at RA with Clarkson Stanfield's *Venice from the Dogana*

1834 George Fripp and William Müller (September to November)

1835 Ruskin's first visit; Harding's second visit; James Holland's first visit

1836

1837 Lewis's second visit (or 1838?)
Thomas Brabazon Aylmer, late 1830s to 1850

1838 Clarkson Stanfield's second visit (October)

1839 William Lake Price

1840 Turner's third visit and William Callow's first visit (August to September)
William Wood Deane, 1840s to 1870

1841 Ruskin's second visit (May)

1842 Richard Dadd in Venice for five days

1843

1844 Holland's second visit

1845 Ruskin's third visit with J.D. Harding

1846 Completion of railway bridge to Venice; Ruskin's fourth visit; Callow's second visit

1847 Outbreak of Daniele Manin's revolt against Austrian rule

1848 Establishment of Republic of St Mark (March)

1849 Venetian surrender and exile of Manin (August); Ruskin's fifth visit with Effie (November to March 1850)

1850

1851 First volume of *The Stones of Venice* published (March); Ruskin's fifth visit with Effie (November to March 1852); David Roberts in Venice for three weeks (September); E.W. Cooke's second visit

1852 George Cattermole

1853 Second and third volumes of *The Stones of Venice* published; Alfred Downing Fripp

1854 George Price Boyce (June)

1855 Cooke's third visit (or 1856?)

1856

1857 Holland's third visit; Edward Lear's first visit; Sanford Robinson Gifford (June to July); Frederick Goodall (June to September)

1858 Holland's fourth visit

1859

1860

Edward Angelo Goodall and Oswald Brierly in Venice 1860s to 1870s; Goodall made 15 visits in all between 1860s and 1890s; Holland appears to have made regular trips during 1860s; Charles Caryl Coleman made regular visits 1860s to 1870s

1861

1862 John Inchbold's first visit; Cooke's third visit; William Bell Scott's first visit

1863 Inchbold's second visit; Holland's fifth visit

1864 Inchbold's third visit

1865 Callow's third visit; Lear's second visit (November)

1866 Austrian defeat in Austro-Prussian War. Plebiscite; Venice voted for re-unification with Italy; John MacWhirter's first visit

1867

1868 Birket Foster, Quiller Orchardson and Fred Walker together in Venice (May)

1869 Ruskin's seventh visit – meets Holman Hunt; Gifford's second visit; W.S. Haseltine's first visit – returns regularly from Rome until his death in 1900

1870 Ruskin's eighth visit; John Bunney settled in Venice until his death in 1882; Walker's second visit (June); John Sargent's first visit with family

1871 Henry Newman's first visit

Birket Foster returned most years 1871–7 to work on the Sealey commission

1872 Ruskin's ninth visit with Albert Goodwin and Arthur Severn

1873 Frank Duveneck's first visit; Bell Scott's second visit

1874 Marcus Stone and Luke Fildes; Sargent's second visit

1875

1876 Ruskin's tenth visit (until spring 1877) with Charles Herbert Moore; Fildes's second visit

1877 Callow's fourth visit; Henry Woods's first vist; Duveneck with William Merrit Chase and Henry Twachtman for nine months

1878 Woods settled in Venice; William Graham settled in Venice; Thomas Moran's first visit

1879 T.M. Rooke (May to December); Whistler arrived (September); Duveneck and students in Casa Jankovitz

1880 Callow's fifth visit; Sargent's third visit (September to spring 1881); Twachtman's second visit

Duveneck returned regularly during the summer from 1880 to 1885; Blum returned regularly during 1880s

1881 Fildes joined Woods in Venice; Twachtman's third visit

1882 Sargent returned

1883 Childe Hassam; Joseph Southall's first visit; Frank Bramley; Joseph Pennell's first of many visits over 30 years

Fildes returned regularly 1883–90; Sargent returned many years until 1913

1884 Rooke's second visit

1885 Otto Bacher returned 1885–6

1886 Moran (May to June)

1887 A. Chevallier Tayler (June to December)

William Logsdail living in Venice late 1880s to early 1890s

1888 Ruskin's final visit

1889 Patrick William Adam's first visit (he returned between 1889 and 1892)

1890 Southall's second visit

William Collingwood in 1890s

1891

1892 William Callow's final visit

1893 Thomas Bush Hardy and Dudley Hardy

1894 Duveneck's last visit; Arthur Melville (early summer)

1895 Sickert's first visit (May, possibly until May 1896)

1896 Reginald Barratt's first visit; Frank Brangwyn

1897

1898 Maurice Prendergast; William Gedney Bunce

1899

1900 Sickert's second visit (summer); Walter Bayes's first visit; Walter Tyndale

Tyndale worked regularly in Venice from 1900 to 1914, settling there in 1922

1901 Sickert's third visit (January to June); Helen Allingham; Wynne Apperley *c.* 1900–4

1902

1903 Sickert's final visit (September to summer 1904); Mortimer Menpes with daughter, Dorothy; Barratt's second visit

1904 Moffat Lindner (or possibly 1903?)

1905

1906 William Horton's first visit; Barratt's third visit

1907 William M. Chase; Brangwyn in Venice for Biennale – met Alfred East and Sargent

1908 Donald Shaw MacLaughlan's first visit – returned each year until 1913; Charles Mackie with A.B. Thomson

1909 William Walcot's first visit (returned between wars); Southall's third visit (returned between wars); Alfred Hayward's first visit (returned often between wars)

1910 William M. Chase; William Horton; F.C.B. Cadell; R.C. Goff

1911 Maurice Prendergast (September to 1912); George Haité; Romaine Brooks

1912 Haité

1913 Sargent's last visit to Venice; William M. Chase; William Horton

1914 Outbreak of First World War

Dictionary of artists

ARA	Associate of the Royal Academy
RA	Member of the Royal Academy
PRA	President of the Royal Academy

Similarly:

RSA	Royal Scottish Academy
RWS	Royal Watercolour Society
RBA	Royal Society of British Artists
RHA	Royal Hibernian Academy
RSW	Royal Scottish Watercolour Society
RI	Royal Institute of Painters in Watercolours
ROI	Royal Institute of Painters in Oil-Colours
NEAC	New English Art Club
OWS	Old Watercolour Society (later RWS)
RE	Royal Society of Painter-Etchers and Engravers

Edwin Austin Abbey, RA, RWS, RI, 1852–1911
Born in Philadelphia and studied at Philadelphia Academy of Fine Arts, before working as an illustrator. In 1880 he settled in England and visited Venice in 1888 and 1893 to make studies for his panel *The Quest of Achievement of the Holy Grail* for Boston Public Library. He was known for his large, decorative murals and for his illustrations of Herrick, Goldsmith and Shakespeare, including Venetian scenes. He was a friend of Ralph Curtis in Venice.

Patrick William Adam, RSA, 1854–1930
Edinburgh painter of portraits and interiors. He visited Venice from 1889 to 1892 during which time he produced a series of watercolours of Venice. He appears not to have returned after 1892.

Andrew Affleck, born 1869
Scottish etcher who produced some of his best work in Venice. His Venetian etchings are often large with rich contrasts, although frequently topographically inaccurate.

Frederick James Aldridge, 1850–1933
Marine painter, who often used watercolour. He lived and worked in Worthing but painted many views of boats on the Venetian Lagoon.

Herbert Alexander, RWS, 1874–1945
Studied at the Slade and Herkomer's School in Bushey, he painted a number of detailed Venetian watercolours.

Robert Graham Dryden Alexander,
1874–1945
Watercolourist influenced by the Barbizon School. He used a loose watercolour style that reflects his friendship with Clausen and Mark Fisher. He painted free watercolours of Venice, for example *Sunset, Venice*, (Victoria and Albert Museum).

Adrian Paul Allinson, 1890–1959
Studied at the Slade and in Munich and Paris. Visited Venice in 1922 and instantly fell in love with it:

In Venice where the traveller is pitched without warning . . . into a Grand Canal with its bobbing gondolas and floating palaces, I had continually to remind myself that the scene was not a mere hallucination conjured out of sleep. I could be no passive beholder here; those crumbling palaces and churches in their mouldering pinks and lemons, those slender bridges and mysterious waterways all clamoured to be painted.

George Henry Andrews, RWS, 1816–1898
In Venice during the 1880s and exhibited Venetian subjects painted in a slightly wooden manner at the RWS.

George Owen Wynne Apperley, RI,
1884–1960
Self-taught landscape painter whose early restrained style gave way to a more vibrant colourful manner, especially after settling in Spain around 1920. His Venetian watercolours date from 1900 to 1904 and some of his nocturnes and church interiors are notable.

Maxwell Ashby Armfield, RWS, 1882–1972
Studied at Birmingham School of Art and in Paris. His interest in Italian art and the techniques of the early Renaissance were shared by Joseph Southall. Published *An Artist in Italy* in 1924, which included a section on Venice, but he was less successful at capturing Venetian light and atmosphere than Southall.

John T. Arms, ARE, 1887–1953
American etcher, born Washington DC and trained as an architect. Worked extensively in Europe and produced etchings of Venice.

Francis Arundale, 1807–1853
Architect and topographer. Studied with Pugin and visited the Middle East. Often wintered in Rome from where he visited Venice. Painted Venetian views in the 1830s and 1840s. Married the daughter of Francis Pickersgill.

Charles Reginald Aston, RI, 1832–1908
Birmingham landscape-painter who worked mostly in watercolour. Worked in Italy and Venice.

James Aumonier, RI, 1832–1911
Born in London and studied at South Kensington Schools. Painted mostly English landscapes in a style close to Thomas Collier and E.M. Wimperis, both of whom were friends. Visited Venice in the 1890s where he painted some effective watercolours.

Thomas Brabazon Aylmer, 1806–1856
Painter of continental views in both oils and watercolours. First visited Venice in the late 1830s but returned regularly. His style is tight and colourful, similar to the Rowbothams.

Alexander Ballingall, worked 1880–1914
Scottish artist who painted watercolours of east coast fishing villages. Also worked in Venice, often on a large scale.

Elaine Barran, born 1892
Born in Leeds, watercolourist and oil painter of landscapes. Worked in Venice during the 1930s and exhibited at the Fine Art Society.

Ainslie Bean, worked 1880s–1910
Watercolourist, often painted Venice. The quality of his work varies from the weak to fine, highly toned works.

Edward H. Bearne, worked 1860s–90s
Painted landscape and genre, mostly in watercolour. Painted watercolours in Venice during the 1880s which he exhibited at the RI.

Robert Anning Bell, RA, 1863–1933
Studied at RA Schools and Westminster School of Art; later worked in Paris and Italy. Figure painter, designer, illustrator and relief sculptor. He visited Venice on several occasions where he painted in watercolour.

Lilian Russell Bell, worked 1890s–1930s
Painted loose watercolours of Venice using a light touch to create sparkling atmosphere. Appears to have worked in Venice in the 1890s.

Eugene Benson, 1839–1908
Born in New York, died in Venice. He first visited Venice in 1871, returned regularly, and exhibited views of Venice at the Philadelphia Centennial Exhibition 1876.

Alfred John Billinghurst, RBA, 1880–1963
Landscape and portrait painter who worked in oils, watercolour and pastels. He often painted water, working beside the Thames or along the coast, and also visited Venice on several occasions.

Geoffrey Birkbeck, RBA, 1875–1954
Norwich painter, occasionally visited Venice, which he painted in loosely handled watercolours.

William Henry James Boot, RBA, RI, 1848–1918
Landscapes, interiors and genre. Art editor of *The Strand Magazine* and illustrator. He travelled widely in Europe and North Africa. Worked in Venice from the 1880s until 1914.

John Henry Bradley, 1832–c.1890
A pupil of David Cox and James Holland, he often worked in Venice from the 1860s onwards in a similar style to that of Holland.

William A. Breakspeare, RBA, ROI, 1855–1914
Genre and figure painter. Studied in Paris and was later involved with the Newlyn School. Painted Venetian figures in the 1880s.

Henry Charles Brewer, RI, 1866–1943
Son of an architectural painter, he studied at Westminster School of Art and later specialized in watercolour landscapes. He often worked in Mediterranean countries, especially Spain and Italy. His watercolours are loose and atmospheric and he particularly enjoyed skies at dawn and sunset. He visited Venice on several occasions and in 1932 held an exhibition, 'Watercolours of Venice and Northern Italy' at the Fine Art Society.

Edward F. Brewtnall, RWS, RBA, 1846–1902
Painter of genre and figures, often set in landscape, his style being rather sweet. He appears to have worked in Venice in the late 1870s.

Frederick Bridgeman, 1847–1928
Born in Alabama, USA and studied in Atelier Jérôme, Paris. He exhibited in London and Paris and worked in Venice.

Sir Oswald Brierly, RWS, 1817–1894
Marine painter in oils and watercolour, travelled widely including a trip around the world, Crimea and the Nile. Appointed Marine Painter to the Queen in 1874. Spent much time in Venice with Edward Angelo Goodall who himself visited Venice 15 times.

Frederick Brill, RBA, worked 1940s to 1960s
Influenced by the Camden Town School. Visited Venice in the 1950s.

Romaine Brooks, 1874–1970
Born in Rome of American parents; brought up

in USA, France and Italy. Married the British artist John Brooks, in Capri in 1903. Visited Venice in 1911 and again in 1915. Painted in Venice, Capri and London. She was impressed by Gabriel d'Annuzio on whom she wrote a book.

George Loring Brown, 1814–1889
Born in Boston. Visited Europe in the 1850s and developed a landscape style influenced by Claude Lorrain. He worked mainly around Rome in the Italian Campagna, but also painted in Venice.

T. Bryant Brown
English landscape-painter, in Venice around 1908.

Andrew Fisher Bunner, 1841–1897
Born in New York, but studied art in Europe. From 1882 lived in Venice, painting oils, but later worked more in watercolour.

Harold Arthur Burke, VPRBA, 1852–1942
Studied South Kensington, RA Schools and Paris. Landscape painter who often worked abroad including Venice.

Clement Burlison, worked 1840s to 1850s
Landscape painter who exhibited Italian and Venetian subjects at the British Institution. J. Burlison also exhibited Venetian works and lived at the same London address.

William Hickling Burnett, worked 1840s to 1860s
London painter of landscapes and architecture, often Italian subjects. He travelled extensively in Europe and North Africa, and worked in Venice in the 1850s in a tight oil style influenced by the Venetian *vedutisti*.

Cameron Burnside, born 1887
Landscape painter who worked in Venice around 1910, producing loosely handled architectural watercolours.

Sir Augustus Wall Callcott, RA, 1779–1884
Studied at the RA Schools and with John Hoppner. Early works were mostly portraits but

later turned to landscape, painting in Italy, Holland and Germany. Influenced by Claude Lorrain. He was in Venice in the 1830s, and although Ruskin did not admire his work, his Venetian oils have a cool luminosity and attention to detail, without being overworked, that makes them effective.

Gabriel Carelli, 1821–1900
Landscape painter born in Italy, but settled in England and married an Englishwoman. He was patronized by Queen Victoria and travelled widely, painting. His Venetian work is detailed and precisely painted.

Emil Carlsen, 1853–1932
Born in Denmark, he settled in USA, but returned to paint in Europe between 1884 and 1886 and 1908 and 1912. He painted Venice in small, quiet monochromatic pictures.

Sir Hugh Casson, PPRA, born 1910
Some elegant and often witty watercolour sketches of Venice.

John Linton Chapman, 1839–1905
Born in Washington DC, the son of an artist. Lived in Rome and Florence with his parents. Financially unsuccessful as a painter, he lived and died in poverty. He painted views of Venice.

James Charles, NEAC, 1851–1906
Studied at the RA Schools and in Paris where he was influenced by the contemporary *plein-air* movement. He visited Venice between 1891 and 1892 and in 1905, painting views with Venetian figures in a style similar to that of Henry Woods.

Lady Chelmsford
Landscape painter who had an exhibition 'Watercolours of Venice and Elsewhere' at the Fine Art Society in 1938.

Charles Cheston, RWS, RE, NEAC, 1882–1960
Painter and etcher of landscape and architectural

subjects. Painted and etched Venice between the wars.

Alexander Christie, ARSA, 1807–1860
Edinburgh painter of historical and genre subjects. Visited Venice in the mid-1840s where he painted some oils.

Sir Winston Churchill, Hon. RA, 1874–1965
Churchill particularly enjoyed painting in Venice and on the French Riviera.

John Cosmo Clark, RA, RWS, NEAC, CBE, 1897–1967
Studied at Goldsmiths, RA Schools and in Paris. Painted landscapes in oils and watercolours, and also worked in Venice between the wars.

Sir Caspar Purdon Clarke, 1846–1911
Born in Ireland and trained as an architect in London. He later became Director of the Victoria and Albert Museum, London and the Metropolitan, New York. He painted architectural studies of Venice in watercolour.

Helen Lavinia Cochrane, 1868–1946
Born in Bath, studied in Liverpool, London and Munich. She lived in Italy for many years and painted in watercolours. In 1925 the Fine Art Society held an exhibition, 'Watercolours of Venice and Liguria in Sun and Mist'.

Samuel Coleman, 1832–1920
Born in Portland, Maine. He lived in Europe between 1871 and 1875, including Venice, Italy and Spain. During this period he painted views of Venice; he later lived in Morocco for some years.

William Collingwood, RWS, 1819–1903
A pupil of J.D. Harding and Samuel Prout, he was known for his Alpine views, but he visited and painted Venice in watercolour during the 1890s.

Alfred Charles Conrade, 1863–1955
Born in Leeds, he studied in Düsseldorf, Paris and Madrid. He often painted architectural subjects in Italy and Spain, and he specialized in church interiors and exteriors while in Venice.

Ebenezer Wake Cook, 1843–1926
Watercolour painter who painted the Thames, Switzerland and Italy. His watercolours are rich in colour and detail, but not overworked, and Venice provided some of his most successful subjects. (*Illustration p.143.*)

Colin Campbell Cooper, 1856–1937
Born in Philadelphia, he studied in Philadelphia and the Academie Julian, Paris. He spent much time painting European cities, including Venice.

Kenyon Cox, 1856–1919
Born in Warren, Ohio. He was in Venice in 1878 with Theodore Robinson, and returned in 1893, but is known for his murals and portraits rather than landscapes.

Christopher Pearse Cranch, 1813–1892
Born in Alexandria, Virginia, he became a Unitarian minister before turning to art. He was in Europe between 1846 and 1849, and again between 1858 and 1860, visiting Venice in September 1860. Cranch was an interesting Nomadic figure, living in several European cities, including Venice where he had a flat in the Palazzo Foscolo in the Calle Pisani on his return there in 1881. He published a poem *In Venice* in 1889 with his own illustrations. He produced a number of pencil sketches of Venice.

Thomas Hartley Cromek, RI, 1809–1873
Landscape painter, the son of an engraver, Cromek travelled extensively in Greece and Italy between 1830 and 1849. He worked in Venice, specializing in architectural watercolours of church interiors and exteriors, painted on a large scale, with great attention to detail.

Charles Cundall, RA, RWS, NEAC, 1890–1971
Landscape and townscape artist trained in Manchester, RCA and the Slade before working

in Europe. As a young man he worked for Pilkington Pottery, but later turned to portraits and landscape. He visited Venice in the late 1940s and again during the 1950s working in both oils and watercolour, but possibly captured the atmosphere best in his watercolour sketches.

Henry Cundall, 1810–1886
British landscape-painter who exhibited Venetian views in addition to his more usual architectural views of London.

Richard Dadd, 1819–1887
Studied at the RA Schools and travelled from 1842 to 1843 to Italy, France, Greece and the Middle East. His promising career was cut short by advancing insanity, and in 1843 he murdered his father. He visited Venice in 1842 and made sketches on the spot, which he later reworked while confined in mental institutions. *Il Redentore* (Laing Art Gallery) is a pencil and body-colour study painted in 1858 and inscribed 'Reminiscence of Venice from a sketch made on the spot in 1842 by Rd Dadd'. It was painted in Bethlehem Hospital.

Henry Darvall, worked 1840s to 1890s
Landscape and mythological painter, he appears to have moved to Venice in 1875 and lived on the Riva degli Schiavoni. Between 1875 and 1889 he exhibited many Venetian views at the Royal Academy.

John Scarlett Davis, 1804–1844
The son of a Hereford shoemaker, he studied at the RA Schools before travelling widely on the Continent. He specialized in watercolours of interiors of churches and art galleries, but because of his limited output, his work is still little known. He painted several interiors in Venice.

Nelson Dawson, ARWS, RBA, RE, 1859–1941
Marine painter who specialized in views of the Cornish coast, he later produced metal and enamel work, becoming known as one of the leading Arts and Crafts metalworkers. He visited Venice before 1895 and produced both watercolours and etchings.

William Wood Deane, OWS, 1825–1873
Architect and painter in watercolour, he travelled in Spain with F.W. Topham and studied watercolour with David Cox. He first visited Venice in the 1840s and appears to have returned regularly until his death. He exhibited many Venetian views at the OWS.

James T. Hervé D'Egville, *c*.1806–1880
Landscape painter, pupil of A. Pugin and himself later a drawing master. He painted mostly views in south east England and Wales, but he worked in Venice during the 1860s.

J.V. de Fleury, worked 1840s to 1860s
London painter who exhibited Venetian subjects during the 1850s and 1860s.

Richard Denew, worked 1820s to 1850s
Painter of Italian landscape, he was an early visitor to Venice, exhibiting *View of the Rialto on the Grand Canal* at the Royal Academy in 1827.

William Dennistoun, 1838–1884
Trained as an architect, he became the first President of the Glasgow Art Club from 1867 to 1868, but later moved to Italy to paint Italian buildings and landscapes in watercolour. He died in Venice.

Frank Dillon, RI, 1823–1909
A pupil of James Holland, he travelled extensively in Europe, Egypt and the Far East, painting topographical views and interiors. He visited Venice at least once in the 1880s.

Frank Dobson, RA, 1888–1963
Known today as a sculptor and draughtsman, his earlier work was in watercolour, and he painted in Venice prior to the First World War.

Alexander Brownlie Docharty, 1862–1940
Studied part-time at Glasgow School of Art, before turning to art as a profession in 1882. He worked in Paris in 1894. He settled in Ayrshire and painted Highland scenes, but visited Venice to paint on a number of occasions. He painted Venice in both oils and watercolour.

Francis Dodd, RA, RWS, NEAC, 1874–1949
Born in Wales he studied at Glagow School of Art. He is known today for his figures and London views, but he worked in Venice between the wars.

Andrew Benjamin Donaldson, RBA, 1840–1919
Landscape, historical and religious painter, he exhibited some Venetian views at the RBA.

Edwin Stafford Doolittle, 1843–1879
Born in Albany, NY, he lived in Rome between 1868 and 1869 before ill health forced him to return to the USA. While in Italy he produced some paintings of Venice.

Sir William Fettes Douglas, PRSA, 1822–1891
Historical and genre painter and President of the Royal Scottish Academy from 1882 to 1891. He visited Italy in 1857, but his Venetian works, which are in watercolour, date to the 1870s.

Charles Edouard Dubois, 1847–1885
Born in West Hoboken, NJ of Swiss parents, he studied in Paris under Gleyre. He often painted in Europe, including Rome and Venice, and died in Mentone.

Ella Du Cane, worked 1890s–1914
Watercolourist and illustrator, she worked on a number of books for A. & C. Black, including *Italian Lakes*. She spent a number of years in Venice painting watercolours in her highly toned palette.

Robert Dudley, worked 1860s to 1890s
Landscape painter who often worked abroad, including France, Spain, North Africa and Venice.

Edmund Dulac, 1882–1953
Born in Toulouse and trained in France, he settled in England in 1906. Illustrator, painter, stage designer, he illustrated a poem, *Venice* in 1912.

Edward Duncan, RWS, 1803–1882
Marine painter in oils and watercolour, he appears to have visited Venice around 1870.

Ronald Ossory Dunlop, RA, RBA, NEAC, 1894–1973
Born in Dublin but educated in England. He painted landscapes in a broad, loose style and worked in Venice between the wars.

James Durden, ROI, 1878–1964
Studied at Manchester School of Art, and painted much in the Lake District. He also painted in Venice in the 1920s and 1930s.

William Dyce, ARA, RSA, 1806–1864
Born in Aberdeen, he was influenced by Italian painting and the Nazarene group in Rome during the late 1820s. In 1832 he visited Venice in the company of David Scott, who painted a watercolour of him in a gondola.

Charles Gifford Dyer, 1846–1912
Born in Chicago, he trained in Paris and Munich. He spent four summers in Venice during the 1870s, painting interiors and architectural views in a loose style.

Joan Eardley, RSA, 1921–1963
Studied at Glasgow School of Art, and specialized in figure studies, seascapes and landscapes painted in a dynamic style. She visited Venice and painted some powerful and colourful canvases.

Sir Alfred East, RA, RI, PRBA, RE, 1849–1913
Born in Kettering, he studied part-time in Glasgow and later in Paris under Bouguereau and

Fleury. He spent some time in Barbizon which influenced his earlier work, before travelling extensively. He visited Venice on several occasions and was there with Brangwyn in 1907. He produced some excellent atmospheric watercolours of Venice.

George Samuel Elgood, RI, ROI, 1851–1943
Watercolourist of architectural and garden scenes, Elgood had a delicate and sensitive style. He visited Italy most summers, and often worked in Venice.

Augustus W. Enness, RBA, born 1876
Held an exhibition 'Italian Lakes, Venice, France' at the Fine Art Society in 1928.

John Evans, worked 1840s to 1890s
Watercolourist, often of Venetian subjects, in the 1870s and 1880s. He exhibited regularly at the RI and RBA.

Dr Arthur Evershed, 1836–1919
Etcher and painter, he was a pupil of Alfred Clint, and worked in Venice around 1900.

Reginald Grenville Eves, RA, RI, ROI, 1876–1941
Eves studied at the Slade under Legros, Tonks and Brown before establishing himself as a successful portrait painter. He painted a number of sparkling watercolours of Venice, mostly in the 1930s.

Wilfred Fairclough, RWS, RE, born 1907
Trained RCA and at the British School in Rome, 1934 to 1937. Fairclough has produced many watercolours and prints of Venice, combining etching and aquatint.

Edmund Fairfax-Lucy, born 1945
Studied City and Guilds and RA Schools under Peter Greenham. Has painted a number of small, tonal oils of Venice.

Henry Waldron Faulkner, 1860–1940
Born Stamford, Conn. and studied in New York and Paris at the Ecole de Beaux-Arts. Faulkner often worked in Venice.

A. Romilly Fedden, RBA, 1875–1939
Studied at Bushey under Herkomer, and in Paris. He lived in France for some years, but also painted much in Venice between the wars, often working in watercolour in restrained colours and usually choosing evening scenes.

Samuel Melton Fisher, RA, 1860–1939
Studied Lambeth and RA Schools and later in Paris. He settled in Italy for ten years and painted many Venetian subjects. He painted mostly genre subjects in Venice, similar to those of Henry Woods, but he also produced some straight views.

James Fletcher-Watson, RI, RBA, born 1913
Landscape and architectural painter in watercolour, he trained as an architect before turning to art. He works regularly in Venice and is the author of a number of books on watercolour painting. (*Illustration p.194.*)

Sir William Russell Flint, RA, RE, PRWS, RSW, ROI, 1880–1969
Born in Edinburgh, Flint was influenced by the work of Arthur Melville, who was a friend of the family. He first visited Italy between 1912 and 1913 but returned several times to Venice which he painted in a broad, effective, watercolour style. Venetian subjects are comparatively rare, however, amongst Flint's *oeuvre*.

Frederick Francis Foottet, RBA, 1850–1935
Born in Sheffield, he studied under the guidance of Ruskin, although he later turned to an Impressionist style. He painted landscapes in oil and was in Venice immediately before the First World War and during the 1920s.

Charles S. Forbes, 1856–1926
American artist who lived in Paris from 1887 to 1889. He visited Venice with Duveneck in 1894, and returned in the early years of this century.

EDMUND FAIRFAX-LUCY
Dusk behind the Church of Il Redentore

Stanhope Alexander Forbes, RA, NEAC, 1857–1947
Studied Lambeth, RA Schools and in Paris under Bonnat. Became a leading member of the Newlyn School. He worked in Venice after 1900, but his Venetian work is not his best.

William Fowler, RBA, worked 1820s to 1860s
Painter of picturesque views in France, Germany and Italy. He appears to have worked in Venice in the 1850s.

William Miller Frazer, RSA, 1864–1961
Studied RSA Schools, Frazer became a landscape painter in a broad Impressionist style. He painted mostly Scottish subjects, but was in Venice in the 1890s where he produced some elegant and fluid paintings.

John Frearson, worked 1790s to 1830s
Frearson exhibited Italian subjects at the Royal Academy from 1800 onwards including *The Rialto at Venice* in 1814. He was possibly an early visitor to Venice, although he might have used prints.

William Edward Frost, RA, 1810–1877
Studied at the RA Schools and became a protégé of William Etty. He painted mostly portraits and mythological subjects, but also visited Venice in 1851 and possibly returned later in the 1850s.

John Fulleylove, RI, VPROI, 1846–1908
Painter of detailed and meticulously executed views of Greece, Italy, Jerusalem and English gardens. He painted many successful Venetian interiors and scenes.

Charles Wellington Furse, ARA, 1868–1904
Studied at the Slade and in Paris, he was a painter of portraits and figures, greatly influenced by Whistler and Sargent. This influence led him to Venice where he painted views in a broad manner reminiscent of Sargent. He died young, of tuberculosis.

George Percival Gaskell, RBA, RE, 1868–1934
Trained at the RCA and in Paris and Italy, Gaskell was for many years Principal of the Regent Street Polytechnic School of Art. He painted landscapes in England and northern Italy including Venice,

and produced many fine prints, often using mezzotint and aquatint in addition to etching.

William Allen Gay, 1821–1910
Born in West Hingham, Mass. he studied in Paris and worked in Italy, including Venice prior to 1850.

Lilian Mathilde Genth, born 1876
Born in Philadelphia, she studied in Paris and painted pastoral scenes in France and views of Venice.

Charles March Gere, RA, RWS, NEAC, 1869–1957
Studied at Birmingham School of Art and in Italy. He was widely talented producing watercolours, decorative work and illustrations for the Kelmscott Press. He visited Venice at least once during the 1920s and painted a number of watercolours there.

Robert Swain Gifford, 1840–1905
Born Naushon, Mass., he was related to Sanford Robinson Gifford. He worked in Venice in 1872, but was reputedly colour blind.

Cass Gilbert, 1858–1934
Prominent American architect who also worked in watercolour. He visited Venice in 1880, 1898, 1908 and 1912.

James Giles, RSA, 1801–1870
The son of an Aberdeen calico-designer, artist and drawing master, Giles visited Italy from 1824 to 1825. He visited Venice in the early months of 1825, making a number of watercolour sketches of skies. These free and loosely drawn studies can be compared to those of Turner, who had been in Venice six years earlier, but Giles could not have seen Turner's work. Sadly Venice was not to feature in his later career for he never returned, becoming known instead for his topographical watercolours of Scotland and hunting scenes in oils.

Robert Charles Goff, RE, 1837–1922
Born in Ireland, he joined the army aged 18, fought in the Crimean War and retired with the rank of Colonel in 1878 to devote himself to painting. In 1903 he moved to Italy and painted watercolours of Florence, Tuscany and Venice. In

JAMES FLETCHER-WATSON
San Vio Canal
Watercolour, 12½ × 18¾in
(31.8 × 47.6cm)

1911 he held an exhibition, including Venetian subjects, at the Fine Art Society.

Walter Goodall, 1830–1889
Younger brother of E.A. and F. Goodall, he trained at the RA Schools, and painted in Venice on several occassions.

Harry Goodwin, worked 1860s–1914
Landscape painter who visited Italy on many occasions. Painted in Venice and Chioggia.

Sylvia Gosse, RBA, RE, 1881–1968
Daughter of Sir Edmund Gosse, a friend of J.S. Sargent, she trained at St John's Wood and RA Schools, and later was influenced by Sickert. She was associated with the Camden Town School and helped Sickert during the 1920s after his wife died. She appears to have worked in Venice during the 1930s.

Florence W. Gotthold, 1858–1930
Born in Uhrichsville, Ohio, she became a painter of genre and people, including Venetians. She probably visited Venice.

James Edward Grace, RBA, 1851–1908
Studied at the RCA and became a landscape painter in oils and watercolour. He worked in Venice during the 1870s and 1880s.

Derek Greaves, born 1927
Born in Sheffield, he studied at the RCA before going to Italy on a scholarship from 1952 to 1954. He exhibited at the Venice Biennale in 1956 and painted Venice during this period.

William Curtis Green, RA, 1875–1960
Important architect who designed the Dorchester Hotel in Park Lane and the National Westminster Bank in Piccadilly. He was also a painter, trained at the RA Schools and he produced watercolours of Venice.

Walter Griffin, 1861–1935
Born Portland, Maine, he studied in Boston and Paris under J.-P. Laurens. Between 1887 and 1915

he spent most of his time working in Europe, especially France and Italy, and he spent 1913 in Venice. He worked in oils and watercolour in an Impressionistic style, and particularly enjoyed working in Venice.

Oliver Dennett Grover, 1861–1927
Born Earlville, Illinois, he became a pupil of Duveneck in Florence and Venice between 1879 and 1881, and later taught at Duveneck's school in Florence. He returned to Venice in 1885 where he worked in pastels and oils.

Carl Haag, RWS, 1820–1915
Born and trained in Germany, arriving in England in the late 1840s. He travelled in the Middle East with Frederick Goodall, becoming famous for his Middle Eastern views, but he also worked in Venice, often painting large and detailed interiors in watercolour.

Trevor Haddon, RBA, 1864–1941
Studied at the Slade under Legros and later worked with Herkomer at Bushey. He travelled widely in Europe and America and spent a year in Rome from 1896 to 1897. He often painted in Venice, producing realistic, highly finished works that look back to Henry Woods. He wrote and illustrated *The Old Venetian Palaces*.

Louis Haghe, HPRI, 1806–1885
Born in Belgium, he trained as a lithographer. He settled in London and became famous for his lithographs of David Roberts's watercolours. After 1852 he worked solely in watercolour and produced detailed pictures of many European cities, including Venice.

William Haines, 1812–1884
Picture restorer and copyist, he often painted copies of Canaletto and Guardi, and sometimes these were passed off as originals. He also painted his own Venetian views in the style of Canaletto and Guardi, sometimes using his own name and sometimes the name of William Henry.

George Haité, RI, ROI, RBA, 1855–1924
Largely self-taught, Haité started work as a designer but moved towards painting during the 1880s. He visited Venice in 1911 and 1912 depicting scenes with people in the *campi* as well as more general views of the Lagoon.

William Matthew Hale, RWS, 1837–1929
Watercolourist. Pupil of J.D. Harding and Collingwood Smith, he specialized in misty views of Italy, often at dawn or dusk, including many Venetian scenes.

Keeley Halsewell, RI, ARSA, 1832–1891
Edinburgh artist who visited Rome in 1868 and returned to Italy regularly during the 1870s. He painted figures at this time, but also found inspiration in Venetian subjects. After 1880 he painted almost exclusively English and Highland landscapes.

James Whitelaw Hamilton, RSA, RSW, 1860–1932
Glasgow painter who was involved with the early development of the Glasgow School. He visited Venice after the first period of the Glasgow School was over – in the 1890s – but his style is rather heavy and better suited to Scottish fishing villages than to Venice.

Letitia Mary Hamilton, RHA, 1878–1964
Born in Monkstown, Ireland she studied at Dublin and Chelsea under Orpen and Brangwyn. She painted extensively in France and Italy between the wars, and often worked in Venice using a bold and colourful style.

Edward Harry Handley-Read, RBA, died 1935
Studied Westminster School of Art and RA Schools, he worked as an illustrator and landscape painter. He often worked in France and Holland, but was also regularly in Venice during the 1920s.

Charles E. Hannaford, RBA, 1863–1955
Studied in Paris and under Stanhope Forbes, he painted in Venice between the wars. His large watercolours are atmospheric and restrained in colour.

Hans Hansen, RWS, 1853–1947
A follower of Arthur Melville in style and subject matter, Hansen worked in the Middle East, North Africa and Venice. His watercolours vary greatly in quality, but at his best, his Venetian works have light and atmosphere.

Martin Hardie, RI, RSW, RE, 1875–1952
Painter and etcher, he studied under Sir Frank Short. He was a close friend of McBey and was with him in Venice in October 1925. He later became Keeper of Prints and Drawings at the Victoria and Albert Museum and wrote on British watercolours.

William Noble Hardwick, RI, 1805–1865
Landscape painter in oils and watercolours, he worked in Venice in the late 1850s, often on a small scale.

W.H. Harriott, RBA worked 1811 to 1837
A watercolourist and pupil of Samuel Prout, he worked in Venice and Vicenza during the 1820s and 1830s.

Glynn Boyde Harte, born 1948
Trained at St Martin's and the Royal College, he paints watercolours of Venice and held an exhibition solely of Venetian works at the Francis Kyle Gallery in 1979. He has illustrated a book on Venice.

Sir George Harvey, PRSA, 1806–1876
Born in Perthshire, he studied at the Trustees' Academy under Sir William Allan. He was known as a painter of historical genre and of Scottish landscapes and his success led to his election as PRSA in 1864. He visited Venice during a trip to Italy in the early 1850s and he painted a number of sparkling watercolours while in Venice.

Charles Webster Hawthorne, 1872–1930
Born Maine, he became a pupil of William Merritt Chase who took him to Venice and introduced him to painting in the city.

Bernard Hay, worked 1880 to 1900
English painter who worked in Venice during the 1890s, often painting café interiors in a bold style. He lived in Brussels during the 1880s.

Colin Hayes, RA, born 1919
Studied history at Christ Church, Oxford and art at the Ruskin School. He first visited Venice in 1939 and has been three times since. He paints both oils and watercolours of Venice.

Thomas Frank Heaphy, 1813–1873
Son of the watercolourist Thomas Heaphy (1775–1835), he was a painter of portraits and historical subjects, but worked in Venice in the 1830s.

Charles Napier Hemy, RA, RWS, 1841–1917
Painter of landscapes and in particular marine subjects, he studied at Newcastle School of Art. He moved from a tighter Pre-Raphaelite style towards a freer approach. He visited Venice in April 1881, probably with Henry Woods, having obtained a commission from the Fine Art Society. Only one Venetian work by him is known today, *Grey Venice*, (Walker Art Gallery). Venice did not appear to have suited him.

Arthur Edward Henderson, RBA, 1870–1956
Architect, born in Aberdeen. He also worked in watercolour and painted architectural views and interiors of Venice.

John Rogers Herbert, RA, HRI, 1810–1890
Trained at the RA Schools, he became known for romantic genre painting. He visited Venice during a trip to Italy in the 1830s, and illustrated Thomas Roscoe's *Legends of Venice* (1838).

Edward Hereford, worked 1880–1915
Watercolourist who exhibited Venetian watercolours at the RI during the 1880s and 1890s.

George Edwards Hering, 1805–1879
Landscape painter, studied in Munich in 1829 and then, after a trip to Switzerland, spent two years studying in Venice. He later travelled in the Middle East and produced small atmospheric oils of the Middle East and Italy, including Venice. His wife, who exhibited as Mrs George Edwards Hering, also painted in Venice.

Herman Herzog, 1832–1923
American painter who is known to have worked in Venice.

Derek Hill, born 1916
Studied stage design in Munich, Paris and London before turning to painting in 1938. Spent many years in Italy after 1948, including two as Art Director of the British School in Rome during the late 1950s. Has worked in Venice.

Frank Hind, worked 1880 to 1903
Painter of landscapes in oil, he travelled widely in Italy, Spain, Holland and the Balearics. His Venetian works date mostly to the 1880s.

Jonathan Edward Hodgkin, RBA, 1875–1953
Watercolourist, he was a successful businessman and amateur artist. Worked in Venice during the 1930s.

Frances Hodgkins, 1869–1947
Born in New Zealand and studied at Dunedin Art School. She travelled in Europe, including Venice, and North Africa between 1901 and 1903, and settled in Paris in 1908. Between 1910 and 1912 she ran her own school in Paris, but settled in St Ives on the outbreak of war. During the 1920s and 1930s she worked throughout Europe, including Venice.

Samuel John Hodson, RWS, RBA, 1836–1908
Studied at the RA Schools, he painted detailed views and landscapes in watercolour and oils. He often painted street scenes and buildings and

worked in Venice painting interiors of churches, views of *campi* and the Riva full of figures.

Charles Edward Holloway, RI, 1838–1897
Studied at Leigh's studio along with Fred Walker. He later became a close friend of Whistler in Chelsea, and is said to have introduced Whistler to watercolour painting. His own style reflects 'The Master' in his oils, watercolours and etchings. He worked in Venice in 1875 and 1895.

Kenneth Holmes, born 1902
Studied Skipton, Leeds and the RCA he was in Italy from 1927 to 1928. He was Head of Huddersfield School of Art and Leicester College of Art, often returning to paint and etch in Venice.

Sir Charles Holroyd, RE, 1861–1917
Etcher, painter and sculptor, he trained at the Slade and subsequently joined the staff from 1885 to 1889. He was in Italy from 1889 to 1891 and from 1894 to 1897. He later became Keeper of the Tate Gallery and Director of the National Gallery. He produced a number of etchings of Venice.

T. Holroyd, worked 1860s and 1870s
London landscape-painter who specialized in Italian views. He was often in Rome and lived there from 1861 to 1862, but he also painted in Venice.

James Clarke Hook, RA, 1819–1907
Painter of coastal, landscape and historical scenes, he trained at the RA Schools and in 1845 won a three-year travelling prize which took him to France and Italy. He visited Venice and was greatly influenced by the colours of Titian. He later painted many historical subjects, some set in Venice, as well as Venetian views.

Edith Hope, RBA, worked 1907 to 1940
Painter in oils and watercolour, mostly of animals, she studied at the Slade. She was also known for her paintings and etchings of Venice.

Charles Horsley, RBA, 1848–1921
Son of G.C. Horsley, he was born in Manchester and studied at Manchester School of Art. Painted portraits and exotic subjects from Egypt, Turkey and India. He also painted in Venice.

Gerald Calicott Horsley, worked 1862–1904
Architect who was a pupil of Norman Shaw, he also painted architectural views of Venice during the 1880s and 1890s.

Thomas H. Hotchkiss, 1837–1869
Born Hudson, NY he settled in Rome in 1861 taking a studio in the Piazza Barberini. In Rome he was a friend of Vedder, and often went up to Venice to sketch during the 1860s. He died young of tuberculosis in Sicily.

Albany Howarth, ARE, 1872–1936
Watercolourist and printmaker, he painted throughout Europe and produced etchings and watercolours of Venice.

William Stokes Hulton, died 1921
Landscape painter who started to work in Venice around 1882. He later settled in Venice with his wife and two daughters living in Calle della Testa No. 6383 near SS Giovanni e Paolo. Hulton was an amateur painter but his Venetian work can be very effective. He wrote *Olympia's Journal* which dealt with his life in Venice. Sickert became a friend of the family and there is a drawing in the Ashmolean showing Mrs Constanza Hulton going to a charity fête in the Giardinetto Reale in 1901, which Sickert executed in black and coloured chalks. Hulton died in Venice.

Aubrey Hunt, RBA, 1855–1922
A great traveller, Hunt worked in France, Italy Morocco and Tangiers. He painted Venetian waterways in a loose, breezy style.

Cecil A. Hunt, RBA, VPRWS, 1873–1965
Trained as a lawyer at Cambridge, he did not start painting full-time until 1919, although he had achieved recognition working part-time. Hunt was particularly known for his watercolours of mountain scenery, although he painted in Venice before and after the First World War.

George Sherwood Hunter, died 1920
Aberdeen painter of landscapes and fishing villages, he worked in London until 1898 when he moved to Penzance. He also painted in Italy and Spain and appears to have worked in Venice in the 1880s.

George Inness, 1825–1894
Born Newburgh NY. A self-taught artist, he lived in England from 1847 to 1859 and in Italy from 1870 to 1874. He worked in Venice in 1872 producing watercolour and body-colour sketches.

James Inskipp, 1790–1868
English painter, mostly of genre and portraits, he also worked in Venice during the late 1830s and 1840s.

Frederick Hamilton Jackson, RBA, 1948–1923
Painter and decorator, he studied at the RA Schools and was later Master of the Antique School at the Slade. In addition to being closely involved with the Arts and Crafts Movement, he wrote and illustrated travel books including, *A Little Guide to Sicily* and *The Shores of the Adriatic*. He painted in Venice prior to the First World War.

Frederick William Jackson, RBA, 1859–1918
Trained at Oldham, Manchester and Paris. He travelled widely in Europe and particularly Italy and Venice, where his atmospheric style was ideally suited. He worked in watercolours as well as painting market scenes in oil.

Francis James, worked 1830s and 1840s
English painter especially of Italian scenes, including Venice and Florence where he lived for some time.

Francis Edward James, RWS, NEAC, RBA, 1849–1920
A friend of Sickert, Brabazon and Tuke, he was respected as a progressive painter in watercolours, often of flowers. He also painted landscapes in Italy, including Venice, and North Africa.

Norman Janes, RE, RWS, 1892–1980
James studied at the Slade along with Charles Cundall and Henry Rushbury. He painted watercolours of the Thames, France and Venice, and his etchings and aquatints of Venice are very atmospheric.

Arthur Henry Jenkins, born 1871
Studied in Edinburgh and Paris, he later became an art teacher. He painted landscapes in Spain and Italy, including Venice, in both oil and watercolour, often on a large scale.

William H. Jobbins, worked 1870s and 1880s
Jobbins went to Venice in 1880 and is best known for sharing a studio with Whistler, probably in the Ca' Rezzonico. It was Jobbins who complained to Woods about Whistler's habit of helping himself to paint. He exhibited a few Venetian pictures at the Royal Academy and later went to India.

John Christen Johansen, born 1876
Born in Copenhagen, he went to the USA as a child, studying at the Art Institute, Chicago, and also in France at the Academie Julian, Paris. He was a pupil of Duveneck in New York, and was probably introduced to Venice by Duveneck.

Henry George Keller, 1870–1949
Born in Cleveland, Ohio, he studied at Cleveland School of Art and in Düsseldorf and Munich, from where he visited Venice.

J.G. Kendall, worked 1840s to 1860s
London landscape painter who painted views in France, Italy and often Venice, in watercolour.

James Kerr-Lawson, 1864–1939
Born in Scotland, he was brought up in Canada, later studying art in Paris and Rome. He painted extensively in Italy, living for a time in Florence. His oils of Venice are subdued in tone, no doubt influenced by Sickert, but his watercolours are more sparkling.

Cecil King, RI, ROI, RBA, 1881–1942
Trained at Westminster School of Art and in Paris. He painted marine scenes and Continental town views, often in Italy and France. He and his wife, Dorothy, who was also a painter, were friends of Nina Hamnett in Paris. He painted in Venice and was represented at the Biennale.

R.H. Kitson, RBA, worked 1920s to 1940s
Watercolourist who worked and lived for a period in Italy, especially Sicily. He also painted in Venice.

James Garden Laing, RSW, 1852–1915
Trained as an architect in Aberdeen before turning to painting in watercolours. He often worked abroad in Holland, France and Venice in a loose, wet technique.

Thomas Reynolds Lamont, ARWS, 1826–1898
Scottish watercolourist of figures in historical settings, he studied in Paris with Poynter, du Maurier and Whistler. He appears to have visited Venice late in his career.

Leslie W. Lang, RBA, born 1886
Studied at the Slade and in Italy. Painted in Venice between the wars.

Philip de Laszlo, PRBA, 1869–1937
Born in Budapest he studied in Hungary, Munich and Paris settling in England in 1907. Although he is known principally for his portraits, he also painted more informal landscapes in oils and watercolour. He liked Venice and painted there on several occasions.

Harold Latham, RI, worked 1920s to 1950s
Watercolourist who painted in Venice.

Charles James Lauder, RSW, 1841–1920
Studied at Glasgow School of Art, he became known for his elegant views in watercolour and prints of European cities. He worked in Venice and recorded the rebuilding of the Campanile.

James Eckford Lauder, RSA, 1811–1869
Edinburgh painter of historical, genre and landscape subjects, he was the younger brother of Robert Scott Lauder and trained at the Trustees' Academy, Edinburgh. Between 1834 and 1838 he was in Rome with his brother, but it was only after 1857 that he turned more towards landscape. He appears to have visited Venice to paint around 1860.

Robert Scott Lauder, RSA, 1803–1869
Studied in Italy for five years during the 1830s, returning to Edinburgh in 1838. He later became Master of the Trustees' Academy, and a noted teacher. Like his brother, he worked in Venice around 1860.

David Law, RSW, RE, RBA, 1831–1902
Edinburgh artist who settled in London, his watercolours were influenced by Birket Foster. He had a particular love for detailed shipping scenes which he found in Venice, and he produced a number of large well-worked Venetian views.

Margaret Fletcher Leadbitter, worked 1920s to 1950s
Scottish landscape and figure painter who studied in London, Paris and Italy. She worked in Venice between the wars.

Edward Le Bas, RA, 1904–1966
Studied architecture at Cambridge University, and painting at the RCA. He was friendly with Sickert and associated with the Bloomsbury Group. He visited Venice on many occasions sometimes, as in 1948, with Duncan Grant and Vanessa Bell.

John Le Capelain, 1814–1848
Jersey painter known for his views of Jersey and the French coast, he painted watercolours in Venice during the 1840s in a style influenced by Turner.

Sydney Lee, RA, RWS, NEAC, RE,
1866–1949
Studied in Manchester and Paris, he became well known for his many watercolours, oils and prints of France, Switzerland, Italy and Spain. He enjoyed working in Venice.

Charles Lees, RSA, 1800–1880
Scottish painter of portraits, genre and landscape, he studied under Raeburn before spending six months in Italy. He appears to have returned to Italy in the 1840s and painted Venetian as well as Italian subjects.

William Leighton Leitch, 1804–1883
Scottish landscape-painter in watercolours who had worked in London as a scene painter with Clarkson Stanfield and David Roberts before visiting Italy. Many of his watercolours depict the Italian lakes, but he also worked in Venice in a topographical style similar to that of David Roberts.

Giffard Hocart Lenfesty, RBA, 1872–1943
Studied at the RCA and in Paris and Florence, he painted broad watercolours of Venice in restrained colours.

Jules Lessore, RBA, RI, 1849–1892
Born in Paris, he studied in Paris before settling in England. He painted a number of watercolours of Venice.

John Frederick Lewis, RA, HRSA,
1805–1876
A painter known for his pictures of Spain and the Middle East, he started as an animal painter studying under Landseer, but turned to watercolours of landscapes around 1825. He visited Switzerland and Italy in 1827, and visited Venice. During the next decade he was involved in Spain publishing *Sketches and Drawings of the Alhambra* with lithographs by J.D. Harding. He returned to Italy in 1838 staying in Rome for two years, and again visiting Venice. In 1841 he moved to Egypt where he stayed for ten years. His Venetian drawings and watercolours are rare, although there are a number in the Victoria and Albert Museum, and it is sad that he did not work more in Venice, as he would have certainly influenced the development of British and American painting there.

T. Hodgson Liddell, RBA, 1860–1925
Born in Edinburgh, he travelled widely, including a visit to China, which resulted in an exhibition of watercolours and a book in 1909. He also worked regularly in Venice.

Vincent Henry Lines, RWS, NEAC,
1909–1968
Studied at the Central School of Art and the RCA, he was a landscape painter and etcher. He painted much in France and Venice after the Second World War.

William Linton, RBA, 1791–1876
Born in Liverpool, he was influenced as a young man by the work of Richard Wilson, and his earlier works were views of the Lake District. He later turned to more classical themes and worked extensively in Greece and Italy. He visited Venice on several occasions between 1839 and the late 1850s, and exhibited views of Venice. Chioggia and the Lagoons. He was a founder member of the Society of British Artists, later the RBA.

Sydney M. Litten, born 1887
Studied at St Martin's and the RCA under Frank Short, and later became Vice-Principal of St Martin's. He produced pen and ink drawings of Venice as well as etchings.

Marian Logsdail, (Mrs Richard Bell) worked 1880s–1910
The sister of William Logsdail, she painted views in Lincoln, where she lived, and in Venice.

Henry Augustus Loop, 1831–1895
Born in Hillsdale, NY, he studied under Peters

Gray and in Paris. He visited Italy twice, from 1858 to 1860 and 1867 to 1869, on both occasions living in Florence and visiting Venice. He was primarily a portrait and figure painter but executed some Venetian views.

Max Ludby, RI, RBA, 1858–1943
Watercolourist, trained in Antwerp. In 1897 he held an exhibition of 60 watercolours entitled 'Some Sketches of Venice'.

Albert Ludovici (Junior), RBA, 1852–1932
The son of a painter, he lived much of his life in Paris. He was greatly influenced by Whistler and painted townscapes of Paris, London and Venice in a delicate, Impressionistic style.

Mary McCrossan, RBA, died 1934
Studied at Liverpool School of Art and in Paris, she painted regularly in Venice during the 1920s in a broad, colourful style.

John Blake MacDonald, RSA, RSW, 1829–1901
Scottish painter, he studied at the RSA Schools and was known for his depictions of scenes from Scottish history. He visited Venice around 1874 and began to exhibit Venetian watercolours, possibly returning in the mid-1880s.

William Stewart MacGeorge, RSA, 1861–1931
Trained at the RSA Schools and in Antwerp, he was closely associated with the Kirkcudbright group of artists which included Hornel. Although his main works depict life in Kirkcudbright, he appears to have visited Venice around 1912 to 1913, for in 1913 he held an exhibition in Edinburgh of Venetian views.

Charles Hodge Mackie, RSA, RSW, 1862–1920
Brought up in Edinburgh, he visited Pont-Aven and met Gauguin and his followers. He produced designs for Patrick Geddes' *Evergreen*, the Scottish

Symbolist magazine. His Symbolist period had ended when in 1908 he visited Venice with Adam Bruce Thomson (1885–1976) and he produced a number of powerful watercolours and some interesting monotypes of Venice. (*Illustration p.144.*)

John MacWhiter, RA, HRSA, RSW, RI, RE, 1839–1911
Trained at the Trustees Academy in Edinburgh, he was influenced as a young man by the Pre-Raphaelites. Always a great traveller, he visited Switzerland, France, Italy, Norway and America painting landscapes in a style which developed freedom and looseness of handling. He probably first visited Venice in 1866, and certainly returned on several occasions. His Venetian watercolours are delicate, sensitive, yet colourful and possibly reflect his earlier admiration for Ruskin.

Alexander Mann, ROI, 1853–1908
Glasgow artist who trained in Paris under Carolus Duran. He was the only artist associated with the Glasgow Boys who visited Venice regularly, although Melville and Whitelaw Hamilton both worked there. Mann's *A Bead Stringer, Venice* was exhibited at the Paris Salon in 1884 and was one of the first paintings by a Glasgow Boy to be noted in Paris. He was in Venice in the early 1880s and certainly returned during the following decade. His style reflects the influence of Sargent as regards his Venetian works.

William Westerley Manning, RBA, ROI, ARE, 1868–1954
Studied at the Academie Julian, Paris and travelled widely painting in France, Spain, Italy, Egypt and Morocco. He worked in Venice in the late 1920s in watercolour, oils and aquatint.

John Marin, 1870–1953
American artist known principally for his later near-abstract watercolours. He was, however, in Venice in 1907 where he produced etchings influenced by those of Whistler.

Paul Marney, 1829–1914
Watercolourist, born in Paris, who lived in Belfast and later Yorkshire. He is known for his town views often painted in a somewhat repetitive manner. He worked in Venice on many occasions.

Frederick Marriott, RE, 1860–1941
Designer, illustrator and educationalist, he was Head of Goldsmiths' Institute from 1895–1925 and a member of the Art Workers' Guild and the Arts and Crafts Society. He painted and etched town scenes with an emphasis on architectural detail, working also in Venice.

Freda Marston, RBA, ROI, 1895–1949
Trained at the Regent Street Polytechnic, in Italy and between 1916 and 1920 with Terrick Williams. She married Reginald Marston and together they painted and etched in Venice in the 1920s.

Reginald St Clair Marston, RBA, ROI, 1886–1943
Studied in Birmingham, Paris and Munich and painted landscapes in oil and watercolour. In Venice during the 1920s.

Alexander J. Mavrogordato, worked 1890s–1930s
Watercolourist of towns and buildings and painted regularly in Italy, including Venice.

Arthur Meadows, 1843–1907
Sea painter, mostly self-taught, he painted in Venice during the 1870s and 1880s.

Sir Hubert James Medlycott Bt., 1841–1920
Educated at Harrow and Trinity College, Cambridge, he was ordained in 1866. He was a proficient part-time painter of landscapes and architectural subjects in watercolour, and his views of Venice have a freshness and sparkle.

Lord Methuen (Paul Ayshford), RA, RWS, RBA, NEAC, 1886–1974
Born at Corsham, Wilshire, he studied at Eton and New College, Oxford before turning to art. His greatest mentor was Sickert, who influenced his style and subject matter. He painted oils and watercolours of Venice.

Caroline St John Mildmay, 1834–1894
English watercolourist who worked regularly in Venice.

James Miller, RSA, RSW, 1893–1987
Studied at Glasgow School of Art under Greiffenhagen and Anning Bell and later taught etching there. He travelled abroad between the wars and painted many watercolours of Venice.

John Miller
Contemporary English painter of somewhat romantic oils and watercolours of Venice.

Gerald Moira, PROI, VPRWS, 1867–1959
Studied at the RA Schools and in Paris, he was a painter of landscapes and figures in oil and watercolour, as well as a decorative artist. His work showed a bravura, possibly influenced by Sargent, and he often painted figures in Venetian settings. He was a Principal of Edinburgh College of Art from 1924 to 1932.

Francis Moltino, worked 1840s to 1860s
Painter of coastal scenes and Thames views, he worked in Venice during the 1860s.

William Monk, RE, 1863–1937
Painter and etcher of architectural subjects, he studied in Antwerp. He became known for his powerful watercolours and etchings of Venice and New York.

Claude T. Stanfield Moore, 1853–1901
Born in Nottingham, he painted seascapes and river scenes, often of the Thames. He also worked in Venice.

George Belton Moore, 1805–1875
Topographical and architectural painter, he was a pupil of A.C. Pugin and later a drawing master. He appears to have visited Venice on several occasions from the 1830s to the 1860s.

Walter Jenks Morgan, RBA, 1847–1924
Studied at Birmingham and the RCA, he became a leading Birmingham painter and illustrator, and worked occasionally in Venice.

Alberto Morrocco, RSA, RSW, born 1917
Born in Aberdeen, he later became Head of painting at Dundee College of Art. He paints still life, flowers, figures and landscapes, and has produced a number of effective Venetian works.

Harry Morley, ARA, RWS, RE, 1881–1943
Studied in Leicester and won a scholarship in architecture to the RCA where he won a travelling scholarship that took him to Italy in 1904. He began work in an architect's office, but in 1907 decided to become a painter. He was in Venice in 1911, where he produced some interesting watercolours, but his later work is more classical and allegorical than topographical.

A. Mulholland
An English nineteenth-century painter of oils and watercolours, often of Venetian themes.

Alexander Henry Hallam Murray,
1854–1934
Member of the John Murray publishing family, he was educated at Eton and Caius College, Cambridge, followed by the Slade. He travelled widely, writing and recording views in watercolour, and his Venetian work is finely executed.

Sir David Murray, RA, HRSA, PRI, RWS, RSW, 1849–1933
Glasgow painter noted for his pastoral scenes in England and France, he worked in Venice on at least one occasion in the years immediately prior to the First World War.

Paul Jacob Naftel, RWS, 1817–1891
Born in Guernsey, he was largely self-taught. He settled in England in 1870, and although his earlier work is mostly of the Channel Islands, he later worked abroad. He exhibited watercolours of Venice at the RWS in the 1860s.

David Dalhoft Neal, 1838–1915
Born in Lowell, Massachusetts he visited Europe in 1862 to study in Paris and Munich, where his teacher Karl Piloty introduced him to Venice. His Venetian work, which often comprises detailed interiors, dates to the 1860s.

Christopher Richard Wynne Nevinson,
ARA, RI, NEAC, RBA, ROI, 1889–1946
Studied in London and Paris, and noted for his progressive approach to painting, which embraced Cubism and Futurism. He visited Venice before the First World War and produced some interesting etchings.

Alfred Pizzey Newton, RWS, 1830–1883
A self-taught artist who attracted the attention of Queen Victoria for his paintings of the Scottish Highlands. He visited Italy including Venice in 1862, and Ruskin admired the detailed accomplishment of his work.

Algernon Cecil Newton, RA, 1880–1968
Studied at Oxford and in London under Frank Calderon and London School of Art. He is remembered today for his views of Camden Town and Paddington, which depict figures by the canal. He was in Venice in 1926 and painted a number of watercolours.

Burr H. Nicholls, 1848–1915
American artist who studied in Buffalo and in Paris under Carolus Duran. He worked briefly in Venice.

Rhoda Holmes Nicholls, 1854–1930
Born in England, she spent three years in Italy on a scholarship before marrying an American artist and spending their honeymoon in Venice. In 1887 she settled in New York. She painted a number of watercolours of Venice and illustrated an edition of W.D. Howell's *Venetian Days* (1892).

Pollock Sinclair Nisbet, ARSA, RWS, 1848–1922
Edinburgh painter who travelled widely in Spain, Morocco and Tangiers. He visited Venice around 1873 and painted a series of Venetian subjects during the 1870s which included several market scenes.

James Noble, RBA, 1797–1879
London painter who specialized in genre and character studies, he also worked on Italian landscapes and painted in Venice during the 1840s.

Arthur Trevithan Nowell, RI, 1862–1940
Studied at Manchester and RA Schools, he was noted for his classical figure painting. He also travelled widely especially in Italy and painted watercolours in Venice.

John O'Connor, RI, RHA, 1830–1889
Started as a theatre scene painter in Dublin and Belfast, settling in London in 1848 where he worked at Drury Lane and the Haymarket. During the 1850s he began to paint topographical watercolours, often of continental cities, and he worked in Venice in the 1870s.

William Oliver, RI, 1804–1853
Landscape painter in oils and watercolour, he travelled widely in Europe, often working in the Pyrenees. He painted in Venice during the 1840s.

Mrs William Oliver, RI, 1819–1885
A pupil of William Oliver, she married in 1840 and accompanied her husband on painting trips abroad, including Venice. She painted well-finished watercolours of Venice over a long period, for after the death of her husband and her subsequent remarriage to John Sedgwick, she continued to work under her name Mrs Oliver.

Emily Mary Osborn, 1834–c.1910
Studied under John Mogford and James Leigh at Dickinson's Academy and she became a painter of genre and historical works. She is known primarily for *Nameless and Friendless*, but she also worked in Venice in the 1870s.

Walter Launt Palmer, 1854–1932
Born in Albany, NY, the son of a sculptor, he studied in Paris from 1873 to 1874 and from 1876 to 1877 under Carolus Duran. He worked in Venice during the early 1870s painting both oils and watercolours. He later specialized in American snow scenes.

Walter Paris, worked 1850s to 1890s
Watercolour painter of landscapes and buildings, he travelled widely in Europe and India. He appears to have worked in Venice during the 1880s.

Maxfield Parrish, 1870–1966
Born in Philadelphia, he became one of America's leading illustrators, and probably visited Venice on several occasions. In 1903 he was sent to Italy by the Century Company to illustrate Edith Wharton's *Italian Villas and their Gardens* and he also worked in Venice. Parrish often used Venetian subjects for illustrations, sometimes changing the topography and character in order to create a romantic mood.

Charles Maresco Pearce, NEAC, 1874–1964
Trained as an architect before turning to art at Chelsea School of Art and in Paris. He was a friend of Sickert and was involved in the Camden Town Group. He painted in Venice in both oils and watercolours.

Harper Pennington, 1854–1920
Born in Baltimore, he studied in Paris and under Duveneck who took him to Venice in 1880. He later worked as a portrait painter.

Sidney Richard Percy, 1821–1886
A member of the Williams family, he painted landscapes, mostly of North Wales. He was a friend of William Callow and visited Venice with him in 1865.

Arthur Perigal, RSA, RSW, 1816–1884
Scottish landscape-painter known for his rather mechanical views of the Highlands. He visited Italy in the 1840s and returned to Venice in the 1870s. His Venetian watercolours are often more sensitive than his Scottish oils.

Henry Pether, 1828–1865
English landscape-painter known for his moonlit views of the Thames. He applied a similar formula to his Venetian works.

Graham Petrie, RI, ROI, 1859–1940
Landscape painter who studied in London and Paris, he travelled widely in Europe often painting in Greece and Venice. An exhibition entitled 'Landscape and Lagoon' was held at the Fine Art Society in 1897. His Venetian work is strongly coloured and handled.

Charles R. Pettafor, worked 1860s to 1890s
English landscape-painter in oils and watercolour with a somewhat sweet style. He worked in Venice in the 1890s.

George Pettitt, worked 1850s and 1860s
English landscape-painter who painted the Lake District and the lakes of Northern Italy. He worked in Venice in the 1850s and 1860s.

Lawrence Barnett Phillips, ARE, 1842–1922
Watchmaker who took up etching and painting in 1882, he produced many etchings of Venice in the 1890s.

William Henry Pike, ROI, RBA, 1846–1908
Plymouth landscape-painter who produced precise watercolours of Venice.

Henry Pilleau, RI, ROI, 1813–1899
Spent his career in Army Medical Corps, taking up art full-time on retirement. He worked regularly in Venice from the 1870s to the 1890s.

Barry Pittar, RBA, 1880–1948
Studied at St John's Wood, the RCA and in Paris. He worked as Chief Architectural Artist to Royal Doulton Potteries at Lambeth and was also an illustrator. He painted in Venice on several occasions during the 1920s.

Sir Edward John Poynter Bt., PRA, RWS, 1836–1919
Leading Victorian neo-classical painter, he first visited Italy in 1853 where he met Frederick Leighton. Studied at the RA Schools before moving to Paris from 1856 to 1859. He appears to have visited Venice in 1860 and there is a watercolour *The Salute by Moonlight* in the Victoria and Albert Museum. Venice, however, rarely featured in his work.

Alfred Praga, RBA, 1867–1949
Liverpool-born portrait and miniature painter, he studied at South Kensington and in Paris. He was a founder member of the Society of Miniaturists in 1895, and painted in Venice between the wars.

John Lumsden Propert, worked 1870s and 1880s
English etcher who often worked in Venice.

John Skinner Prout, RI, 1806–1876
Nephew of Samuel Prout, he was born in Bristol and became a friend of William James Müller. He copied his uncle's style and often his subject matter, so that Venetian subjects appear regularly in his work. There is no evidence, however, that he ever visited Venice.

James Ferrier Pryde, 1866–1941
Edinburgh artist trained at the RSA Schools and in Paris, he was noted for the posters he designed with William Nicholson. His oils and watercolours of Venice are highly subjective, often showing buildings, seen from below in exaggerated scale.

William Purser (Junior)
English architect who painted views of Venice during the 1930s. He exhibited a *Bridge of Sighs* and a *Ducal Palace* at the 1830 Royal Academy Exhibition. It is possible that they were based on prints rather than on direct observation.

James Baker Pyne, VPRBA, 1800–1870
Born in Bristol, he embarked upon a legal career, but turned to painting. He was self-taught, but acquired a reputation in Bristol, where he took pupils. One was William Müller who wrote in 1843, 'In early life, placed under the tuition of my friend, J.B. Pyne – nay, serving a regular apprenticeship to the arts with him, to whom I owe so much – I commenced painting in earnest'. In 1835 he moved to London, and thereafter began to visit Italy and France to paint. He was greatly influenced by Turner, and his Venetian oils show this influence in their pale-yellow tones and dramatic effects. His Venetian watercolours, however, owe more to the draughtsman's approach of Callow and Wyld.

Thomas Pyne, RI, RBA, 1843–1935
Son and pupil of James Baker Pyne, he painted mostly English landscapes, but also worked in Venice which he appears to have visited on several occasions.

Arthur Rackham, VPRWS, 1867–1939
Illustrator of children's books and fantasy stories, he studied at Lambeth School of Art. In addition to his illustrations he also painted landscapes in watercolour and worked in Venice in the early years of the twentieth century.

Frank Randal, worked 1880s–1900
John Ruskin employed Frank Randal to paint in France and Italy between 1881 and 1886, but although he was in Verona in 1884, there is no evidence that he worked in Venice for the Guild of St George. He did work in Venice later using a delicate watercolour technique.

William Bruce Ellis Ranken, VPROI, RI, 1881–1941
Born in Edinburgh, he studied at the Slade and worked mostly in England and France. He often painted interiors, sometimes on a large scale, including Venetian interiors.

William Wellwood Rattray, ARSA, RSW, 1849–1902
Glasgow artist who specialized in views of the Highlands, he worked in Venice in the 1890s.

Samuel Read, RWS, 1815–1883
Architectural painter, a pupil of William Collingwood Smith, he painted interiors and exteriors of churches and secular buildings in England and Europe, including Venice.

Archibald Reid, ARSA, RSW, ROI, 1844–1908
The brother of Sir George and Samuel Reid, he was born in Aberdeen and studied at the RSA Schools. He travelled in Europe painting townscapes and landscapes, and visited Venice on several occasions.

Sir George Reid, PRSA, HRSW, 1841–1913
Known as a portrait painter and a somewhat conservative President of the RSA, he was also a fine illustrator and sensitive watercolourist. He painted in Venice during the 1880s.

John Robertson Reid, RBA, ROI, RI, 1851–1926
Born in Edinburgh, he studied at the RSA Schools. He moved to London and Cornwall, becoming closely involved with the emerging school of Realist painters like Clausen, who wanted to depict workers on the land. He first visited Venice around 1910 and found it to his liking, painting many Venetian watercolours in his later years.

Robert Payton Reid, ARSA, 1859–1945
Scottish artist who trained at the RSA Schools, Munich and Paris. He painted mostly Scottish landscapes but also worked in Venice.

Frederick Charles Richards, RE, 1887–1932
Etcher and draughtsman, he studied at the RCA where he later taught. He published pencil sketchbooks of many cities including Venice, and his etchings of Venice are effective.

Frederick Stuart Richardson, RSW, RI, ROI, 1855–1934
Born in Bristol, he studied art in Paris and later painted coastal scenes and harbours in Britain, Holland and Venice.

Leonard Richmond, RBA, RI, ROI, died 1965
Landscape painter, writer and art educationalist, he worked in Venice during the 1920s.

Herbert Davis Richter, RI, RSW, ROI, RBA, 1874–1955
Flower and landscape painter, he studied under Sir Frank Brangwyn and John Macallan Swan. He painted richly-coloured oils and watercolours of Venice.

Harry Arthur Riley, RI, born 1895
Trained with Walter Bayes and at St Martin's, he painted mostly watercolours of Venice.

Alexander Wallace Rimington, RBA, ARE, 1854–1918
Trained in London and Paris, he often painted in France, Italy and Spain. He worked on several occasions in Venice painting watercolours with restrained colours. His wife, Evelyn Janes Rimington, also worked in Venice.

David Robertson, born 1885
Etcher and architect, he was born in Strathblane and studied at Glasgow School of Art. He produced etchings of Venice.

Tom Robertson, ROI, 1850–1947
Studied at Glasgow School of Art and in Paris. He painted atmospheric pictures in North Africa and Venice which he visited on several occasions. He worked in watercolours, oils and pastels.

Theodore Robinson, 1852–1896
American artist who visited Venice from 1878 to 1879 with Kenyon Cox and met Whistler and others of the Duveneck Boys. He later lived and painted on Capri.

Alexander Ignatius Roche, RSA, 1861–1921
Studied at Glasgow School of Art and in Paris, he painted portraits and landscapes as well as historical subjects, influenced by Puvis de Chavannes. Venice did not feature in the work of the Glasgow Boys until the initial innovative period was over, and Roche first visited Venice around 1891, probably returning later in the 1890s.

Louis Conrad Rosenberg, ARE, 1890–1964
Born in Portland, Oreg., he studied etching under Malcolm Osborne at the Royal College of Art. He split his time between London and New York, often working in etching and dry-point in Venice.

Joseph Thorburn Ross, ARSA, 1849–1903
Son of the Edinburgh artist, Robert Thorburn Ross, he painted lively and spontaneous watercolours, visiting Venice in the 1890s.

Thomas Charles Leeson Rowbotham, 1823–1875
The son and pupil of Thomas Leeson Rowbotham, he, like his father, became a watercolourist and drawing master. He wrote several books on art and was noted in later years for his highly toned Italian views, often of the Italian lakes. He also exhibited a number of Venetian watercolours, although it seems unlikely that he ever visited Italy.

Sir Walter Westley Russell, RA, RWS, NEAC, 1867–1949
Studied at Westminster School of Art under Frederick Brown, he later became Professor at the Slade and Keeper of the Royal Academy. He painted mostly English landscapes and portraits, but also painted quiet oils of Venice, probably during his later years.

David Scott, RSA 1806–1849
The brother of William Bell Scott, he trained at the Trustees' Academy, later painting and

illustrating historical and literary subjects. He visited Italy and Venice from 1832 to 1834.

Henry Courtney Selous, 1811–1890
Trained at the RA Schools, he became a successful genre painter, and illustrator of Shakespearean subjects and children's books. He also painted landscapes and worked in Venice.

Joseph Severn, 1793–1879
Studied at the RA Schools and accompanied John Keats to Rome in 1820, being present when he died the following year. He remained in Rome until 1841, a successful portrait painter, returning as British Consul from 1860 until his death. He visited Venice and painted a number of Venetian scenes. His son, Arthur Severn, married Ruskin's niece.

Margaret Shaw, ARWS
Trained at the RCA from 1938 to 1941, she exhibited watercolours of Venice at the RWS in the years after the Second World War.

Thomas Frederick Mason Sheard, RBA, 1866–1921
Studied at Oxford University and in Paris, he specialized in town and market scenes, often in the Middle East, but he also worked in Venice. He was Professor of Art at Queen's College, London.

Thomas Sidney, 1853–1903
Landscape painter, he was born and died in London but lived for many years in Venice.

Henry Simpson, NEAC, 1853–1921
Born in Suffolk, Simpson painted landscapes and figures, that display a particular love of the Middle East and Venice, which he visited on several occasions. He was a friend of Walter Tyndale and is recorded as being in Venice in 1903.

William Simson, RSA, 1800–1847
Born in Dundee, he studied at the Trustees' Academy. His earlier work comprises landscapes in Scotland and Holland, and he visited Italy from

1834 to 1835 where he painted Italian and Venetian views, often in watercolour. His later work is mostly genre.

Frederick Smallfield, ARWS, 1829–1915
Genre and figure painter in oils and watercolour, he studied at the RA Schools and was influenced by the Pre-Raphaelite Movement. He painted typical Venetian figures such as *Venetian Water Carrier* in a detailed manner.

George H. Smillie, 1840–1921
Born in New York City, the son of James Smillie the engraver. He became a well-known landscape painter, mostly of American views, but he also painted in Venice.

Arthur Reginald Smith, RWS, RSW, 1871–1934
Yorkshire artist in watercolour, he painted mostly Yorkshire subjects, but also worked in Venice.

Frank Hill Smith, 1841–1904
Born in Boston, he studied in Paris under Bonnat. He lived and worked for many years in Europe, mostly in Venice, and later became Director of Boston Museum of Fine Art School.

Henry Pember Smith, 1854–1907
Born in Waterford, Connecticut, he was an associate of Frank Duveneck and often worked in Venice.

William Collingwood Smith, RWS, 1815–1887
Born in Greenwich, London, he had lessons from J.D. Harding who became a close friend. He was a prolific watercolourist, working in England and abroad, particularly in Italy, and like J.D. Harding, he enjoyed working in Venice. His watercolours of Venice have the elegance of line associated with William Callow and Harding.

William Harding Collingwood Smith, RBA, 1848–1922
Named after his father's friend and mentor, he

painted genre and historical subjects in oil, as well as more informal landscapes in watercolour, influenced by his father and Harding. He worked in Venice in the mid-1880s.

Richard Gay Somerset, ROI, 1848–1928
Manchester landscape-painter who worked primarily in Wales and Italy. He exhibited Venetian subjects at the RA in the 1880s.

Alan Sorrell, RWS, born 1904
Studied at Southend and the RCA, he won the Rome Prize and spent from 1928 to 1931 in Rome, later teaching at the RCA. He painted in Venice.

Frank Spenlove-Spenlove, RBA, RI, ROI, 1868–1933
Trained in London, Paris and Antwerp, he painted genre, turning later to landscape in England, Holland and Venice.

Walter Brookes Spong, worked 1880s–1914
Watercolourist who travelled widely, he exhibited many Venetian subjects at the RI.

Arthur Spooner, RBA, worked 1890s–1940
Nottingham landscape-painter who worked in Venice between the wars.

Leonard Russell Squirrell, RWS, RI, RE, 1893–1979
Studied at Ipswich and the Slade. He was a prolific painter in oils, watercolour and pastels as well as an etcher. Between the wars he worked in France and Venice on many occasions.

George Clarkson Stanfield, 1828–1878
The son of Clarkson Stanfield, he shared his father's taste for foreign travel and painted in northern France, Holland, the Rhine, Switzerland and at the Italian lakes, as well as in Venice.

Francis Philip Stephanoff, 1790–1860
The brother of James Stephanoff and the son of a Russian portrait and scenery painter, he was a genre and historical painter, as well as an architectural draughtsman and good violinist. Like his brother, he painted Shakespearean and historical scenes set in Venice, although it is not known if he ever visited the city.

Alfred George Stevens, 1817–1875
Painter, sculptor and designer, he studied in Rome from 1833 to 1842, visiting Florence, Naples and Venice. His career in London developed as a sculptor rather than a painter, although his drawings are extremely fine. His Venetian watercolours and drawings thus date to his early career.

George Washington Stevens, 1866–1926
Born at Utica, NY, he later became Director of Toledo Museum of Art. He visited Europe and produced some Venetian views.

William Arnold Stewart, FRSA, 1882–1953
Yorkshire painter who worked in Venice in the 1920s.

Adrian Scott Stokes, RA, VPRWS, NEAC, 1854–1935
Studied at RA Schools and in Paris, he painted widely on the Continent including mountain scenes in the Tyrol, Spain and Austria, as well as pastoral scenes in France and Holland. He also worked in Venice.

Adrian Durham Stokes, 1902–1972
Educated at Rugby and Magdalen College, Oxford, he studied art at the Euston Road School. He painted still lifes, nudes and landscapes and wrote extensively on art. He had a special regard for Venice, painting there and writing *Venice, an Aspect of Art*, (1945).

Douglas Strachan, HRSA, 1875–1950
Aberdonian painter of portraits, figures and murals. He worked in Venice as a young man, but later in his career turned to stained glass.

George Edmund Street, 1824–1881
Leading Victorian architect whose major

commissions included the Law Courts and St James the Less, Westminster. He visited Italy including Venice in 1853, making drawings and notes and published an account in *Brick and Marble in the Middle Ages: Notes of Tours in the North of Italy*, (1855), a book which helped to popularize the Italian Gothic. He was in Venice again in 1857 and 1868.

Arthur Haythorne Studd, 1863–1919
Studied at the Slade and in Paris, he fell under the influence first of Whistler then of Gauguin, following him to Brittany in 1890 and later working in Samoa and Tahiti. His Venetian oils are small in scale and have the restrained tones of Whistler.

Samuel John Stump, *c*.1783–1863
Studied at the RA Schools and became known for his portraits of stage personalities. He also painted in Venice during the 1830s.

Frederick Taylor, RI, 1875–1963
Studied at Goldsmiths College, London, in Paris and in Italy. He painted Venice over many years, both in oils and watercolour.

Sir Henry Thompson, 1820–1904
Distinguished surgeon and collector of Nanking China, he was a good amateur painter who had studied under Alfred Elmore and Alma-Tadema. He painted in Venice during the 1870s and 1880s.

William Holt Yates Titcomb, 1858–1930
Genre painter, often in watercolour, he studied at Bushey under Herkomer, the RCA, and in Paris and Antwerp. He appears to have discovered Venice late in his career, working there in the 1920s.

Charles F. Tomkins, 1798–1844
Scene painter who worked alongside Clarkson Stanfield and David Roberts, he also painted caricatures and watercolours in a style influenced by Callow and Holland. He painted in Venice during the 1840s.

Francis William Topham, RWS, 1808–1877
Painter who specialized in rustic scenes with peasants and farm animals, he travelled in Ireland and Spain searching for suitable subjects. He was a close friend of Edward Angelo Goodall and accompanied him on three visits to Ireland, and it is likely that he also accompanied him on one of his 15 visits to Venice. Although he avoided Venetian panoramas, he did paint Venetian flower stalls and market people, mostly in the late 1860s.

Samuel Griffiths Tovey, worked 1840s to 1860s
Bristol painter of architecture and Venetian scenes, who exhibited Venetian subjects at the main London societies.

Marianne Trench, ARBA, born 1888
Studied at the Slade and painted in Venice between the wars.

Henry A. Trier, worked 1920s and 1930s
Held exhibition entitled 'Venice and Paris' at The Fine Art Society, 1926.

Dwight W. Tryon, 1849–1925
Born in Hartford, Connecticut, he studied in Paris from 1876 and was greatly influenced by the Barbizon painters. He liked to paint twilights, sunsets and moonrises. He worked in Venice in the late 1870s.

Henry Scott Tuke, RA, RWS, NEAC, 1858–1929
Studied at the Slade, in Florence from 1880 to 1881, and in Paris from 1881 to 1883. He was associated with the Newlyn School, working within their restricted palette. In the later 1890s his palette lightened and he painted many sparkling scenes along the Cornwall Coast. He was a friend of J.S. Sargent and Horatio Brown and was a welcomed guest in Venice, although his Venetian subjects are comparatively rare.

Walter Spencer-Stanhope Tyrwhitt, RBA, 1859–1932
Educated at Radley College and Christ Church, Oxford he began an architectural training before turning to art. He painted architectural subjects in watercolour, visiting Venice on a number of occasions where his friend Walter Tyndale lived. His wife, Ursula Tyrwhitt, NEAC (1878–1966) trained at the Slade and also worked mainly in watercolour. Together they painted in Venice alongside Henry Simpson and Graham Petrie.

Charles Frederick Ulrich, 1858–1908
Born in New York City, he painted genre and people at work. He settled in Venice in 1886, painting the working people of Venice, including *Glass Blowers of Murano*.

Murray McNeel Caird Urquhart, RBA, born 1880
Born in Kirkcudbright, he studied at Edinburgh, the Slade, in Paris and for a time with Sickert at Westminster. He often painted in Italy, and Venice especially suited his limpid watercolour manner which recalls Steer and Connard. He worked in Venice from around 1910 to 1930.

Charles Vacher, RI, 1818–1883
Studied at the RA Schools and in Italy, he was a keen traveller and visited Italy, France, North Africa and Egypt. In addition to rapid watercolour sketches made on the spot, he painted larger, more meticulously finished oils. He also worked in Venice.

Sydney Vacher, 1854–1934
A nephew of Charles Vacher, he studied at the RA Schools, and produced mostly etchings of Venice.

Eugene Laurent Vail, 1857–1934
Born in France of an American father, he was educated in the USA returning later to live in France. He painted in Venice during the early years of the twentieth century.

Miss J. Vivian, worked 1860s and 1870s
London artist who painted detailed oils of Venice.

Sydney Curnow Vosper, RWS, 1866–1942
Landscape and figure painter and etcher who trained first as an architect before studying art in Paris. He worked in Venice during the 1920s.

Robert Thorne Waite, RWS, 1842–1935
Watercolour painter of landscapes in England, Wales, Holland and Venice. His first visit was probably in 1874, and he returned subsequently.

Frederick Walmisley, 1815–1875
Painter of genre, portraits and some landscapes, he trained at the RA Schools. He lived for a time in Rome during the 1840s and painted scenes from Italian life. He also worked in Venice.

George Stanfield Walters, RBA, 1838–1924
Born in Liverpool, he settled in London in 1865, painting river scenes and coastal views in watercolour. He also painted shipping on the Venetian Lagoons.

Orlando Frank Montague Ward, born 1868
Landscape painter in oils and watercolour, he lived in Paris and Italy and later in London. He visited Venice on several occasions until the 1920s.

Louisa, Marchioness of Waterford, 1818–1891
Amateur painter and celebrated beauty, she married the Marquis of Waterford and lived, after his death in a hunting accident, at Ford Castle, Northumberland. She was a friend of Ruskin and Burne-Jones, and painted in a style influenced by the colouring and subject matter of the Venetian School. She visited Venice and painted watercolours of the city.

Charles John Watson, RE, 1846–1927
Etcher and watercolourist, he worked in Norfolk, France and Italy, where he enjoyed depicting lively market-scenes and church interiors. His Venetian work deserves more notice.

Herbert Parsons Weaver, RBA, 1872–1945
Studied at Worcester and the RCA, he painted landscapes and architectural subjects, often abroad, including Venice where he worked between the two World Wars. He was later Principal of Shrewsbury School of Art.

John Ferguson Weir, 1841–1926
Born in West Point, N.Y. he was the son of the artist Robert W. Weir who had lived for a time in Rome. He visited Europe with his wife between 1868 and 1869 and painted in Venice on this trip.

Julian Alden Weir, 1852–1919
The brother of J.F. Weir, he studied in Paris from 1873 to 1877 and in 1883 he visited Venice with his bride, meeting Frank Duveneck.

Joseph Walter West, VPRWS, 1860–1933
Studied at St John's Wood, the RA Schools and in Paris, he painted detailed genre and landscape in oils, watercolour and tempera; his later work became broader in handling. He often worked in Italy, including Venice.

William Ainsworth Wildman, ARWS, RBA, born 1882
Studied in Manchester, the RCA and Paris, he exhibited Venetian subjects between the two World Wars.

Christopher David Williams, RBA, 1873–1934
Trained at the RCA and RA Schools, he travelled widely in Europe and North Africa. His Venetian oils are restrained in colour.

Harry Willson, worked 1813 to 1851
Painter of architectural subjects and landscapes and writer on art. He published *Fugitive Sketches in Rome and Venice* in 1838 and painted oils of Venice, sometimes circular in format, which have been likened to Guardi.

Oscar Wilson, 1867–1930
Trained at the RCA and in Antwerp, he painted genre scenes and interiors. He painted some scenes set in Venetian cafés.

William Heath Wilson, 1849–1927
The son of Charles Heath Wilson, ARSA, he was Headmaster of Glasgow School of Art for a period. He spent much time in Italy and painted limpid oils of Venice.

Willie Wilson, RSA, RSW, 1905–1972
Edinburgh painter closely involved with Gillies and Maxwell, he painted powerful watercolours in the South of France, the Italian Dolomites and also in Venice.

Edgar Wood, 1860–1935
Leading Manchester Arts and Crafts architect, and founder of the Northern Art Workers' Guild. He also painted in watercolour and there is an example entitled *Torcello Cathedral* at Whitworth Art Gallery.

Harold Workman, RBA, ROI, born 1897
Trained at Oldham and Manchester, he painted oils and watercolours of Venice during the 1950s and 1960s.

William Lionel Wyllie, RA, RI, RE, 1851–1931
Trained at Heatherleys and the RA Schools, he became known for his oils and etchings of harbours and marine scenes. He worked abroad including Holland, Turkey and Venice.

George Henry Yewell, 1830–1923
American painter born in Havre de Grace, he studied at the National Academy of Design, New York before leaving for Paris in 1856 to study under Couture. He returned to Europe in 1867 spending several months in Venice before settling in Rome. He also spent the summer of 1872 in Venice. His Venetian pictures are usually detailed interiors of St Mark's and the Ducal Palace. In 1878 he returned to New York, his wife having run off with the English seascape painter Edwin Ellis.

List of illustrations

Black and white illustrations

Index